HOOKER'S
FINEST FRUITS

HOOKER'S FINEST FRUITS

A selection of paintings of fruits
by WILLIAM HOOKER
(1779–1832)

Introduction by
WILLIAM T. STEARN

Descriptions by
FREDERICK A. ROACH

THE HERBERT PRESS
in association with
The Royal Horticultural Society

© 1989 by The Herbert Press Ltd and The Royal Horticultural Society
Copyright under the Berne Convention

First published in Great Britain 1989 by
The Herbert Press, an imprint of A&C Black (Publishers) Ltd
35 Bedford Row, London WC1R 4JH
Reprinted 1997

Designed by Pauline Harrison
Typeset in Sabon by BAS Printers Limited, Over Wallop, Hampshire
Printed and bound in Hong Kong by South China Printing Co. (1988) Limited

A CIP catalogue record for this book is available from the British Library.

ISBN 1-871569-05-2

CONTENTS

INTRODUCTION

WILLIAM HOOKER

(1779–1832)

Illustrator of Flowers and Fruits, and his Associates

by William T. Stearn 9

THE PLATES

1 KIRKE'S GOLDEN REINETTE APPLE 25

2 GRAVENSTEIN APPLE 27

3 HAWTHORNDEN APPLE 29

4 RIBSTON PIPPIN APPLE 31

5 MARGIL APPLE 33

6 FEARN'S PIPPIN APPLE 35

7 COURT OF WICK APPLE 37

8 BLENHEIM ORANGE PIPPIN APPLE 39

9 BORSDORFF APPLE 41

10 BEAUTY OF KENT APPLE 43

11 CORNISH JULY FLOWER APPLE 45

12 KERRY PIPPIN APPLE 47

13 KESWICK CODLIN APPLE 49

14 DUTCH CODLIN APPLE 51

15 NONPAREIL APPLE 53

16 SCARLET NONPAREIL APPLE 55

17 RED QUARRENDEN APPLE 57

18 SYKE HOUSE APPLE 59

19 ALEXANDER APPLE 61

20 SIBERIAN HARVEY CIDER APPLE 63

21 TRUE ST GERMAIN PEAR 65

22 JARGONELLE PEAR 67

23 COLMAR PEAR 69

24 BROWN BEURRÉ PEAR 71

25 CRASSANE PEAR 73

26 CHAUMONTEL PEAR 75

27 GANSEL'S BERGAMOTTE PEAR 77

28 WILLIAMS' BON CHRÉTIEN PEAR 79

29 SECKLE PEAR 81

30 GRIMWOOD'S ROYAL GEORGE PEACH 83

31 NEAL'S EARLY PURPLE PEACH 85

32 ACTON SCOTT PEACH 87

33 BRADDICK'S AMERICAN PEACH 89

34 BOURDINE PEACH 91

35 GALANDE PEACH 93

36 NOBLESSE PEACH 95

37 RED MAGDALENE PEACH 97

38 BREDA APRICOT 99

39 BRUSSELS APRICOT 101

40 ORANGE APRICOT 103

41 MOOR PARK APRICOT 105

42 RED ROMAN NECTARINE 107

43 ELRUGE NECTARINE 109

44 PITMASTON ORANGE NECTARINE 111

45 FAIRCHILD'S EARLY NECTARINE 113

46 VIOLETTE HÂTIVE NECTARINE 115

47 WHITE NECTARINE 117

48 IMPÉRATRICE PLUM 119

49 GREEN GAGE 121

50 CATHERINE PLUM 123

51 NECTARINE PLUM 125

52 COE'S GOLDEN DROP PLUM 127

53 MOROCCO PLUM 129

54 LA ROYALE PLUM 131

55 WILMOT'S NEW ORLEANS PLUM 133

56 PRÉCOCE DE TOURS PLUM 135

57 SHROPSHIRE DAMSON 137

58 PEAR-SHAPED QUINCE 139

59 BIGARREAU CHERRY 141

60 MORELLO CHERRY 143

61 MAY DUKE CHERRY 145

62 ELTON CHERRY 147

63 KNIGHT'S EARLY BLACK CHERRY 149

64 WATERLOO CHERRY 151

65 BLACK EAGLE CHERRY 153

66 BLACK TARTARIAN CHERRY 155

67 FLORENCE CHERRY 157

68 TRADESCANT CHERRY 159

69 DUTCH MEDLAR 161

70 NOTTINGHAM MEDLAR 163

71 PEAR-SHAPED SERVICE 165

72 CHILI STRAWBERRY 167

73 ROSEBERRY STRAWBERRY 169

74 WILMOT'S LATE SCARLET STRAWBERRY 171

75 PINE STRAWBERRY 173

76 DOWNTON STRAWBERRY 175

77 YELLOW ANTWERP RASPBERRY 177

78 RED ANTWERP RASPBERRY 179

79 BLACK HAMBURGH GRAPE 181

80 ESPERIONE GRAPE 183

81 RAISIN DES CARMES GRAPE 185

82 VERDELHO GRAPE 187

83 BLACK FRONTINIAC GRAPE 189

84 BLACK CORINTH GRAPE 191

85 BLACK PRINCE GRAPE 193

86 RED WARRINGTON GOOSEBERRY 195

87 WILMOT'S EARLY RED GOOSEBERRY 197

88 WHITE DUTCH CURRANT 199

89 LARGE BLUE FIG 201

90 WHITE FIG 203

91 BLACK MULBERRY 205

92 BLACK ROCK MELON 207

93 QUEEN PINEAPPLE 209

94 COB NUT 211

95 LARGE FRENCH WALNUT 213

96 HIGH-FLYER WALNUT 215

Bibliography 217
Index 219

THE PLATES IN THIS EDITION have been reproduced from the original paintings of William Hooker commissioned by the Horticultural Society of London between 1815 and 1820, with the exception of plates 31, 36, 43, 47, 74 and 94 which are reproduced from engravings in Hooker's *Pomona Londinensis* (1816–18). The original works are in the Lindley Library of the Royal Horticultural Society. The authors and publisher are grateful to the Royal Horticultural Society for their co-operation and permission.

This is the first time that William Hooker's original paintings have been gathered together, with the best of the engravings, for publication in volume form.

INTRODUCTION

WILLIAM HOOKER
(1779–1832)
Illustrator of Flowers and Fruits,
and his Associates

William T. Stearn

THE POMOLOGICAL BACKGROUND

ALTHOUGH FRUITS LACK THE DIVERSITY of flowers in form and colour, many, especially those which become pulpy or juicy and are predominantly red, purple and yellow, having evolved in accordance with colour discrimination and selection by fruit-eating birds, possess for man both a gastronomic and an aesthetic appeal, which has led to their portrayal by artists of distinction, among them Pierre-Joseph Redouté (1759–1840) and William Hooker (1779–1832). This is especially so for the domesticated fruits increased and varied through human selection over many centuries. As the number of variants raised and grown in a given area multiplied, so more and more evident became the need to distinguish and name them. Of that the Roman writers on horticulture were certainly aware, for they listed the variants (now called cultivars) they esteemed. However, the credit for being the first to record and describe in some detail the apples and pears of any area belongs to a brilliant young German medical student Valerius Cordus; he died of fever in 1542 aged only 29 (cf. Stearn, 1986), but his unprecedented work, *Annotationes*, was not published until 1562. It deals with thirty-one apple cultivars and fifty pear cultivars of Hessen and Saxony but has no illustrations. Individual kinds of fruit are too numerous and overlap too much in their characters, even though varying within definite limits around a mean, to be recognizable satisfactorily from descriptions alone, which are necessarily analytical and give no immediate mental picture of a particular fruit. For this a good illustration is essential, but the publication in quantity of coloured plates adequate for identification did not begin until the eighteenth

century (cf. Bunyard, 1914). A notable example is Johann Kraft's *Pomona Austriaca* (Vienna, 1790–1796).

Pomona was the Roman goddess of fruit trees and hence of fruits, as her name implies, being derived from *pomum*, 'fruit'. In the same way that botanists during the seventeenth century transferred the name *Flora* from the Roman goddess of flowers to a catalogue, usually descriptive, of the plants of an area, e.g. Simon Pauli, *Flora Danica* (Copenhagen, 1648; cf. Wein, 1932), horticulturists in the eighteenth century used the name *Pomona* for a treatise on fruit and fruit trees, e.g. B. Langley, *Pomona or the Fruit-Garden illustrated* (London, 1729), J. Mayer, *Pomona Franconica* (Nürnberg, 1776–1801). Later 'pomology' or *pomologia* became the accepted name for the study of fruits and their cultivation, e.g. J. H. Knoop, *Pomologia* (Leeuwarden, 1755). Thus the artist William Hooker (1779–1832) had ample precedent for entitling *Pomona Londinensis* his book of illustrations of fruits grown in the London area, as likewise T. A. Knight had for his *Pomona Herefordiensis* dealing with cider and perry fruits of Herefordshire.

One of the most influential pomological works of the eighteenth century was the *Traité des Arbres fruitiers* (2 vols.; Paris, 1768) by H. L. Duhamel du Monceau (1700–1782), particularly valued in Britain because various fruits cultivated there had come from France and had sometimes been renamed. For example, the English 'Green Gage' plum is the French 'Reine Claude', as Hooker noted. Confusion prevailing during the seventeenth and eighteenth centuries in the naming of fruit trees resulted in a buyer rarely being sure of getting what he wanted. The economic importance of remedying the indiscriminate naming of fruits accordingly led some very knowledgeable horticulturists to produce books seeking to promote uniform standard nomenclature by means of authoritative descriptions and illustrations. Nowhere was the need for these more appreciated than in England.

Thus, to quote Edward Ashdown Bunyard (1878–1939), the most scholarly English pomologist of the twentieth century, 'the opening years of the nineteenth century were the Golden Age of pomology in this country [England]. The extraordinary expansion of commerce and the great prosperity it brought had an enormous influence upon horticulture and its literature. The remarkable output of books, many illustrated in an elaborate and costly manner, is evidence not only of a great gardening interest but of the means to encourage it. By a happy coincidence this period coincided with the appearance of several men whose names will always be prominent in pomological history. Thomas Andrew Knight, Thompson, Lindley, Ronalds, Hooker and

Brookshaw, all produced their best work between 1800 and 1837; and during that period systematic pomology was established in this country.' (Bunyard, 1914). These were years of recovery from the Napoleonic Wars. Concerning William Hooker, Bunyard remarked that 'the skill of Hooker as a painter of fruits has never been equalled in this country, and here [in his *Pomona Londinensis*] he is at his best'. The present volume *Hooker's Finest Fruits*, by reproducing some of his fruit illustrations, should make evident the justice of Bunyard's assessment of Hooker's talent as a pomological artist.

WILLIAM HOOKER AND FRANZ BAUER

DESPITE WILLIAM HOOKER'S EMINENCE as a portraitist of fruit, relatively little is known about his life as distinct from his achievements. He should not be confused, although he has been, with his much more illustrious, better known and well-documented namesake Sir William Jackson Hooker (1785–1865), who was also a skilled botanical artist and was successively professor of botany in the University of Glasgow and director of the Royal Botanic Gardens, Kew. Botanical generic names commemorate them both, *Hookera* (Liliaceae), now treated as a synonym of *Brodiaea*, named for William Hooker and *Hookeria* (Musci) named for William J. Hooker, both published in 1808. Sir William's reputation, apart from his Glasgow teaching and his association with Kew, rests upon numerous publications to which he contributed text and sometimes illustrations. William Hooker is to be honoured primarily as an artist and engraver for his illustrations to four meritorious works: Salisbury's *Paradisus Londinensis* (1805–1811), Knight's *Pomona Herefordiensis* (1813–1818), his own *Pomona Londinensis* (1816–1818) and Pursh's *Flora Americae septentrionalis* (1814); he also contributed plates to the *Transactions of the Horticultural Society of London*. The colour 'Hooker's Green' commemorates him.

William Hooker was born in London in 1779 and died there in 1832. Evidently he received a good education which enabled him to associate at ease with botanists and the wealthy horticulturists of the London Horticultural Society. He described himself on the title-page of the *Paradisus Londinensis* as having been 'Pupil of Francis Bauer Esq., Botanic Painter to their Majesties', presumably with pride but presumably also as a notable professional qualification. Franz Bauer (1758–1840), 'der grösste Pflanzenmaler' as Pritzel designated

him, stands with his brother Ferdinand (1760–1826) among the greatest botanical artists of all time (cf. Stearn, 1960). Austrian-born he came to England from Vienna in 1788. Sir Joseph Banks, ever a shrewd judge and encourager of talent, induced him in 1790 to stay as his resident artist at the Royal Gardens of Kew, originally as Banks's employee, then after Banks's death in 1820 as his pensioner, free to depict whatever plants he liked. Bauer died at Kew and is commemorated in the parish church on Kew Green by a memorial tablet appropriately adorned with floral decorations. His illustrations of plants, mostly unpublished and mostly in the British Museum (Natural History), London, combine meticulous accuracy and attention to minute detail with skilled graphic technique and graceful presentation; they are masterpieces of botanical art. Bauer, unlike the earlier G. D. Ehret, had no need for pupils, being employed by wealthy Sir Joseph Banks, and William Hooker is the only one he is known to have had, apart from Queen Charlotte and Princess Elizabeth. He must have thought highly of young Hooker's talent and potentialities to have trained him so well. Indeed Hooker's fruit paintings may be regarded as pomological counterparts of Bauer's botanical ones; they display the same quality of life-like precise representation.

HOOKER AND SALISBURY'S *PARADISUS LONDINENSIS*

EMBOLDENED POSSIBLY BY THE SUCCESS OF CURTIS'S *The Botanical Magazine or Flower Garden displayed*, begun in 1787 and reaching its 21st volume in 1805, and of Andrews' *The Botanist's Repository for new and rare Plants*, begun in 1797 and reaching its 6th volume in 1804, William Hooker began publication in 1805 of a rival periodical likewise depicting new and rare plants. The title-page of the first part reads *The Paradisus Londinensis or coloured Figures of Plants cultivated in the Vicinity of the Metropolis. By William Hooker, Pupil of Francis Bauer Esq., Botanic Painter to their Majesties at Kew.* No author is given for the text, but Hooker did not write this. Sowerby and Smith's *English Botany*, begun in 1790, gave precedent for such apparently concealed authorship as J. E. Smith's name did not appear on the title-page until 1795. A later title-page (1806) to the *Paradisus* states *The Descriptions by Richard Anthony Salisbury Esq. . . ., the Figures by William Hooker.* 'With regards to the Plants themselves', says the Preface, 'only such as are new, uncommonly beautiful, or incompletely figured by others, will be selected;

and of these the harvest is abundant.' There was indeed a remarkable array of new plants then coming into cultivation. In the *Paradisus Londinensis* Hooker illustrated plants introduced from Australia, the Caucasus, India, Japan, North Africa, South Africa, Eastern North America and Southern Europe. However, it seems that only very well-to-do enthusiastic gardeners subscribed to the three current periodicals illustrating them, especially as these periodicals sometimes portrayed the same plants. For example, a Western Australian plant grown by James Colvill in Chelsea was illustrated in the *Paradisus Londinensis* (t. 73) in June 1807 as *Burtonia grossulariaefolia* and in the *Botanist's Repository* (t. 472) in July 1807 as *Hibbertia crenata* (cf. Stearn, 1982), then in the *Botanical Magazine* (t. 1218) in 1809.

Richard Anthony Salisbury (1791–1829), Hooker's collaborator, was a very able botanist but he had no respect for plant names published by other botanists if he thought, as he frequently did, that he could coin a more fitting name himself. Thus in the first two parts (June–July 1805) of the *Paradisus Londinensis* he substituted a new and now illegitimate name of his own, *Protea acuifolia*, for *P. nana* Thunb. and likewise a new and illegitimate name, *Vaccinium buxifolium*, for *V. brachycerum* Michaux. He published many other such unnecessary names in the *Paradisus Londinensis* as well as descriptions of undoubted new species. Salisbury* was a founder member of the Horticultural Society of London and from 1805 to 1816 its secretary. Thus a common interest in horticulture, particularly pomology, and in botany may have brought him and Hooker together. Unfortunately Salisbury's love and acute observation of plants were offset by devious and dishonest behaviour which earned him dislike, animosity and ultimately ostracism by James Edward Smith (1759–1828), President of the Linnean Society (cf. Stearn, 1988; Walker, 1988),

* When the Swiss botanist Augustin Pyramus de Candolle (1778–1841) visited England in 1816 he made the acquaintance of Salisbury together with other British botanists who used the rich library and herbarium of Sir Joseph Banks at Soho Square, London and recorded his impressions in his *Mémoires et Souvenirs* (1862). Of Salisbury he wrote: 'Un autre habitué de l'herbier de Banks était Salisbury. Il était brouillé avec Brown et présentait le contraste le plus formel avec lui. C'était un homme d'esprit, vif et d'une pétulance extraordinaire, qui par le physique et le moral resemblait plus à un Languedocien qu'à un Anglais. Il me prit vite en amité et me fit mille politesses, comme le font tous qui n'aiment pas Brown et me font l'honneur de me regarder comme celui qui peut lui disputer le premier rang . . . Salisbury m'amusait beaucoup par son esprit, m'instruisait quelque fois par ses communications, mais je ne pouvais défendie d'une certaine défiance quant à la justesse de ses observations botaniques et quant à son caractère. Il était brouillé avec Smith comme avec Brown et tout annonçait alors un homme difficile à vivre. Ma position entre lui et Brown était souvent délicate, surtout vis-à-vis du dernier.'

Samuel Goodenough (1743–1827), William Roscoe (1753–1831) and their friends; the one with most justification for grievance was Robert Brown (1773–1845). This influential botanical group unfairly extended censure of Salisbury to his friends and associates, notably S. F. Gray and J. E. Gray, but Hooker seems to have escaped it.

Salisbury reciprocated, but less effectively, the enmity of Smith and his circle. In the *Paradisus Londinensis* he never missed an opportunity of sarcastically criticizing Smith's work. Whether Salisbury's unpopularity affected the sale of the *Paradisus Londinensis* is uncertain but likely; if so, it must have reduced Hooker's income as an artist and engraver and he certainly found other work. William Roscoe was a subscriber, for in a letter to him on 2 April 1806 Smith proposed a scornful motto for the *Paradisus Londinensis*:

> What malice lurks beneath this fair disguise?
> The devil again in *Paradise* tells lies!
> But now, how plausible so'er his tale is,
> We always take his words *cum grano Salis.*

Smith also remarked that 'Salisbury has printed a most abusive and lying pamphlet against my Engl. Bot. I have *written proof* of 2 gross falsehoods of his lately. I find no one minds him and all my friends are anxious for my silence.' The pamphlet mentioned is *The Generic Characters in the English Botany collated with those of Linné* (London, February 1806).

Whatever opinion may be held about Salisbury's often controversial text and egotistical nomenclature, no one can doubt the accuracy and utility of Hooker's careful drawings of new or little-known species.

Salisbury manifested his admiration by dedicating to Hooker under plate 98 (March 1808) a new Western North American genus of Liliaceae (Alliaceae) which he named *Hookera coronaria* 'in memoriam Gulielmi Hooker, pictor hujusce operis'. Later, under plate 107 (September 1808), the last one, Salisbury added another species, *Hookera pulchella*, remarking 'if my ideas respecting the genus are right they will be confirmed in spite of Dr J. E. Smith's opposition, whose multiplied acts of injustice to me, whether open or concealed, I sincerely forgive.' The sincerity of that forgiveness may well be doubted. Smith published a new genus of mosses in *Transactions of the Linnean Society* 9: 275 (November 1808) which he named *Hookeria* in honour of his young friend William Jackson Hooker. Instead, however, of renaming this on account of Salisbury's earlier *Hookera coronaria*, he renamed the latter *Brodiaea grandiflora* in the Linnean Society *Transactions* 10: 2 (March 1810), to com-

memorate his friend James Brodie (1744–1824) of Brodie Castle, Elgin. Salisbury naturally took this as a deliberate insult. However, the ostracism of Salisbury by Smith and his friends ensured that Smith's names *Hookeria* and *Brodiaea* came into general use and are now officially conserved. Thus, somewhat unfairly, the botanical commemoration of William Hooker by a genus now well-known and comprising fifteen species has been suppressed. Salisbury himself changed so many plant names validly published by other botanists that he could not logically complain about receiving the same treatment, but he did! In his posthumous *The Genera of Plants* 86 (1866) he stated that *Hookera* was dedicated to 'William Hooker, n. Londini 1779, Florum et Fructuum Pictor vix ulli secundus', then went on to attack Smith's action and pay a further compliment to Hooker: 'Sir J. E. Smith . . . was so offended with me for contradicting his opinions that in a paper read after the publication of my first species [*Hookera coronaria*, 1 March 1808] at a meeting of the Linnean Society on the 9th of April 1808 but not published till 3 years [actually 2] after in the 9th [actually 10th] volume of their Transactions he called this genus after a *Scotch* cryptogamist James Brodie Esq. That gentleman is little indebted to him for commemorating his name in any way with such paltry revenge; for what will an impartial historian say, if he compares the benefits Botany has derived from the rich owner of *Brodie House*, with those figures which entitle William Hooker's name to descend to posterity in the glorious company of Robert's, Joubert's, Aubriet's, Basseporte's, Merian's, Spaendonch's [Spaendonck's], Elwet's [Ehret's], Sowerby's, Redouté's, the two Bauers' and Sydenham Edward's, another victim of *Sir* J. E. Smith's misrepresentations?' By associating Hooker with such an array of distinguished botanical artists Salisbury certainly gave him a handsome tribute.

Publication of the *Paradisus Londinensis* began with the issue of three plates on 1 July 1805 and ended with plate 117 on 1 September 1808. For two plates Salisbury issued changed text, having changed his taxonomic views. Against the opinion of Hooker he described a new Australian genus *Burtonia* under plate 73 (June 1807) but in 1808 he issued new text under the heading *Hibbertia*, thus agreeing with Hooker and cancelling his earlier one, a procedure which has misled some later botanists. Likewise under plate 64 (March 1807) he published text headed *Anneslia grandiflora* which he later replaced by text headed *Anneslia falcifolia* (cf. Stearn, 1982).

KNIGHT'S *POMONA HEREFORDIENSIS* AND PURSH'S *FLORA AMERICAE SEPTENTRIONALIS*

DESPITE THE QUALITY OF ITS ENGRAVED HAND-COLOURED plates, the *Paradisus Londinensis* can hardly have been a lucrative undertaking and before its end Hooker had begun other work. He was an expert engraver and colorist and evidently possessed a special knowledge of apples. In 1811 Thomas Andrew Knight (1759–1838) became President of the Horticultural Society of London but he had been prominent in its affairs from the beginning. Thus he and Hooker must have become well acquainted some years before 1808. Knight was a country gentleman with strong scientific and practical interests in horticulture and agriculture and he had been worried since 1795 by the decline in vigour and productivity of the old cider apple and perry pear cultivars in Herefordshire, where they were economically important for the making of cider and perry. They were propagated by grafting. Knight studied their history and himself raised new cultivars from seed. He believed that the collective product of a single seed by vegetative propagation (which would now be called a *clone*), such as each of the old apples and pears was, had a limited life-span, comparable to that of man but with much longer duration. This view was revived by Marietta Pallis in 1916 (cf. *Annales Musei Goulandris* 7: 163; 1985) but is unprovable. A more modern view is that clones are potentially immortal unless they die through climatic changes or virus or other infection (cf. Stearn, 1949). The decline in grafted stocks observed by Knight was probably due to the transmission of virus diseases. His studies resulted not only in the raising of seedlings to produce more vigorous long-lived fruit-trees but also in a beautiful pomological book, *Pomona Herefordiensis containing coloured Engravings of the old Cider and Perry Fruits of Herefordshire, with such new Fruits as have been found to possess Excellence*. With this work, published in parts each having three plates, between 1808 and 1811, Hooker was closely associated. He did not draw the illustrations, which were mostly by a local amateur artist, Miss Elizabeth Matthews, but he engraved and possibly improved the plates and sold the parts from his London address. Later he engraved the plates for James Forbes's *Oriental Memoirs* (1813–1814).

The Horticultural Society of London began to publish its sumptuous quarto *Transactions* in 1807 and about this time Hooker became associated with the Society, engraving the plates and himself as the Society's artist contributing many original illustrations until his illness in 1820. Before 1811 the Society had established a Fruit Committee of which Hooker became a member;

it published its first report in 1813 (*Transactions* 2: 58–62). This concluded that 'every possible accuracy of description must be of little avail, to enable those who are not very conversant with the subject, immediately to know one kind from another, unless accompanied by a faithful coloured representation of the fruit described; and in this particular your Committee has been very fortunate, having received the greatest assistance from one of their number, Mr William Hooker, whose great skill in his profession, and whose quickness in seizing the true characteristics of each tree or fruit, have only been surpassed by the zeal, and diligence, which he has manifested in the pursuit.' Some of these fruit drawings were published in the *Transactions*, some in his *Pomona Londinensis*. The fate of the whole collection is described below.

While thus employed Hooker did not cease to draw and engrave botanical illustrations. Thus he provided 24 plates for the *Flora Americae septentrionalis* (London, 1814) by Frederick Pursh (1774–1826), an important pioneer Flora of North America recording 3076 species (cf. Ewan, 1979) based on much more extensive material than any previous botanist had handled. Pursh was a German-born gardener from Saxony, obviously well educated and with considerable botanical knowledge, who emigrated to the United States in 1799. William Smith Barton (1766–1815) of Philadelphia employed him as a botanist from 1805 to 1808. Thus botanical specimens collected on the remarkable transcontinental expedition of 1804 to 1806 by Captain Meriwether Lewis (commemorated by the genus *Lewisia* Pursh) and William Clark (commemorated by the genus *Clarkia* Pursh) came into his hands for study. In 1811, with fragments of these and with much other material, possibly not rightfully acquired, he came to England. Aylmer Bourke Lambert (1761–1842), the possessor of an enormous private herbarium and library, befriended him, for Pursh's drinking habits made him ever short of money, gave him working facilities, and encouraged him in writing his *Flora*, which he gratefully dedicated to Lambert. Sir J. E. Smith and Sir Joseph Banks, both possessing large herbaria, also helped and one of the trio brought Pursh and Hooker together. Of the twenty-four plates all but one (t. 7, *Solanum heterandrum*, by Pursh) are by Hooker; they include figures of thirteen new species collected by Lewis and Clark. Most copies have these engraved plates only in black and white, but a few coloured copies exist, including one in the library of the Royal Botanic Gardens, Kew. As Hooker drew them from dried specimens, Pursh must have provided some information on the colouring. The plates, though few, make a valuable contribution to the *Flora*, being drawn and engraved with Hooker's customary skill. According to J. W. Francis (quoted by Ewan,

1979), Pursh, whose alcoholism had been evident in America, 'drank up all the booksellers renumeration' long before publication of the *Flora* in 1814, being 'his own worst enemy: drunk, morning, noon and night'; he 'would not steal anything in the world, rum, gin, whisky or the like excepted'. Presumably Hooker got his remuneration direct from the publisher, not from Pursh! The latter died in Montreal in 1820, destitute.

THE *POMONA LONDINENSIS*

THE *Pomona Londinensis containing colored Engravings of the most esteemed Fruits cultivated in the British Gardens* (London, c.1816–1818), with text and plates by Hooker himself, is his most important contribution to pomology. It appeared in seven parts, each with seven plates, published from 5 York Buildings, New Road, Marylebone, London, presumably Hooker's residence. There were two states, the Small Imperial Quarto and the superior Atlas state with highly finished plates; the Lindley Library of the Royal Horticultural Society possesses a copy of the latter. These are possibly the finest illustrations of fruits ever published, so lifelike and appetising that one almost feels that they could be picked off the plate, so beautiful that they stand as works of art in their own right. They illustrate 13 apples, 8 pears, 7 plums, 5 peaches, 4 nectarines, 4 cherries, 2 grapes, 1 apricot, 1 white currant, 1 cobnut, 1 raspberry and 1 strawberry. Particularly impressive is Hooker's portrayal of the White Dutch Currant with the berries translucent and the seeds within them visible. His aim was to select those variants possessing distinctive qualities. Growers around London provided him with fine samples, particularly Mr Padley in charge of the gardens at Hampton Court Palace; from here came the fruits illustrated in the present volume on plates 31 (Neal's Early Purple Peach), 34 (La Bourdine Peach), 36 (Noblesse Peach), 47 (White Nectarine), 48 (Impératrice Plum), 49 (Green Gage Plum), 50 (Catherine Plum), 52 (Coe's Golden Drop Plum), 54 (La Royale Plum) and 56 (Précoce de Tours Plum). He also illustrated fruits grown in Brompton, Highgate, Isleworth, Kew, Marylebone, Paddington, Richmond, Thames Ditton and Twickenham in the London area and others from Elton in Gloucestershire, Newington in Kent and Wallington in Northumberland. Some original drawings for these, once the property of the Horticultural Society, are now among the Hooker Drawings in the Lindley Library of the Royal Horticultural Society at Vincent Square, Westminster, London. They have had an eventful history.

THE HOOKER DRAWINGS

As NOTED ABOVE, THE HORTICULTURAL SOCIETY OF LONDON (founded in 1804) early appointed a Committee on Fruit from which it received the report already quoted commending Hooker's great skill, zeal and diligence in the portrayal of fruit.

The Council of the Society commissioned him to produce 25 such coloured drawings annually and published lists of them in the *Transactions* beginning with 1 May 1815. He continued to provide 25 until May 1820.

The Preface to the Society's *Transactions* vol. 3 (dated January 1820) states: 'The Collection of Drawings of Fruits, formed under the Direction of a Committee, is already considerable ... In justice they cannot omit to state, that to the correct eye and skilful hand of Mr William Hooker the Artist regularly employed by the Society, they owe this invaluable assemblage, the importance of which as standards of reference, will long be felt and acknowledged.'

Unfortunately ill-health forced him to relinquish this pleasant and rewarding task. The printed list for May 1821 to May 1822 records only 9 drawings, instead of 25, for that year, with a sad apology: 'The Council regrets that, on account of the severe indisposition of Mr Hooker, the Artist employed by the Society, they have not been able to complete the usual number of Drawings of Fruits for the past year, the above being the whole that have been executed.' These last drawings reveal Hooker at the height of his powers. Then suddenly he became incapacitated and apparently never painted any more. The nature of his illness is not recorded, but was probably a stroke or maybe severe arthritis. He died twelve years later, in London, in 1832.

To continue the illustration of fruits the Society engaged the services of Charles John Robertson in 1820, then Barbara Cotton and the more celebrated Mrs Augusta Innes Withers, who later contributed illustrations to the *Pomological Magazine* and other works, above all to James Bateman's gigantic folio *The Orchidaceae of Mexico and Guatemala* (1837–1841).

Hooker not only portrayed fruits for the Horticultural Society; he also did some flowers and published some articles in the *Transactions*, e.g. an account of 'Williams Bon Chrétien' pear in vol. 2: 258 (1817) and of apples imported from Rouen in vol. 2: 298 (1817). Botanically important among his illustrations in the *Transactions* is one of a fruiting shoot of a new species of guava (*Psidium*, family Myrtaceae) with purple fruits which Sabine named *Psidium cattleianum* in the *Transactions* 4: 316, t. 11 (16 May 1821). This

commemorates its grower William Cattley, a merchant and keen horticulturist to whom John Lindley gratefully dedicated the orchid genus *Cattleya* in 1821. Although Sabine's description is brief, Hooker's excellent plate, supplemented by Lindley's more detailed plate with flowers in his *Collectanea botanica* t. 16 (1821), conclusively establishes the plant's identity. A native of Brazil it is now widely planted in the tropics and known as the Purple Guava or Cattley Guava. As noted by C. A. Schroeder in *Journal of the Arnold Arboretum* 27: 315 (1946), Sabine's name has priority over *Psidium littorale* Raddi in *Opuscula scientifici* 4:254 (1823) adopted, for example, in *Hortus Third* 923 (1976).

Hooker's illness also delayed publication of the *Transactions*. Accordingly the preface, dated 'December 1824', to vol. 5 states: 'The severe and continued indisposition of Mr William Hooker, in whose charge the entire execution of the engravings had always remained, having rendered him incapable of fulfilling his engagements, considerable time elapsed before the necessary arrangement could be made to supply his place.'

Hooker's drawings for the Horticultural Society were mounted in folio volumes and incorporated in its extensive library in Lower Regent Street, its home since 1819. By 1859 the Society had assembled there some 1500 drawings of flowers and fruits, a collection such as existed nowhere else in Britain and was rivalled only by the *vélins* in the Paris Muséum National d'Histoire Naturelle. Financially, however, the Society was in a perilous state, having become heavily in debt, although its very wealthy aristocratic members could without difficulty have saved it from near bankruptcy. A mood of despair and panic overwhelmed the Society's Council. They resolved in January 1859 to sell immediately the Regent Street house and its unsurpassed library including the drawings by Hooker, Ferdinand Bauer, Mrs Withers and others. With hindsight one can see that this hasty action was a tragic mistake but the Council thought they had no alternative (cf. Fletcher, 1969; Tjaden, 1987). The library was dispersed irretrievably at auction by Sotheby's in March 1859; the drawings were sold in lots for only £212 in all, probably half their value even then. The Society's affairs so greatly improved in 1860 that it leased an area of about 20 acres at South Kensington, on part of which the British Museum (Natural History), the Geological Museum and the Science Museum now stand. In the Society's new garden and buildings the library, purportedly sold on account of being little used, but more probably for lack of storage space, could have been accommodated. By now it was too late; the books and drawings had been scattered forever. Fortunately not all of them had gone abroad beyond recovery. Those that have come back through purchase and bequest, among

them the Hooker drawings and the Reeves drawings of Chinese plants, are now treasures of the Royal Horticultural Society's Lindley Library.

In 1926 the Council of the Royal Horticultural Society (as the Horticultural Society of London became in 1861) was able to buy back the volumes of fruit and flower drawings which had passed into the library of John Napier of Leighton, whose book plate they bear. E. A. Bunyard promptly compiled a list of the fruits figured (Bunyard, 1927); they include cultivars no longer in cultivation but historically interesting e.g. Apples 'Ord' and 'Borsdorf', Pears 'Aston Town' and 'Gansell's Bergamotte', Plum 'Royale' and 'Catherine', and others still grown and esteemed, Apples 'Gravenstein', 'Blenheim' and 'Ribston', Pears 'Williams' Bon Chrétien' and 'Seckle', Plum 'Green Gage'. These drawings then became part of the Lindley Library established in 1869 under a trust deed with provisions designed to prevent any repeat of the 1859 disaster (cf. Fletcher, 1969:210). Examination of Hooker's masterpieces of pomological art reveals them as equal or even superior to paintings of fruit by the great Pierre-Joseph Redouté (1759–1840). Redouté's period of creative activity extended to about fifty-five years and he was painting a lily the day before he died. Hooker's lasted less than twenty years. One cannot but think with pity and sadness that he then passed his next twelve years so tragically incapacitated by illness as never again to benefit horticulture and botany by the exercise of his splendid talent as an artist and engraver. The plates reproduced here provide examples of his ability to observe and faithfully to portray the fine distinctions of fruit, which sets him among the great pomological artists of all time.

REFERENCES

BUNYARD, E. A. 1914. A guide to the literature of pomology. *Journal of Royal Horticultural Society* 40: 414–449.

BUNYARD, E. A. 1927. The Hooker and Lindley drawings. *Journal of Royal Horticultural Society* 52: 218–224.

DUNTHORNE, G. 1938. *Flower and Fruit Prints of the eighteenth and early nineteenth centuries*. London.

EWAN, J. 1979. Pursh's *Flora* in American botany. Prefixed to *Historiae Naturalis Classica* facsimile of F. Pursh, *Flora Americae septentrionalis* (1814).

FLETCHER, H. R. 1969. *The Story of the Royal Horticultural Society 1804–1968*. London etc.

HOOKER, W. 1816–1818. *Pomona Londinensis*. London.

KNIGHT, T. A. 1813–1818. *Pomona Herefordiensis*. London.

PURSH, F. 1814. *Flora Americae septentrionalis*. London.

SALISBURY, R. A. 1805–1811. *The Paradisus Londinensis . . . the Figures by William Hooker*. 2 vols. London.

STEARN, W. T. 1949. The use of the term 'clone'. *Journal of Royal Horticultural Society* 74: 41–47.

STEARN, W. T. 1960. Franz and Ferdinand Bauer. *Endeavour* 19: 27–35.

STEARN, W. T. 1982. Nomenclatural history of *Hibbertia grossulariifolia* (Dilleniaceae). *Brunonia* 5: 213–219.

STEARN, W. T. 1986. Historical survey of the naming of cultivated plants. *Acta Horticulturae* 182: 19–28.

STEARN, W. T. 1988. James Edward Smith (1759–1828), first President of the Linnean Society, and his herbarium. *Botanical Journal of the Linnean Society* 96: 199–216.

TJADEN, W. 1987. The loss of a library. *The Garden. Journal of the Royal Horticultural Society* 112: 386–388.

WALKER, M. 1988. *James Edward Smith*. London.

WEIN, K. 1932. Die Wandlung im Sinne des Wortes Flora. *Fedde, Repertorium Specierum novarum, Beihefte* 66: 74–87.

THE PLATES

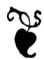

KIRKE'S GOLDEN REINETTE APPLE

Malus domestica Borkhausen Rosaceae

The genetic makeup of the diverse varieties of apple grown today is highly complex and several species of *Malus* were involved. In the USSR, apples grow wild in the forests of the Caucasus and Turkestan where several species occur, including *M.sylvestris*, the crab apple, and *M.pumila*, parent of the dwarfing rootstocks. Over the thousands of years the various species have grown in the forests, many hybrids have emerged. In Turkestan, some of the fruits of these wild apples are comparatively large and little inferior to some cultivated varieties. Although there are many differences of view about the relative importance of the species involved, *M.domestica* is the name given to the group hybrids.

Apples were grown in Palestine about 2000 BC and in Egypt there are records of their cultivation in 1298–1235 BC. They were also grown to a considerable extent in ancient Greece and Rome. Pliny listed twenty-three varieties. In England their cultivation followed that in Europe and was greatly extended after the Norman Conquest in 1066. The first record of a named variety was of the Old English Pearmain, a dessert and cider apple, in 1208. Apples were taken to America by the earliest settlers. At first seedlings were grown, but later named varieties from Europe were imported.

Kirke's Golden Reinette, more generally called Golden Reinette, is known under many synonyms throughout Europe and was probably brought to England in the seventeenth century. In 1674, Worlidge wrote that it was 'preferred in our plantations for all occasions', and in 1744 Ellis recommended it for its regular cropping. Hogg, in 1860, said it was grown in the counties around London for the city markets, where it always commanded a high price. It is a good-quality, late-keeping dessert apple which has been popular in the United States as in England, but it is no longer grown commercially in England. It is still in collections of varieties.

PLATE 1 labelled *Kirke's Golden Reinette*

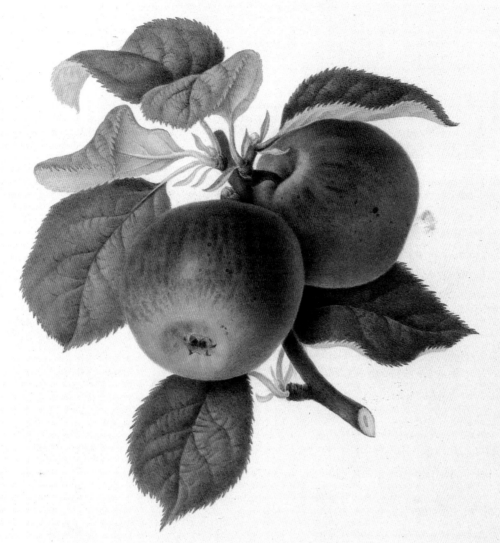

W. Hooker 1816.

Kirkes Golden Reinette.

GRAVENSTEIN APPLE

Malus domestica Borkhausen Rosaceae

Gravenstein is the oldest apple still to be grown in many countries, including those of Europe and in the United States and Canada. It first became prominent in Germany where it has been a favourite apple for over 200 years. It was given its name from the Castle of Grafenstein in Schleswig-Holstein where it was first grown about 1760, supposed to have been a seedling in the garden of the Duke of Augustenberg. Other records indicate that it was in fact an Italian apple, Villa Blanc, sent to Schleswig-Holstein, or that it was first sent to Germany by the brother of Count Chr. Ahlefeldt of Graasten Castle in South Jutland. It is also thought to have reached Denmark even earlier, in 1669.

Specimens of Gravenstein, the produce of a tree imported from Holland, were sent to the Horticultural Society in 1819 by the nurseryman John Wilmot. Although this variety has usually been well thought of by all English writers, it has never been widely planted in England, although it has continued to be grown in Europe and in the United States, where it was first described in 1824. It has been important in Nova Scotia as an apple grown for export.

Gravenstein is a large apple and besides being a very well-flavoured dessert fruit, it is also excellent for cooking. Picked in August, it will keep from September to December. Since Hooker made his painting, redder mutations have been introduced. Its flesh is creamy-yellow, crisp and juicy with a mixture of sweetness and acidity, giving it a distinctive flavour.

PLATE 2 labelled *The Gravenstein Apple*

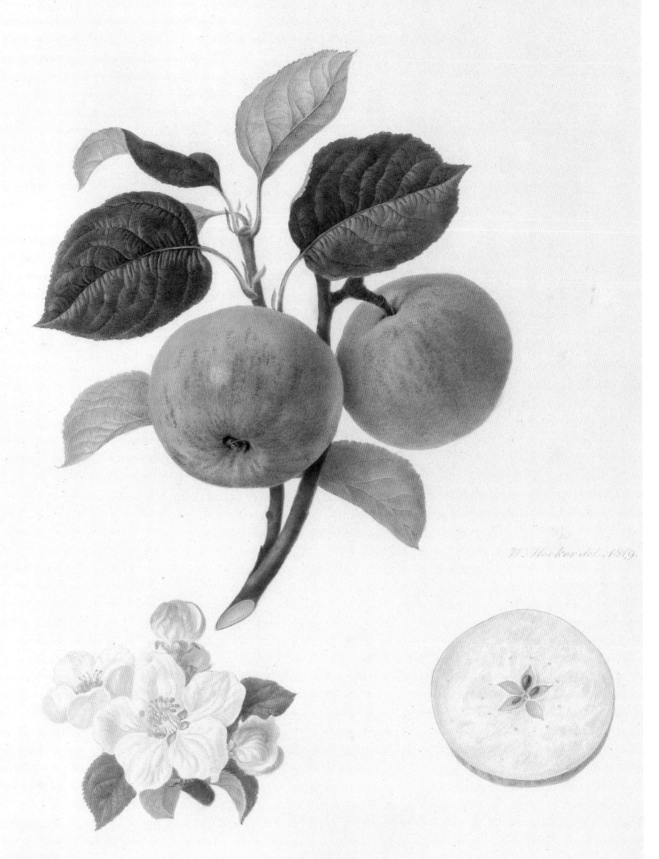

W. Hooker del. 1819.

The Gravenstien Apple.

HAWTHORNDEN APPLE

Malus domestica Borkhausen Rosaceae

Hawthornden is a large attractive-looking cooking apple which, William Hooker said, was raised at Hawthornden, a romantic place near Edinburgh celebrated as the birthplace and residence of William Drummond, a famous poet and historian (1585–1649). This apple was first mentioned in the nursery catalogue of Leslie and Anderson of Edinburgh, but does not seem to have become known in London until about 1790 when it was introduced by the Brompton Park Nurseries. It was extensively cultivated and highly regarded in most parts of Scotland. Hooker in 1816 thought it might be found useful by the market gardeners around London as its conspicuous, and even beautiful, appearance should be sufficient to ensure a rapid sale in Covent Garden market and, since it was equal in quality to most other varieties, the fact that it cropped more heavily should mean that it could be sold below average price.

The heavy cropping of Hawthornden was referred to by Forsyth in 1824, and Hogg in 1860 said it was one of the most valuable and popular apples in cultivation, in season from October to December. The apples, which can be very large, are greenish-yellow with a red blush where exposed to the sun. Their flesh is white, crisp and tender, very juicy with an agreeable and pleasant flavour. Unfortunately, Hawthornden is very susceptible to apple scab, a disease caused by the fungus *Venturia inaequalis*, which is probably one of the reasons why, although this variety was extensively planted in gardens and by growers for market in the past, it subsequently lost its appeal. It is still in existence in fruit collections and occasionally found in gardens.

PLATE 3 labelled *The Hawthornden Apple*

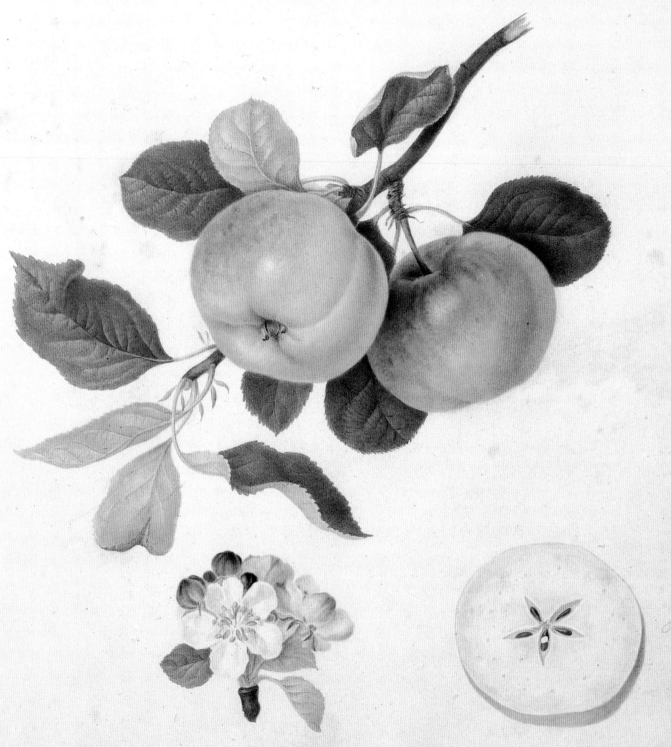

W. Hooker. 1816.

The Hawthornden Apple.

RIBSTON PIPPIN APPLE

Malus domestica Borkhausen Rosaceae

Although Hooker thought that Ribston had originally been imported as a tree from France, the generally accepted history of its origin is that it was raised from seeds brought from Rouen in Normandy, planted in the grounds of Sir Henry Goodrick at Ribston Hall, Knaresborough, about 1707. The original tree stood until 1810, when it was blown over in a gale but continued to crop in a horizontal position until 1835 when it died. By the end of the eighteenth century Ribston was widely grown in nurseries and orchards and became highly thought of in the London markets where its qualities both for dessert and culinary use were appreciated.

By the middle of the nineteenth century Hogg said no apple was more extensively cultivated in Britain. In the United States in 1938, Hedrick considered Ribston to be one of the few imported apples worth growing, not for its appearance but for its rich flavour, pleasant aroma and firm crisp flesh. It throve best in New York, New England and Canada. Ribston has also been grown to a considerable extent in many other countries including those in the southern hemisphere. It is still appreciated in England as a high-quality apple for the garden, in season from October to January. It is believed that Cox's Orange Pippin was bred, about 1825, by Cox from the seed of Ribston.

PLATE 4 labelled *The Ribston Pippin*

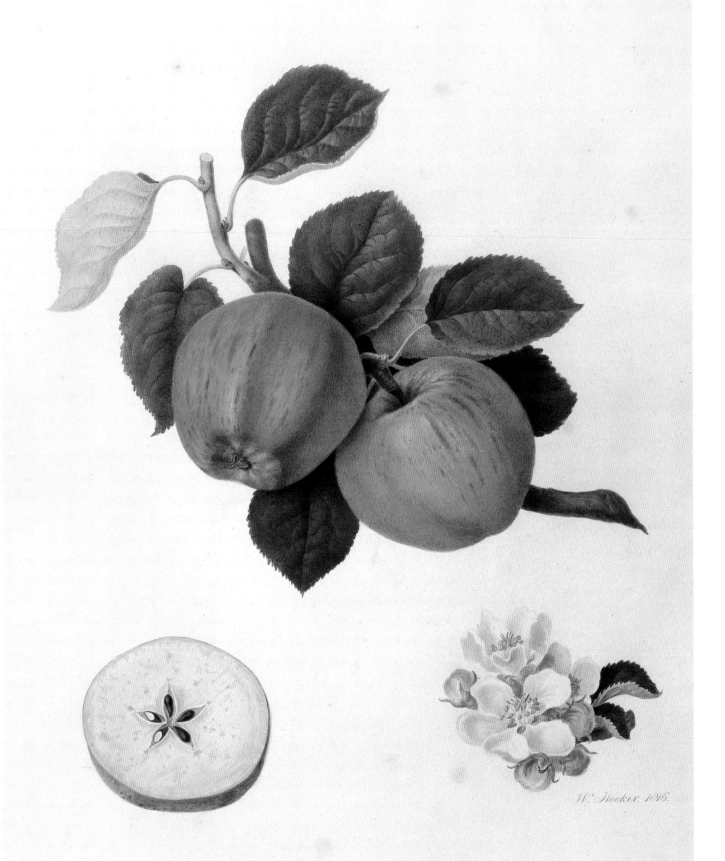

W. Hooker 1816.

The Ribston Pippin.

MARGIL APPLE

Malus domestica Borkhausen Rosaceae

Little is known of the origin of Margil, or when it was first grown
in England. In 1750 it was grown to a considerable extent in the
Brompton Park Nurseries, London, where George London, who had
previously worked in the gardens at Versailles, Paris, under de la Quin-
tinye, was in partnership with Henry Wise, so it seems likely that Margil
had been brought over from France by London. It was grown in many
countries of Europe under a great range of synonyms.

Margil, a small dessert apple somewhat like a small Ribston, is
still grown to a limited extent in English gardens and in Europe, and
also in the United States although it has never been considered of
importance there. It has always been considered of good quality. Wil-
liam Hooker said that Margil was very generally cultivated in gardens
around London where it was highly esteemed as excellent for dessert
and for culinary use. However, he said it did not possess sufficient
beauty to become a favourite in the London markets, where intrinsic
merit too generally yielded to appearance as a criterion of a fruit's value
– as is often the case today!

Its flesh is creamy-white tinged with green, firm but rather coarse-
textured and dry, sweet and with a rich aromatic flavour. It keeps in
good condition from October to January.

PLATE 5 labelled *The Margil*

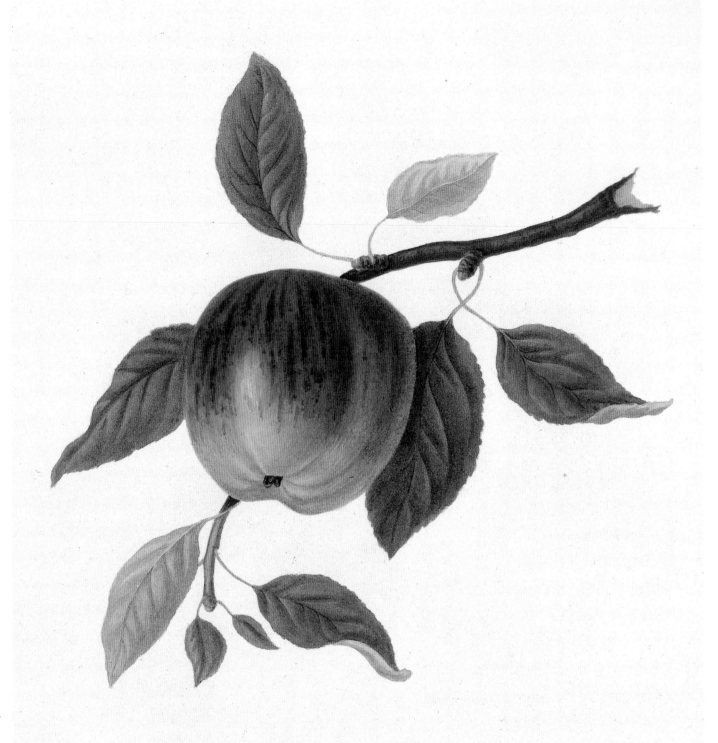

The Margil.

FEARN'S PIPPIN APPLE

Malus domestica Borkhausen Rosaceae

Fearn's Pippin was raised in the garden of Mr Bagley, at Fulham, London, some time prior to 1780. By the time Hooker wrote about it in 1816, he said that it was generally cultivated in gardens near London and was much liked as a winter fruit for dessert. It continued to be popular as, in 1866, Hogg said it was an excellent apple either for dessert or cooking, in use from November to February, and it was grown very extensively by London market gardeners for supplying Covent Garden.

Although Fearn's Pippin is still in existence and is still considered to be a good-quality dessert apple, it is too small for modern commercial use. Hooker thought it rather large for dessert although the measurements he quoted for the apples were slightly less than those in recent fruit trials in England. Tastes in apple size have changed and markets now want larger dessert fruits.

PLATE 6 labelled *Fearns Pippin*

[34]

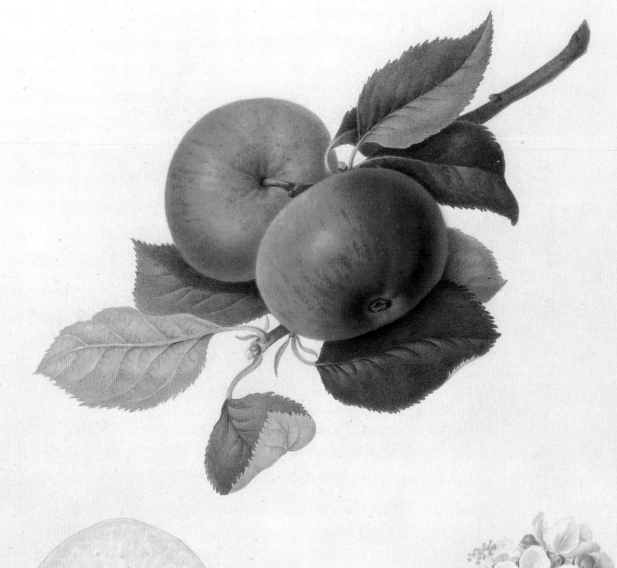

W. Hooker. 1816.

Fearns Pippin.

COURT OF WICK APPLE

Malus domestica Borkhausen Rosaceae

This dessert apple originated at Court of Wick, Yatton, Somerset, presumed to be from the seed of Golden Pippin, a famous dessert apple known in 1629, and was introduced by Wood of Huntingdon in 1790. It had been appreciated in Somerset before its general distribution and was very well spoken of by Billingsley, who carried out a survey of Somerset for the Board of Agriculture at the end of the eighteenth century. He wrote, 'The favourite apple, both as a table and cider fruit, is Court of Wick Pippin. It originated from the pip, or seed of the Golden Pippin, and may be considered as a beautiful variety of that fruit. In shape, colour and flavour, it has not its superior. It cannot be too strongly recommended.'

Golden Pippin had long been regarded as among the best dessert apples and Court of Wick, rather similar in shape and colour, was soon accepted in England as also one of the best with its yellow, crisp, very juicy and highly flavoured flesh. It was in season from October to March. Hooker, like all other writers in the nineteenth century, spoke very highly of Court of Wick. He, as others, was impressed by the heavy cropping of the trees especially when grown on dwarfing rootstocks. However, in the United States Downing in 1857 said it did not succeed in his country, although he agreed it was a very well flavoured apple. Court of Wick may still exist but it is no longer planted in England.

PLATE 7 labelled *The Court of Wick Pippin*

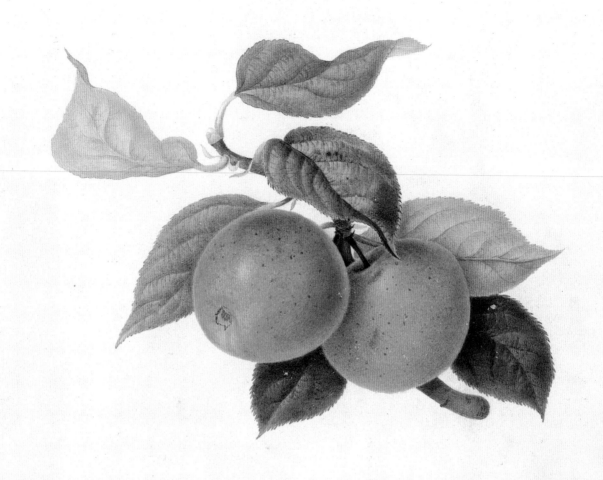

W. Hooker. 1816.

The Court of Wick Pippin.

BLENHEIM ORANGE PIPPIN APPLE

Malus domestica Borkhausen Rosaceae

Blenheim Orange originated about 1740, in the garden of Mr Kempster in the village of Old Woodstock, Oxfordshire, England, just outside the boundary of Blenheim Park, home of the Dukes of Marlborough and the birthplace of Sir Winston Churchill. The original, ageing tree grew in the garden and continued to crop for about a century. Its attractive apples drew admiring gardeners to see the fruits and take home scions from the tree to grow in their own gardens. Locally it was known as Kempster's apple. It was not, however, until 1818 that this variety was first listed by London nurserymen, and within a few years its qualities resulted in Blenheim Orange being extensively planted in England, and it spread to America, Australia and many parts of Europe.

The fruits are very large for a dessert apple, but Blenheim Orange is a dual-purpose variety, being equally suitable for cooking. Its flesh is creamy-white, rather coarse-textured and having a very rich, aromatic flavour. It is at its best from November to January. Blenheim Orange grows readily from seed; the seedlings do not differ very much from the parent type and so numerous variations occur. It is still grown in gardens in England but only occasionally for market.

PLATE 8 labelled *The Blenheim Orange Pippin*

[38]

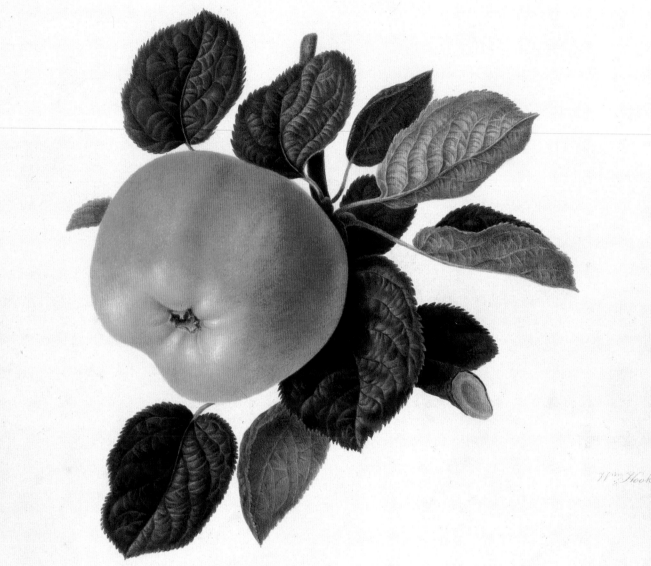

W^m Hooker

Flower bud section

The Blenheim Orange Pippin.

BORSDORFF APPLE

Malus domestica Borkhausen Rosaceae

Borsdorff is a very old German apple recorded by Valerius Cordus, a German writer, in 1561 (under the name Porstorffer) as being cultivated in Meissen, Saxony; it may have taken its name from a village called Borsdorf (Porstorf). In Germany it was described as being more highly esteemed than any other apple.

It was first grown in England at Brompton Park Nurseries, Kensington in 1785 and, at the beginning of the nineteenth century, was a popular apple both with the public and the Royal Family. It was also known as the 'Queen's apple' as Queen Charlotte, wife of George III and daughter of a German duke, was so fond of it that she had a considerable quantity imported annually from Germany.

In season late, from November to January, it has whitish-yellow flesh, crisp and juicy and with a sweet, vinous flavour. Hogg said it resisted frost better than most varieties. However it lost favour in England and though grown in the United States never seems to have been of importance.

PLATE 9 labelled *The Borsdorff Apple*

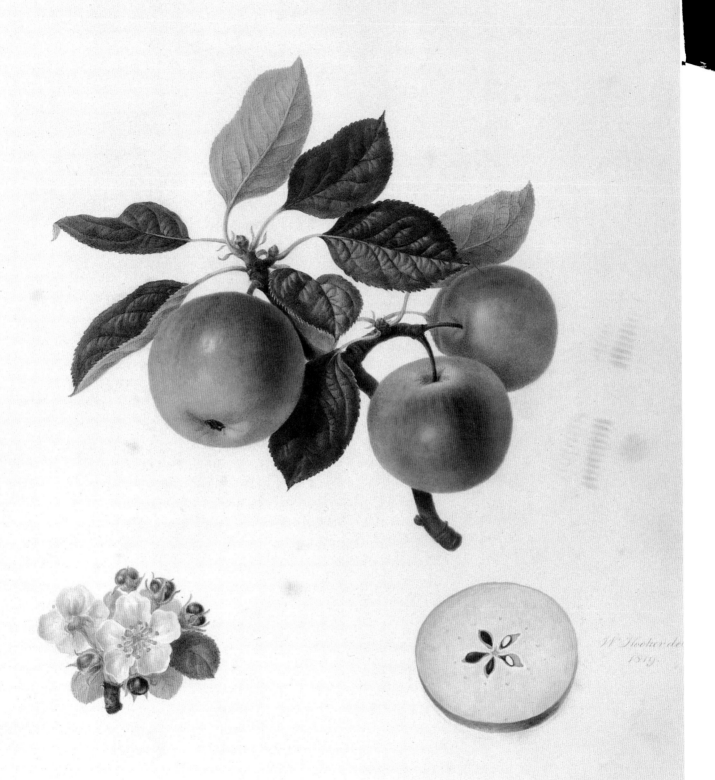

The Borsdorff Apple.

BEAUTY OF KENT APPLE

Malus domestica Borkhausen Rosaceae

Beauty of Kent is a cooking apple, still in existence, which is of uncertain origin but as most of the synonyms used for it in Europe include the word 'Kent', presumably it had a connection with that county. It was not mentioned by any of the English writers until Forsyth, gardener in charge of the Royal Gardens at Kensington and St James's, wrote in 1806 that it was a fine, large apple, ready in September but keeping until the end of April. Hogg, in 1860, said that when well grown, Beauty of Kent was perhaps the most magnificent apple in cultivation. Its great size, the beauty of its colouring, the tenderness of its flesh and profusion of its juice, made it one of the most desirable culinary varieties, either for a small garden or for extended cultivation. He added that it was widely grown and was one of the most popular apples.

Among the older varieties, Beauty of Kent was still grown in commercial orchards in Kent during the first half of this century, but the need to limit the number of varieties for market meant that it has now virtually disappeared, although it is still a favourite in some gardens. It is a very large apple, somewhat irregular in shape, and has creamy-white, coarse-textured flesh with slightly acid juice.

PLATE 10 labelled *The Beauty of Kent*

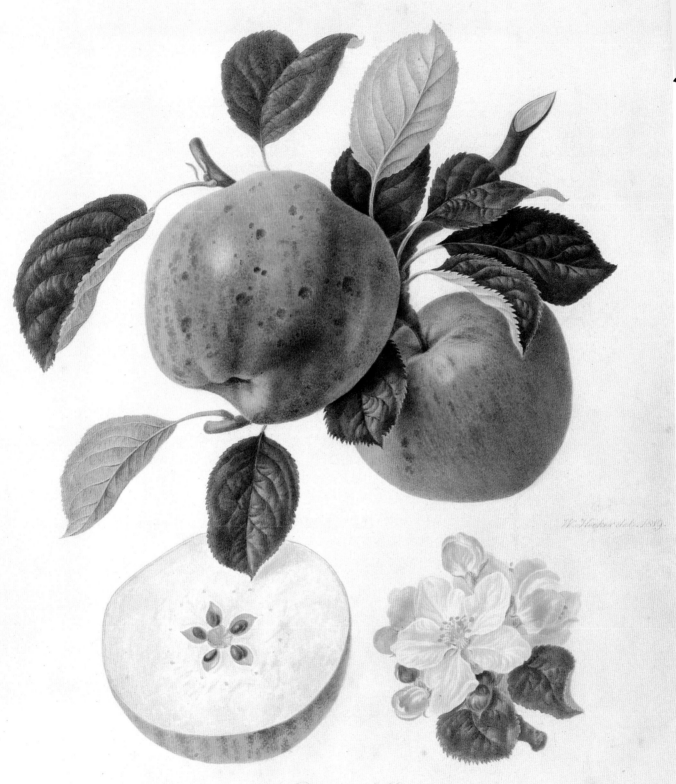

The Beauty of Kent.

CORNISH JULY FLOWER APPLE

Malus domestica Borkhausen Rosaceae

This variety, generally known as Cornish Gilliflower, was found grow-
ing in a cottager's garden near Truro some time before 1800, and was
included in Forsyth's *Treatise of Fruit Trees* in 1806 as Gilliflower, but
was not brought to the attention of the Horticultural Society until 1813
by Sir Christopher Hawkins. The apple was thought to be of such
importance by the Committee of the Society that they awarded a Silver
Medal to Sir Christopher. However, there is some doubt as to whether
this was a new apple, as Switzer in 1724 had mentioned Gilliflower
and July Flower apples.

Contemporary writers agreed that Gilliflower was one of the best
varieties in the nineteenth century, of high aromatic flavour, but unfor-
tunately it was not a very good bearer. For this reason it never became
of commercial importance and though it has existed in Europe under
several synonyms it does not seem to have been grown in the United
States. In season from November to March, it has yellow flesh which
is orange beneath the skin and is firm, fine-textured and sweet. It is
still grown in England.

PLATE 11 labelled *The Cornish July-flower*

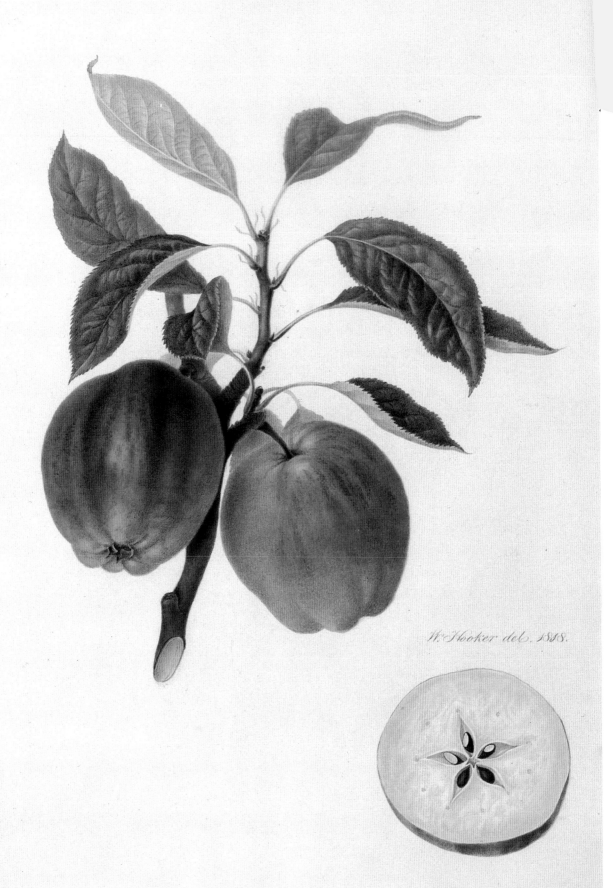

W. Hooker del. 1818.

The Cornish July-flower.

KERRY PIPPIN APPLE

Malus domestica Borkhausen Rosaceae

Kerry Pippin is one of the few apples raised in Ireland that, in the past, was recognized as of value by growers in England. A dessert apple, it was for long cultivated in Ireland before being introduced to a wider market by a nurseryman, Robertson of Kilkenny. It first became known in England in the early part of the nineteenth century and, according to William Hooker, it was exhibited and greatly admired at a dinner of the Horticultural Society held at Hampton Court in London in September 1813. Subsequently, Kerry Pippin was favourably mentioned by Forsyth in 1826 and Hogg in his *Fruit Manual* of 1860. However, it never seems to have become a variety of any importance, though well liked by those who grew it. It still exists in the fruit collections in England.

The fruits of Kerry Pippin, though fairly small, are of attractive appearance as they ripen, with their fine, clear yellow ground colour flushed with orange-red and tinged and streaked with red on the parts exposed to the sun. There is some russet on the less sunny side. The apple is in season from late August to September or rather later and has crisp, firm, yellow flesh, sweet and with a very pleasant flavour.

PLATE 12 labelled *The Kerry Pippin*

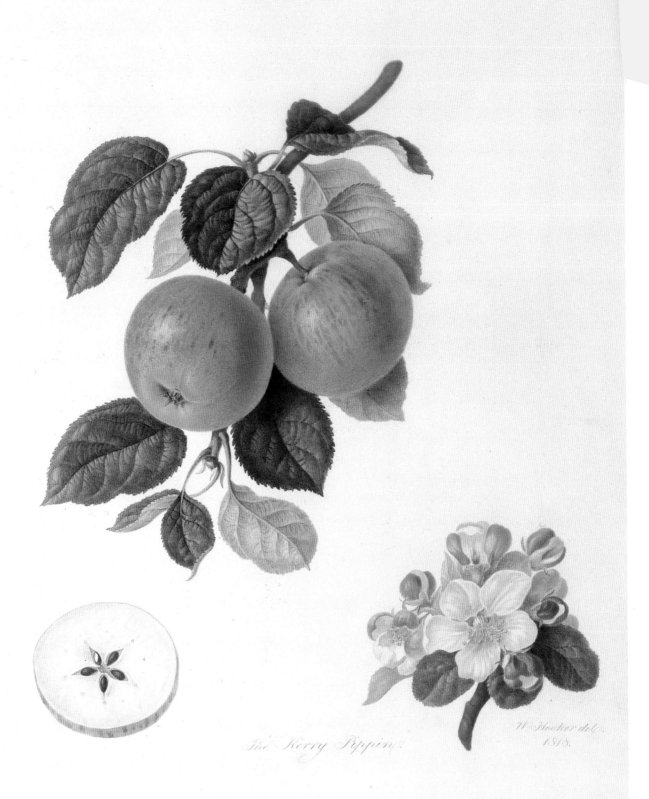

The Kerry Pippin.

W. Hooker del.
1818.

KESWICK CODLIN APPLE

Malus domestica Borkhausen Rosaceae

Keswick Codlin is one of the many Codlin type of cooking apples which have been grown in England for many hundreds of years, but although a number of them, like Keswick Codlin, still exist, they are now little grown. Keswick Codlin was found as a seedling growing among a quantity of rubbish behind a wall at Gleaston Castle, near Ulverstone, Lancashire, in England about 1790, and was first brought to notice by John Sanders, a nurseryman at Keswick who sent it out as Keswick Codlin. It became popular in the north of England, where it is still grown today, as an early cooking apple that crops heavily.

In the past, Keswick Codlin was regarded as one of the earliest and most valuable of culinary apples. It was used as early as the end of June for tarts when it was quite small and green, but is usually picked in late August and can be used in September and October. It has creamy-white, slightly green flesh with a rather coarse texture and a slightly acid flavour. It tends to become mealy when kept too long.

PLATE 13 labelled *The Keswick Codlin*

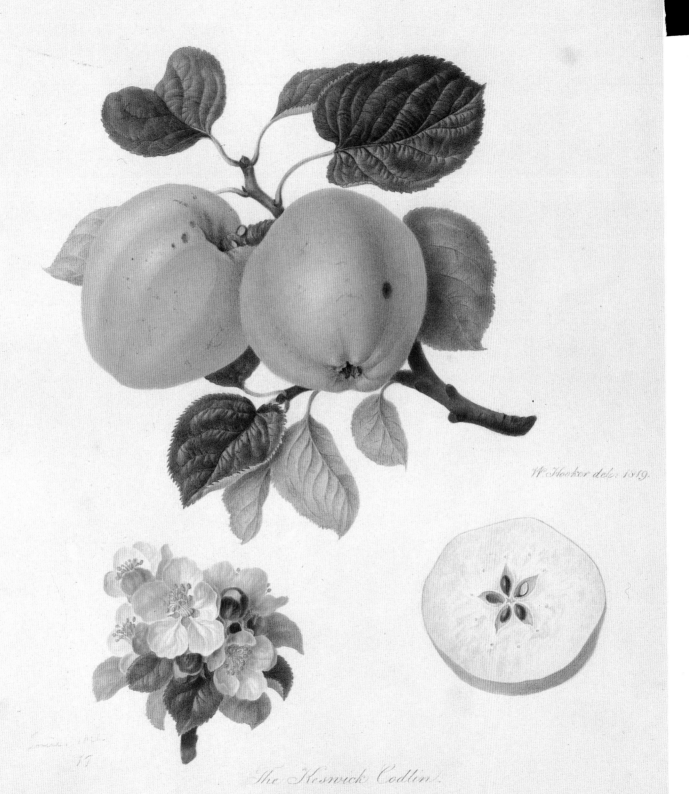

W. Hooker delt. 1819.

The Keswick Codlin.

DUTCH CODLIN APPLE

Malus domestica Borkhausen Rosaceae

'Codlin' was originally an old English name given to small green apples used for cooking, but was later used for those considered best for 'coddling' or parboiling. Dutch Codlin is thought to have come from Holland and was first reported in England in 1783. Its Dutch origin is confirmed by the fact that it was also known by a number of synonyms implying a Dutch connection. During the last century, Hogg considered it was one of the best early cooking apples, in season from August until the end of September, but today, although its season may be extended by a month or two, there is very little demand for cooking apples of this type. Although Dutch Codlin still exists in collections of varieties, like so many of the varieties from the past, it is no longer of any importance.

The apples are very large, especially for a Codlin type, have very firm white flesh, and are subacid and slightly aromatic.

PLATE 14 labelled *The Dutch Codlin*

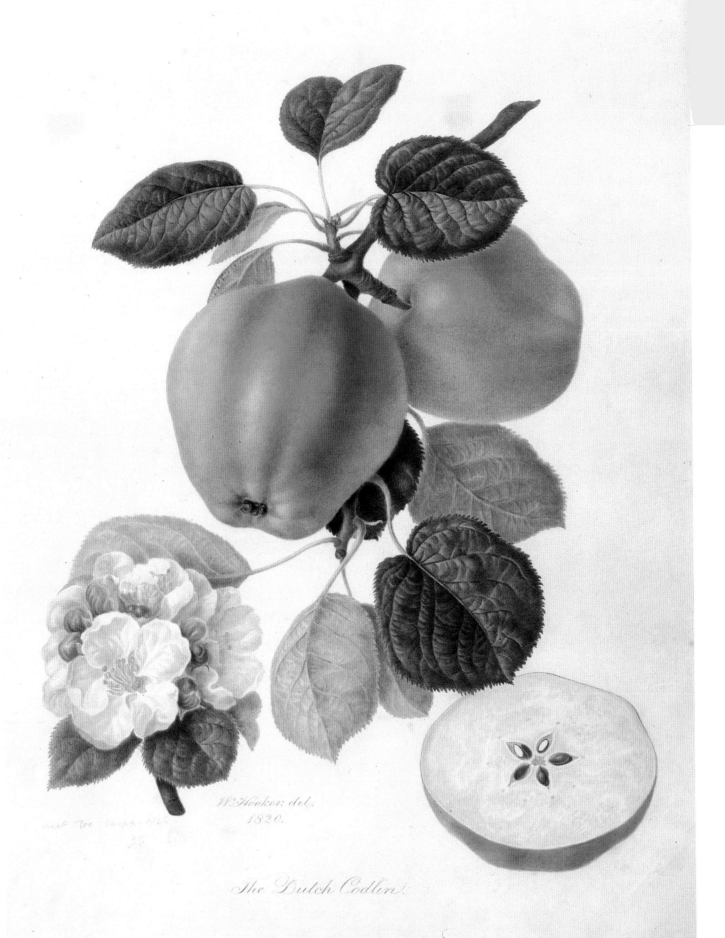

W. Hooker del.
1820.

The Dutch Codlin.

NONPAREIL APPLE

Malus domestica Borkhausen Rosaceae

Nonpareil is a good quality dessert apple which has been known under numerous synonyms in the orchards of Europe and was brought to England from France in the sixteenth century. According to Switzer, writing in 1724, 'This Apple is no Stranger to England though it might have its original from France, yet there are Trees of them about the Ashtons in Oxfordshire, of about a hundred years old, which (as they have it by Tradition) was first brought out of France and planted by a Jesuit in Queen Mary or Queen Elizabeth's time.' Richard Bradley, Professor of Botany at Cambridge University, who wrote much about fruits in 1736, said Nonpareil was one of the best apples and that a nurseryman, Fairchild of Hoxton, London, budded it on to dwarfing rootstocks and grew the trees in pots which he thought could be used for decorating the dinner table.

In the middle of the nineteenth century, Nonpareil was one of the most popular dessert apples, keeping well from January to May, although its season now is considered to be from December to March. The fruits, of medium size, have greenish-white, fine-textured, juicy, slightly acid flesh with a pleasant aromatic flavour. Downing said it was little esteemed in the United States in the last century, but it is still well liked by some gardeners in England.

PLATE 15 labelled *The Nonpareille*

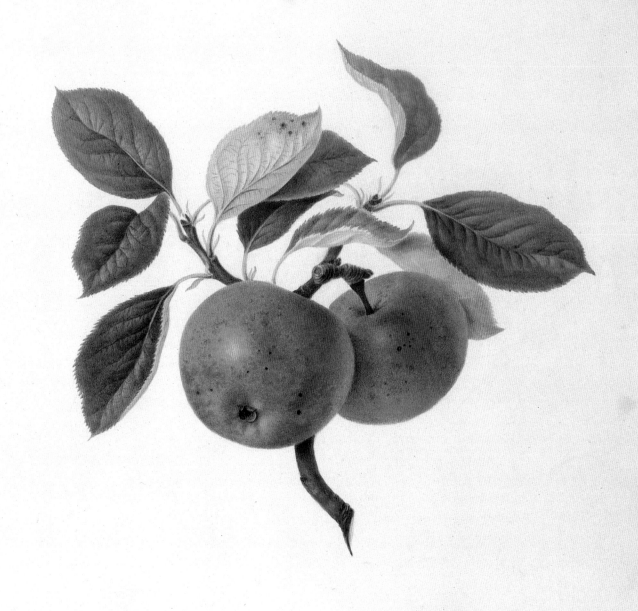

W. Hooker delt. 1817.

The Nonpareille.

SCARLET NONPAREIL APPLE

Malus domestica Borkhausen Rosaceae

The dessert apple Scarlet Nonpareil was raised in the garden of a public house at Esher, Surrey, England about 1773, believed to be from the seed of Old Nonpareil. It was distributed by the nurserymen Grimwood and Wykes at Kensington who sold a great many trees. As Hooker said, several distinct varieties were known in nurseries and gardens by the name of Nonpareil – the Green, the Golden and the Scarlet – and had been submitted to the committee of the Horticultural Society. Of these, he considered that the Scarlet had the strongest claim to preference.

Scarlet Nonpareil was exported to the United States but was of little importance there. It continued to be popular in England until well into the present century, receiving an Award of Merit from the Royal Horticultural Society in 1901. It is still grown in fruit collections and occasionally in gardens. The apples, in season from January to the end of February or March, are yellowish-green, flushed with bright orange-red, and have greenish russet patches.

PLATE 16 labelled *The Scarlet Nonpareille*

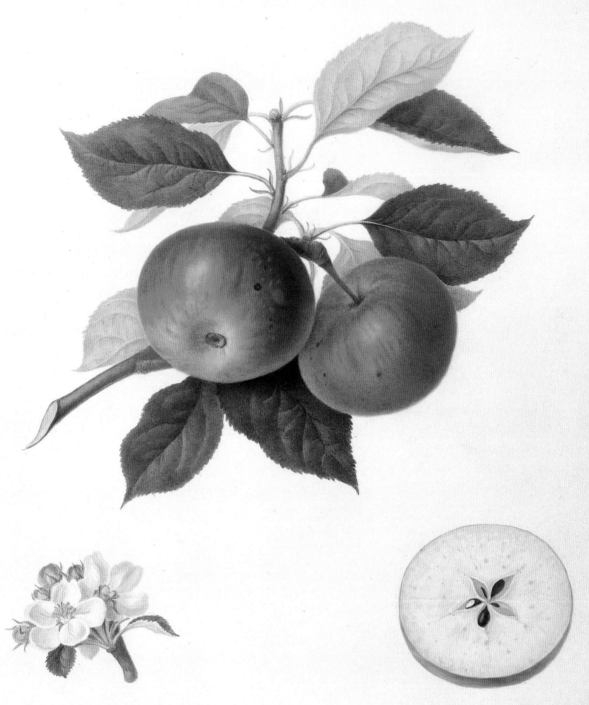

W. Hooker. 1816.

The Scarlet Nonpareille.

RED QUARRENDEN APPLE

Malus domestica Borkhausen Rosaceae

Red Quarrenden, more generally known as Devonshire Quarrenden, is thought to be a native of Devon in the south-west of England, a view supported by the fact that many of the synonyms by which it is known in Europe include reference to Devonshire. There has been a suggestion that it originally came from France, from the Carentan, an apple-growing district of Normandy, 'Quarrenden' being a corruption of 'Carentan'. The first recorded reference to this variety was by Worlidge in his *Vinetum Britannicum* in 1678. Little is known of it in the eighteenth century and the first mention of it in a nursery list seems to have been in that of Miller and Sweet of Bristol in 1790. William Hooker in 1817 wrote that though Red Quarrenden was well known in nurseries around London, little of its fruit was ever brought to market.

The position about the distribution and use of this apple described by Hooker continued very much the same throughout the last century, with the fruit being much appreciated by private gardeners but not planted by commercial growers. It continued to be popular with gardeners in Devon. The medium-sized, somewhat flat apples are very attractive with their overall bright crimson flush. Their flesh is greenish-white, crisp, juicy and sweet with a pleasant, aromatic flavour. The apples are ready to eat in late August to early September, and are best eaten straight away as they become greasy if stored.

PLATE 17 labelled *The Red Quarenden Apple*

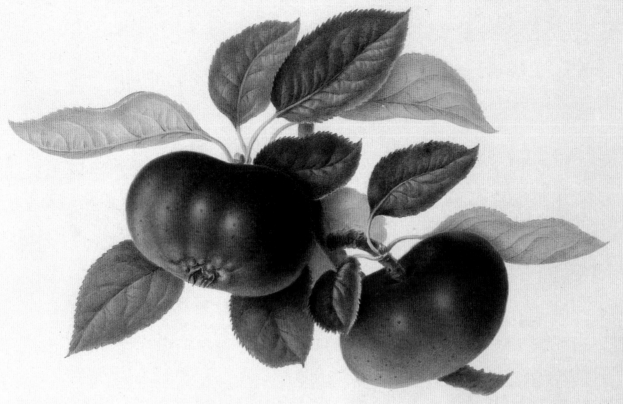

W. Hooker del.
1817

The Red Quarenden Apple.

SYKE HOUSE APPLE

Malus domestica Borkhausen Rosaceae

Syke House Russet, as this dessert apple was originally called, was found growing in an orchard in the small village of Syke-house in Yorkshire about 1780. It was sent by Messrs Perfect of Pontefract, a famous Yorkshire nursery started in the seventeenth century, to Lee and Kennedy, nurserymen at Hammersmith, London. It was sold under a number of different synonyms in the countries of Europe: in France one synonym was 'd'Hôpital anglais', another 'Reinette de Hôpitaux', and one name used was English Hospital Reinette. In 1821, a German writer, Diel of Frankfurt, translated the English name as 'Sikhouse', and thought it was given this name either because its brisk flavour was considered good for invalids, or that it had originated in the grounds of a hospital!

Hooker, in 1816, said that the Syke House apples were small and seldom as large as the one he had painted. In Yorkshire, the colour was green with much russet but in the south, in a good season, it was a handsome red, with streaks and patches of russet over the whole fruit. The apples kept in good condition until February. Their flesh was yellow, firm, crisp and juicy, with a pleasant flavour of extraordinary richness. Hooker considered it one of the best dessert varieties they had and Hogg, in 1860, supported this view, saying that Syke House was one of the most excellent dessert apples of high flavour and bore very heavy crops. It was still being grown in the present century but, like many other apples once of high repute, has virtually disappeared.

PLATE 18 labelled *The Syke-house Apple*

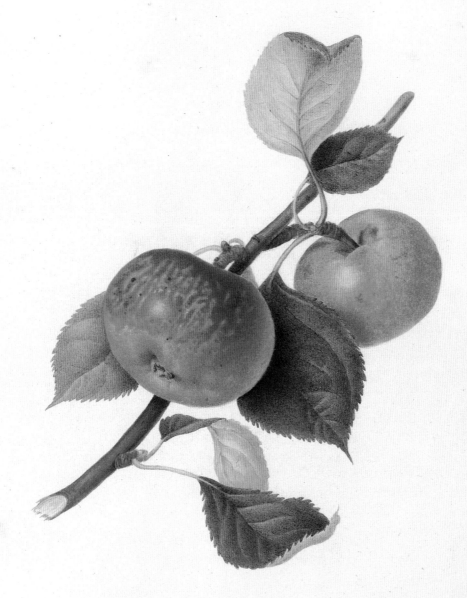

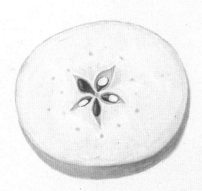

The Syke house Apple.

ALEXANDER APPLE

Malus domestica Borkhausen Rosaceae

Alexander, an apple of extraordinary size, is thought to have originated in the Ukraine in Russia where it was known in the 1700s. Trees were not brought to England until 1805, when they were grown in the nursery of Lee and Kennedy, at Hammersmith, London. As the first apples from the trees at the nursery were inferior to the imported fruits, some specimens were obtained direct from Riga to show to the meeting of the Horticultural Committee in 1817. Although a native of southern Russia, this variety flourished around Riga and was called Alexander as a compliment to the Emperor Alexander, to whom some of the apples were sent as a present each year. The old Russian name was Arport.

This magnificent apple was generally used for cooking but, in the past, it was sometimes used, because of its noble appearance, with other fruits in the table display. Alexander was fairly widely planted in the United States, especially in northern regions where it stood the cold well. It still exists in England. The fruits have yellowish, firm, rather coarse-textured flesh, somewhat dry and slightly acid with little flavour.

PLATE 19 labelled *The Alexander Apple*

[60]

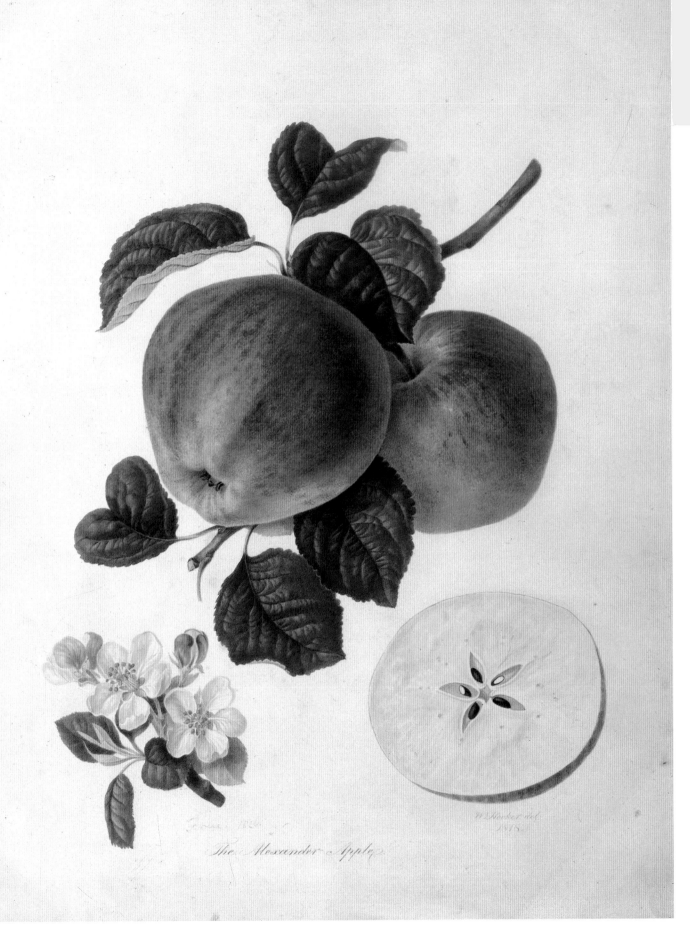

The Alexander Apple.

SIBERIAN HARVEY CIDER APPLE

Malus hybrid Rosaceae

Siberian Harvey is a cider apple bred by Thomas Andrew Knight who crossed the Yellow Siberian crab, *M. baccata*, with pollen from Golden Harvey, a *M. domestica* dessert apple. The Siberian Crab is a native of Russia and is particularly winter hardy, able to withstand low temperatures which would kill most *M. domestica* varieties. Of recent years it has often been used in the breeding of winter hardy varieties that may also show resistance to the disease apple scab, *Venturia inaequalis*, but Knight's use of the species is the first recorded instance of its deliberate employment. Golden Harvey is a good-quality, late-keeping dessert apple with firm, very sweet, aromatic flesh. It originated in Herefordshire, probably in the 1600s.

Knight's intention in carrying out this cross was to raise good-quality apples combining sweetness and other characters suitable for making cider. He succeeded in producing two varieties, Siberian Harvey and Foxley, which first fruited in 1807. Siberian Harvey was immediately recognized as a good cider apple and Knight was awarded a prize for it by the Herefordshire Agricultural Society in their competition to encourage the production of new varieties. Its good-sized fruits, ripe in October, had intensely sweet juice. Knight considered it to be superior to any other cider variety then in cultivation.

PLATE 20 labelled *The Siberian Harvey*

W. Hooker del. 1818

Pub. Feb 1. The Siberian Harvey.

TRUE ST GERMAIN PEAR

Pyrus communis Linnaeus Rosaceae

The pears cultivated in Europe and many other parts of the world were derived from *Pyrus communis*, a native of Europe and northern Asia, found growing wild in the woods and forests of the Caucasus and Turkestan. Although it grows wild in Britain it is doubtful if it was indigenous here. There is little evidence of the use of the fruits of the wild pear as food by prehistoric peoples in Europe. The fruits are small, hard, gritty and sour and therefore unattractive to seekers of food.

Pears were a popular fruit with both the Greeks and the Romans. Pliny described a wide range of varieties differing in colour, flavour, texture, season and keeping qualities. It is likely that pears were introduced to Britain by the Romans and were also grown in many parts of Europe. Some of the earliest records show that both fruits and trees were imported from France in the thirteenth century for supplying the English royal household and gardens. Pears were always a fruit of great importance in France and many new varieties originated there, including True St Germain. According to Merlet, a French pomologist writing in 1680, this was found as a wild seedling on the banks of the Fare, a little river in the parish of Saint-Germain d'Arée. This was confirmed by de la Quintinye, the head gardener to Louis XIV, who laid out the gardens at Versailles, and who said it was also known as 'the unknown pear of the Fare'.

This pear enjoyed a period of popularity in both England and the United States during the last century, but it was replaced by better varieties. Its appearance, with green, roughish skin turning to greenish-yellow and covered with russet dots, was not very attractive. The flesh was whitish and very melting and buttery, with a refreshing, perfumed flavour. It needed to be grown well, as under adverse conditions it became gritty and useless. It was in use from November to December but under good conditions could be kept till March. Hooker considered it to be among the best of the winter pears.

PLATE 21 labelled *The true St. Germain Pear*

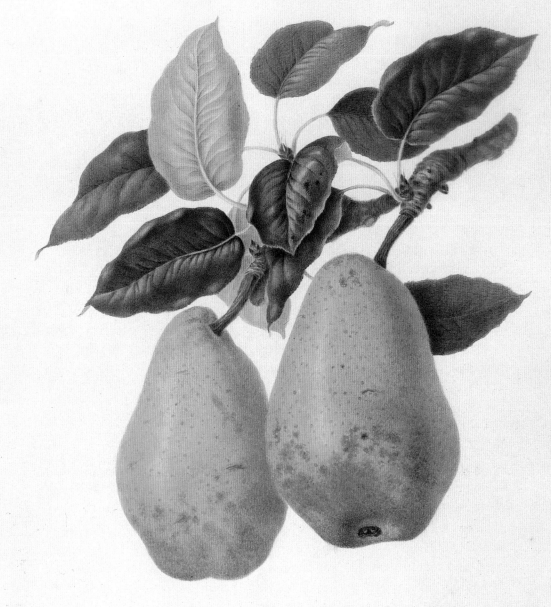

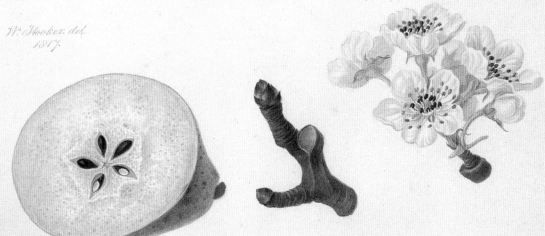

W. Hooker del.
1817.

The true St Germain Pear.

JARGONELLE PEAR

Pyrus communis Linnaeus Rosaceae

Jargonelle is one of the oldest of all pear varieties. Its name appears to have been derived from Jargon, anciently Gergon, a corruption of Groecum. Merlet, writing in 1675, suggested that Jargonelle was the *Numidianum Groecum* of Pliny. Pliny said that the Numidian was of Greek origin; and one variety of it was the Tarentine, which Cato the Elder (BC 234–149) had advised should be planted on Roman suburban farms catering for buyers coming from the town.

The first reference to Jargonelle in England was by John Parkinson in 1629: 'Peare Gergonell is an early peare, somewhat long, and of a very pleasant taste.' In 1724 Switzer wrote, 'The month of August produces many good Pears, one of the earliest and best of which is the Jargonell, a Pear we have had a pretty while in England, though of French Extraction.' Batty Langley illustrated it in 1727 as Jargonel. For many years this was regarded as the best of the early summer pears in both England and the United States, and it used to be one of the most common pears sold in New York markets; but, though still grown in gardens, it has been replaced by newer varieties in both countries.

The fruits are very attractive with their long stalks and yellowish-white, tender flesh of good flavour, but they have a short season and are best eaten straight off the tree.

PLATE 22 labelled *The Jargonelle Pear*

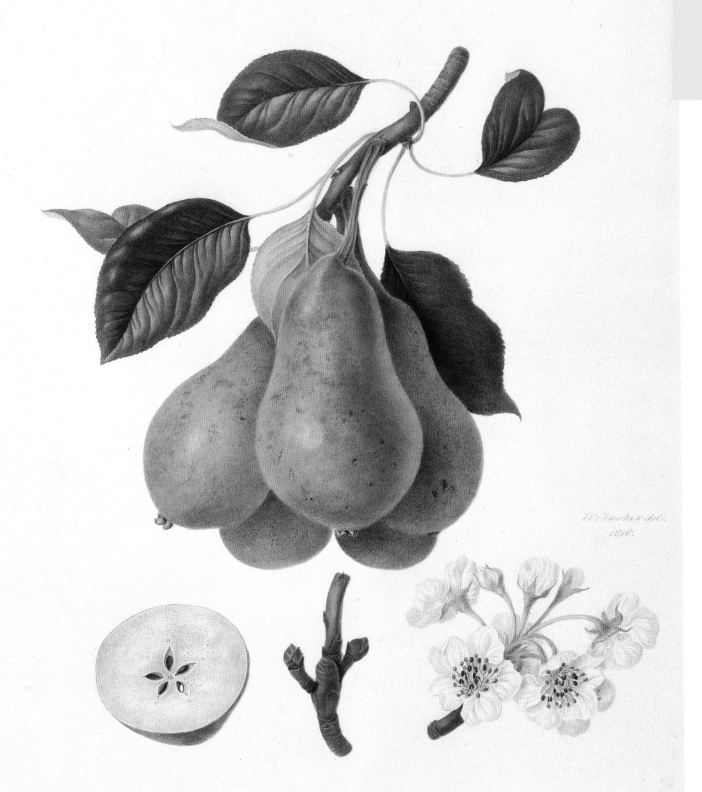

W. Hooker del.
1818.

The Jargonelle Pear.

COLMAR PEAR

Pyrus communis Linnaeus Rosaceae

This is believed to be an old Belgian pear of which de la Quintinye wrote in 1693, 'The pear of Colmar came to me under that name, from an illustrious, curious Gentleman, and from another place under the name of the Manna pear and that of Bergamot. Its skin is gentle and smooth, its pulp tender and its juice very sweet and very sugared, in which you have a picture of a very excellent pear, but affected by the soil and situation.'

Switzer, in 1724, also considered Colmar an excellent pear and suggested it was supposed to be a seedling from Winter Bonchrétien which it somewhat resembled. Like his predecessors, Hooker thought very highly of Colmar and said that its vigour and fertility entitled it to be recommended. It was in perfect condition for eating in December and January, but, if packed in a jar with dry sand and placed in a cool cellar, it would keep until March or later. This method of prolonging the storage life of fruits was regularly practised by the Romans, using amphorae as containers.

Colmar d'Été is an early pear and is not related to Colmar. The latter seemed to disappear from cultivation during the last century, possibly one reason being that unless given the protection of a wall, the fruits became shrivelled and insipid.

PLATE 23 labelled *The Colmar Pear*

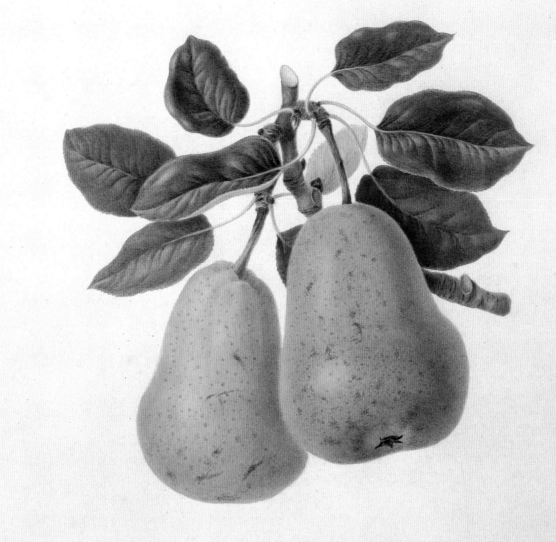

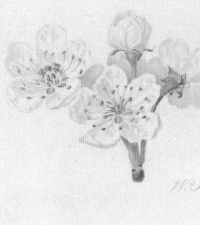

W. Hooker del.
1817

The Colmar Pear.

BROWN BEURRÉ PEAR

Pyrus communis Linnaeus Rosaceae

Brown Beurré is a very old French variety which was recorded by the earliest French and English writers. It was the first variety to be called 'Beurré' in France. Olivier de Serres, known in France as the father of agriculture, wrote in 1608 that this variety, known previously as Isambart, was 'now called Beurré'. The name was subsequently applied to all pears whose flesh had a melting quality, a character that had already been referred to by the German pomologist Cordus (1515–44) who, in his books *Annotationes*, described fifty pears and thirty-one apples. He wrote that Schmalzbirn, the Butter pear, was so called because it melted in the mouth like butter or some liquid mixture.

The English writer Rea, in 1665, said this pear was cultivated in England under the name of 'Beuré de Roy', and Worlidge in 1691 wrote that it was the best summer pear, melting in the mouth. It seems to have been one of the first of this type of pear to be planted on any scale in Europe and England, and, coming at a time just before the eighteenth-century period of intensive interest in pear breeding in France and Belgium, it played an important part in contributing its desirable characters.

Worlidge, in 1691, still called this pear, 'Bureé de Roy' and thought it one of the best September varieties. It became known as Brown Beurré because of its golden russet colour, often with a red flush which gave it a brown or even grey appearance. In the United States, Downing described it in 1857 as almost too well known to need description and said that the variable appearance of its colour, depending on the soil and situation, had given rise to differences in its name, one being Beurré Gris. It still exists but is now grown on a very limited scale.

PLATE 24 labelled *The Brown Beurré Pear*

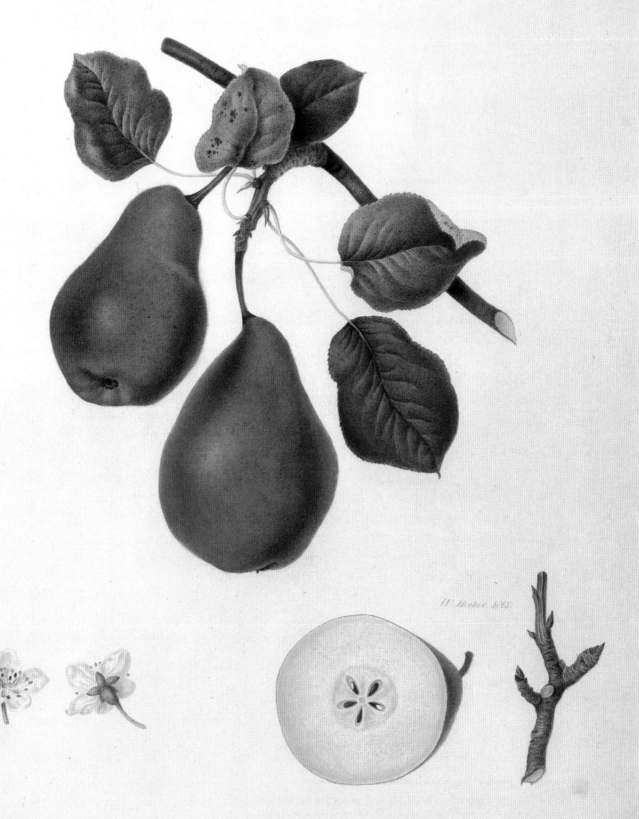

W. Hooker. 1815.

The Brown Beurrè Pear

CRASSANE PEAR

Pyrus communis Linnaeus Rosaceae

Crassane is a very old variety which was first mentioned in the seventeenth century and was probably of French origin. De la Quintinye wrote of it in 1693 as a useful pear but noted that it had a certain biting sharpness, which might make it necessary to eat it with sugar. There was a suggestion that, since de la Quintinye said the pear had been called 'Crasane because of its shape which looks as if it were squeezed down', its name might have been derived from the Latin word *crassus* which signifies 'thick'. In 1724 Switzer, who considered 'Cresanne' one of the best pears, added that it 'was very much esteemed by her late Majesty Queen Ann (1665–1714) if that will make any Addition to its Worth'.

Although Crassane, as its name is now spelt, is not an attractive pear owing to its dumpy shape and dark green skin with russet dots, becoming paler as it ripens, its tender, buttery flesh and sweet, perfumed flavour were responsible for its good reputation in the past. However, modern market demands have led to this old variety being no longer planted either in England or the United States, although it does still exist in collections of varieties.

PLATE 25 labelled *The Crasanne Pear*

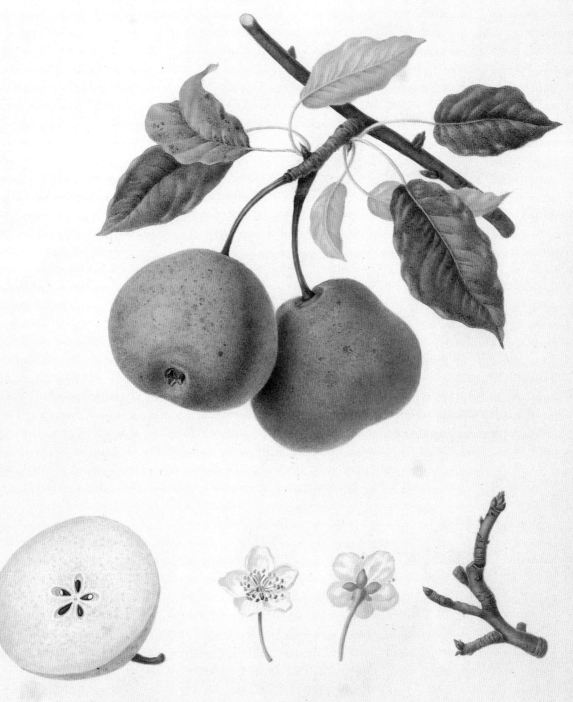

W. Hooker.
1815.

The Crasanne Pear.

CHAUMONTEL PEAR

Pyrus communis Linnaeus Rosaceae

Chaumontel arose about 1660 in France, as a wild seedling in the garden of Château Chaumontel, between Luzarches and Chantilly, north of Paris. This was the information given by Merlet in 1675, and in 1765 Duhamel du Monceau saw the original tree, then over a hundred years old, bearing a heavy crop. Unfortunately in the cold winter of 1789 it was killed.

Hooker, in 1818, said that considerable imports of Chaumontel were received during November and December each year from the Channel Isles of Jersey and Guernsey and were eagerly purchased by London fruiterers. Chaumontel has always been considered a pear which requires adequate warmth to ripen it satisfactorily and Hooker said it did best against a wall. In the United States Downing said that Chaumontel had not proved very successful except in very favourable situations and should prove better in the south.

This is a good quality pear and, though having rough skin, has white, melting, very sweet flesh with a vinous flavour but is inclined to be gritty. It still exists but is little grown.

PLATE 26 labelled *The Chaumontelle Pear*

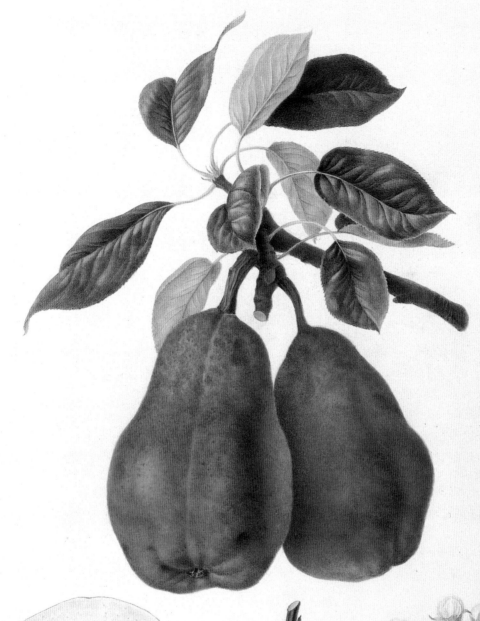

W. Hooker 1818.

The Chaumontelle Pear.

GANSEL'S BERGAMOTTE PEAR

Pyrus communis Linnaeus Rosaceae

This pear was raised by Lieutenant-General Gansel at his home, Donne-land Hall, near Colchester, England, in 1768 from the seed of Autumn Bergamot, itself a pear of great antiquity believed by some to date back to the time of the Romans. It seems to have been well liked after it was introduced, as Forsyth included it in his list of recommended pears in 1806. Later, after its arrival in the United States, Downing in 1857 considered it a promising pear.

William Hooker said Gansel's Bergamotte was an excellent pear, of sweet flavour and well liked by the public. This was shown, at the time he was writing in 1818, by the fact that fine samples of the pear were selling for two shillings and sixpence each! – a very high price at that time. Hooker did however say it was a shy bearer, that the blossoms were very subject to damage in cold weather and that it did best given the protection of a wall. It was best eaten in November but would keep in good condition for a month.

It is still in existence, although of no importance in England; but in 1921 it was well thought of in the United States for its white, buttery, melting flesh, abundant sugary juice and slightly musky aroma.

PLATE 27 labelled *Gansel's Bergamotte Pear*

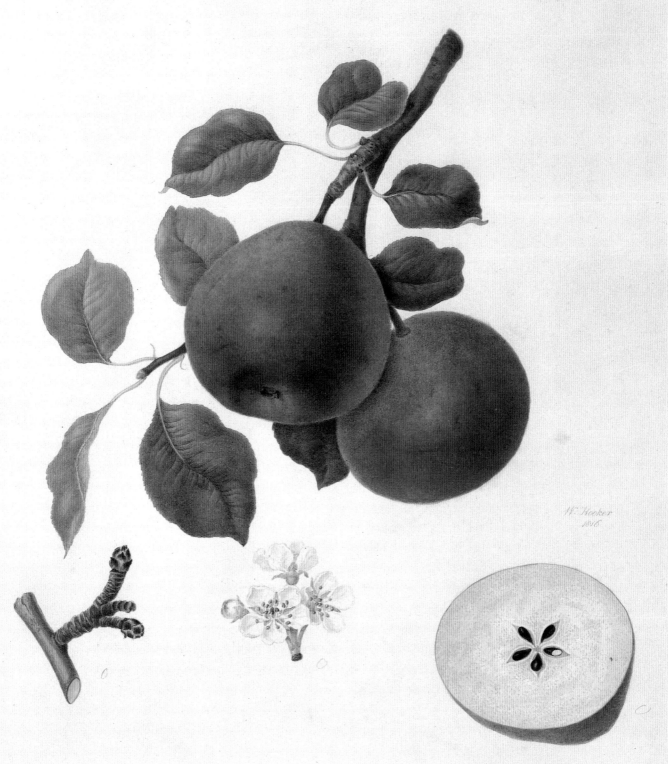

W. Hooker
1816

Gansel's Bergamotte Pear.

WILLIAMS' BON CHRÉTIEN PEAR

Pyrus communis Linnaeus Rosaceae

Williams' Bon Chrétien, the famous Bartlett pear in America, was found, or was possibly raised, in the garden of a schoolmaster named Wheeler at Aldermaston, Berkshire, England. It was a young tree in 1770. The garden passed to another schoolmaster, Stair, who sent grafts to Richard Williams, nurseryman of Turnham Green, Middlesex, and he propagated and distributed the pear under his own name. In 1797 or 1799 it was taken to the United States by John Carter of Boston, for Thomas Brewer, who planted it in his grounds at Roxbury, Massachusetts, under the name of Williams. In 1817, Enoch Bartlett of Dorchester, Mass., became the owner of Brewer's estate and, not knowing the name of the pear, allowed it to be distributed under his name and so it became Bartlett, one of the most important pears in the United States, used both for the fresh fruit market and for canning.

In England, after its introduction, it was distributed to many nurseries and in 1816, when the pear was discussed by the Horticultural Society, it was recommended as superior to any other pear in its season of late August to September. Williams is still regarded very highly in many countries of the world and is the most widely grown of any variety of pear.

The fruits are large, with thin skin, the flesh is fine-grained except at the centre where it is slightly granular, and the pears are very juicy and sweet with a strong musky flavour. They are excellent when canned. Williams has the additional advantage that if it is picked under-ripe it can still ripen to perfection.

PLATE 28 labelled *Williams' Bon-Chrétien Pear*

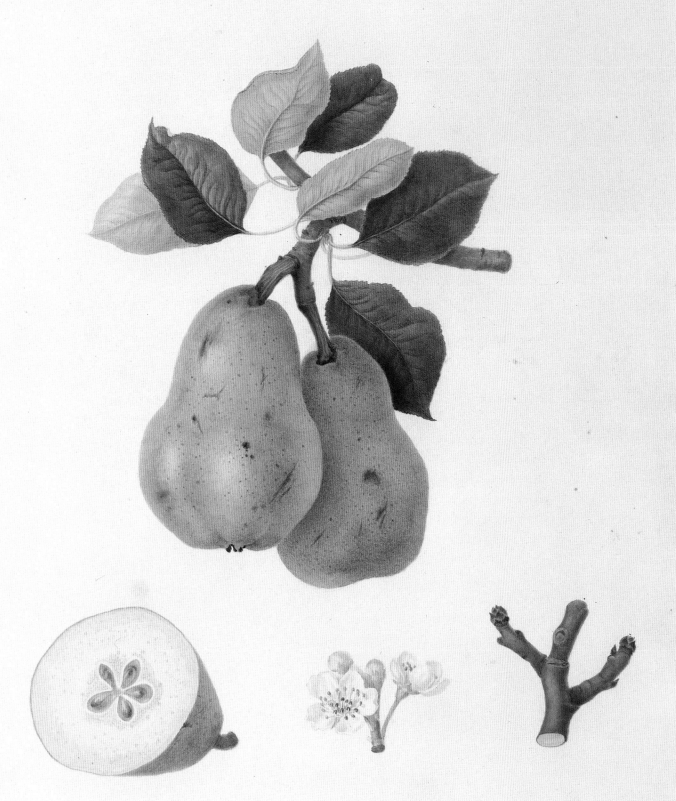

W. Tucker 1816

Williams' Bon-Chrétien Pear.

SECKLE PEAR

Pyrus communis Linnaeus Rosaceae

Unlike the other pears painted by William Hooker, Seckle is American and quite distinct from all the European types. In the United States it has long been appreciated, especially for garden use, and, though of small size, it has sold well on account of its good quality.

About 1765, there was a well-known sportsman and cattle dealer in Philadelphia known as Dutch Jacob who, each year in early autumn, on returning from his shooting excursion, would regale his neighbours with pears of an unusually delicious flavour, without revealing where they came from. After some time he bought a strip of land adjoining the river Delaware, about four miles from Philadelphia, and it was here that Jacob's favourite pear grew. As it had some resemblance to the German pear, Rousselet, Downing suggested in 1857 that it might have grown from seed of this variety brought by a German settler. Later the farm was owned by a Mr Seckle who introduced the pear under his own name.

In 1819 Seckle and several other varieties were sent by Dr Hosack of Philadelphia for trial to the Horticultural Society in London. Although Seckle has been grown on a limited scale in England it has never attained the popularity it had in the United States, where only its small size prevented its becoming the country's most frequently planted variety, appreciated for its melting, buttery, juicy flesh with a rich and unusually powerful aromatic flavour.

PLATE 29 labelled *The Seckle Pear*

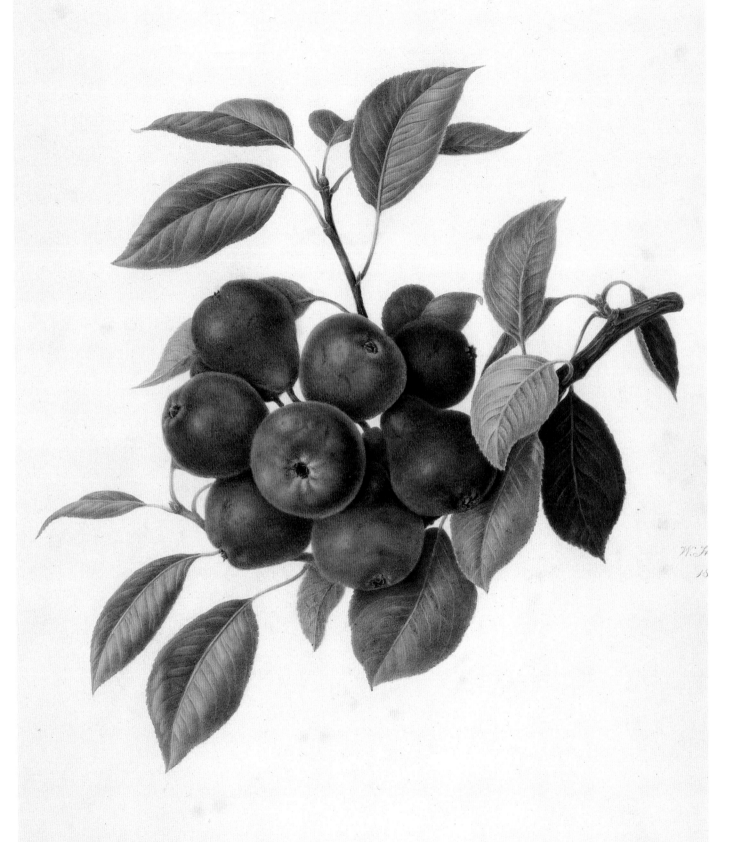

The Seckle Pear.

GRIMWOOD'S ROYAL GEORGE PEACH

Prunus persica Linnaeus Rosaceae

Although the specific name *persica* suggests that the peach originated in Persia, as the Greeks and Romans thought, it was in fact a native of China. There it grows wild in parts of the north and in Middle Manchuria, and also in North Korea. Peaches were cultivated in China many centuries BC. From China they were taken along the old silk route, over the mountains of central Asia to Persia, thence to Greece and Italy.

The peach was first referred to by Theophrastus, the Greek writer (*c.*370–286 BC), as a Persian fruit, and it was probably brought to Greece at the time of Alexander the Great. Pliny described several varieties and said peaches were in demand for invalids and their juice was drunk with wine or vinegar. Peach stones were found on a Roman site near the river Thames in London, but these probably came from imported fruit. There are records of peaches having been grown in France in the sixth and eighth centuries AD, and their cultivation had become general by the ninth century. The first reference to peaches being grown in England was in 1216, and in 1275 they were planted in the garden of the Tower of London. Peaches were among the fruits sold in the streets of London in the fourteenth century and at that time were regarded as a common fruit. The climate then was warmer than it is today.

Although many varieties of peach were grown in gardens during the seventeenth to nineteenth centuries, generally given the protection of garden walls, most of the peaches sold in the markets were imported. Grimwood's Royal George was the French variety, Grosse Mignonne, well known in France in the mid seventeenth century. The new name was given to it by a nurseryman, Grimwood of Kensington, as a tribute to King George III (1760–1820). It was grown under its original name in the United States and there, as everywhere, was considered a first-rate variety, with large, handsome fruits of excellent flavour. It still exists today as Grosse Mignonne.

PLATE 30 labelled *Grimwood's Royal George Peach*

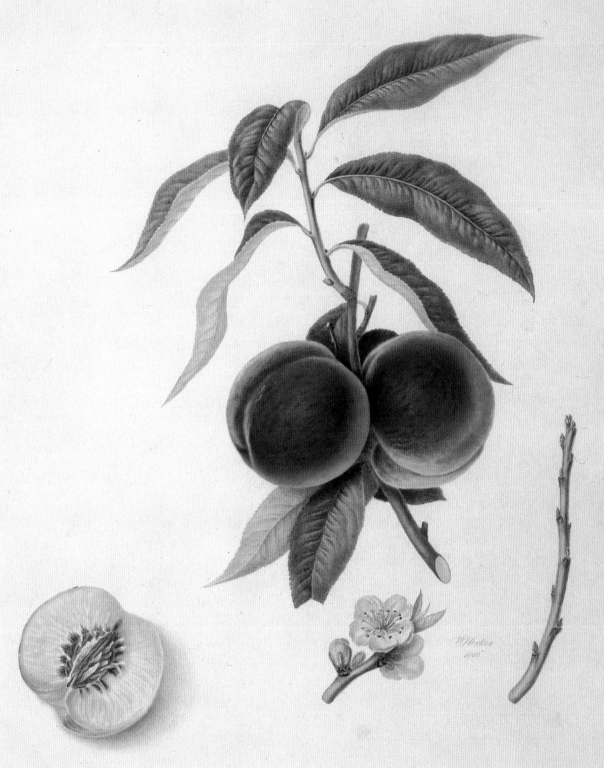

Grimwood's Royal George Peach.

NEAL'S EARLY PURPLE PEACH

Prunus persica Linnaeus Rosaceae

William Hooker, in his *Pomona Londinensis*, included Neal's Early Purple and Grimwood's Royal George (synonymous with Grosse Mignonne) as distinct varieties, and, though his paintings of the two show very similar cross-sections of their fruits, there is some difference in their colouring. However, although Hooker obviously thought the varieties were distinct, all other writers after 1824 classified Neal's Early Purple as a synonym of Grosse Mignonne.

Hooker said that Early Purple had long been cultivated in the Royal Gardens at Hampton Court, and the specimen from which he made his painting had come from the King's gardener there, Mr Padley. Forsyth, also a gardener to the King at Kensington and St James's, omitted this variety in the 1806 edition of his book, but included it in the 1824 edition. Loudon, in 1834, included the classification of peaches determined by Thompson, who was in charge of the gardens of the Horticultural Society where peaches were included, with other fruits, in trials of many thousands of varieties made to sort out their numerous synonyms. Thompson classified Neal's Early Purple, along with thirty-one other varieties, as a synonym of Grosse Mignonne. In 1860 Hogg, who also said the varieties were the same, wrote that a nurseryman named Neal sold two plants of his Early Purple to Mr Padley at Hampton Court for five guineas. It was from these trees that Hooker had his specimens.

The explanation for this mix-up is that, as Hogg said, Grosse Mignonne can be grown, with little variation, from its own seed and some nurserymen introduced their seedlings of it as new varieties. A few peaches come fairly true from seed and there may have been slight differences between Grosse Mignonne and Neal's Early Purple; but as Lindley said, writing in 1841 of the synonyms of Grosse Mignonne, the differences between these, including Early Purple, were so slight as not to make them worth cultivating as distinct varieties. The practice of introducing old varieties of fruits, or their similar seedlings, as new varieties was very common among nurserymen throughout the sixteenth to nineteenth centuries and was a frequent complaint of contemporary writers. The Horticultural Society's trials did much to sort out the synonyms.

PLATE 31 labelled *Neal's Early Purple*

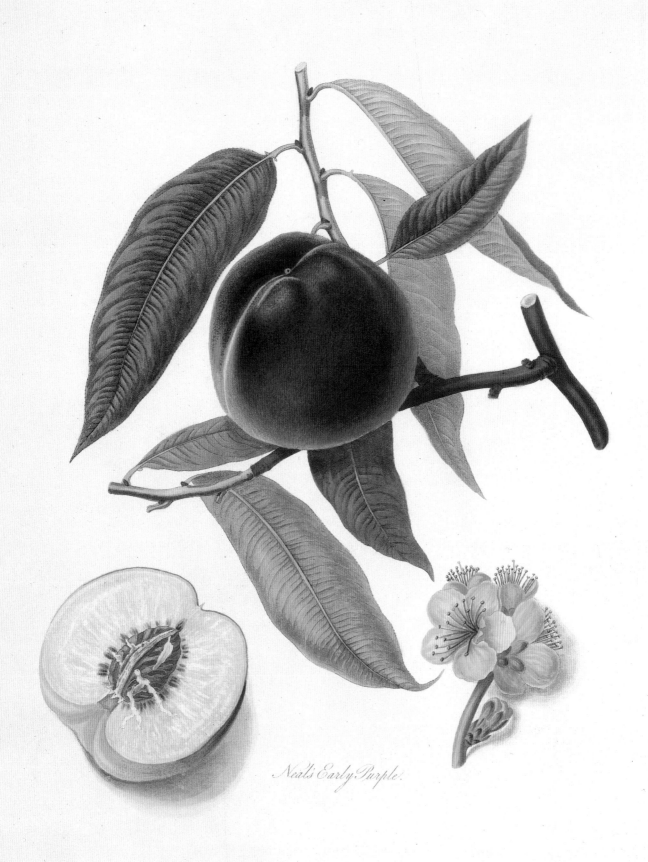

Neal's Early Purple.

ACTON SCOTT PEACH

Prunus persica Linnaeus Rosaceae

Among many other fruits, Thomas Andrew Knight bred peaches, of which Acton Scott and Springrove were two that he raised at his home at Downton Castle, in Herefordshire, England. Knight first showed fruits of Acton Scott to the committee of the Horticultural Society in London in 1813. He bred this variety by crossing Noblesse, which Switzer in 1724 said was not equalled by any other peach for its flavour and size, with Red Nutmeg, a very early old French variety known to Gerard in 1597 and described by Parkinson in 1629.

Acton Scott was regarded by the committee as being an excellent peach, with very rich, sweet, juicy, yellow flesh. It was distinguished by the whiteness of its skin if not in direct sunlight. It was a freestone, ripe in August, its earliness having been inherited from Red Nutmeg. This factor enabled Acton Scott to ripen even in the poorest climate so that, in the United States, it was found to thrive and ripen well in the north.

One disadvantage of this variety was its small size, another character inherited from Red Nutmeg, so that although it was still grown on a limited scale in the present century, it has never been widely planted.

PLATE 32 labelled *The Acton Scott Peach*

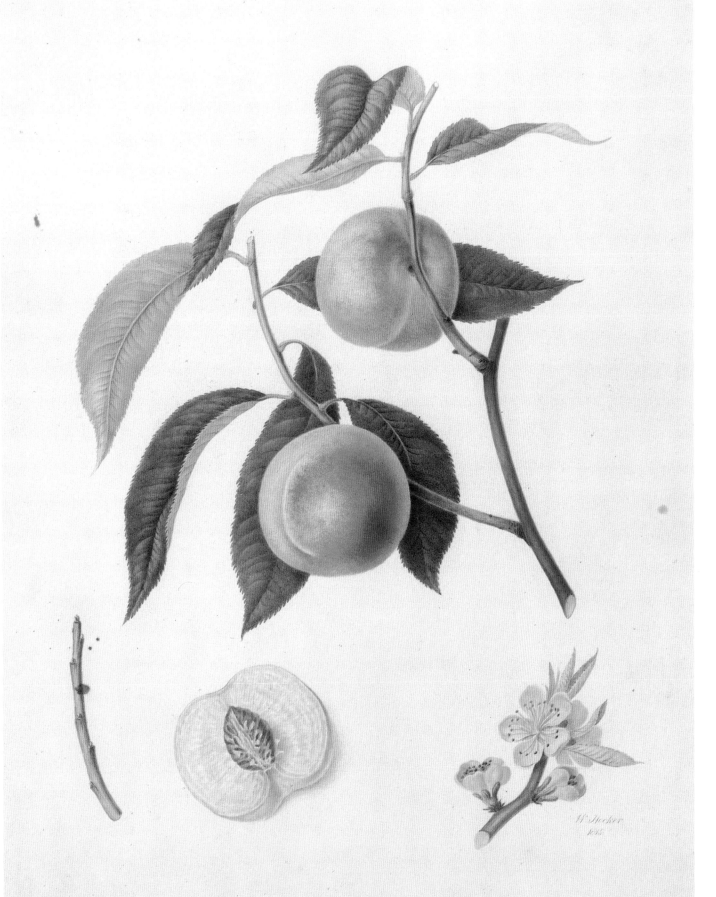

The Acton Scott Peach.

W. Hooker
1812

BRADDICK'S AMERICAN PEACH

Prunus persica Linnaeus Rosaceae

This was a new peach shown to the Horticultural Society in London by John Braddick in 1815. It was described as of medium size, with pale yellow skin tinged red and with juicy, pale yellow flesh, ripe in September.

Braddick gave the following account of the origin of his peach. He said that some years earlier, when travelling through Maryland, Virginia and neighbouring areas, he had been interested to see the way peaches were grown in the farm orchards. These orchards usually consisted of 1000 or more standard trees and most of their crops were pulped, fermented and then distilled to produce peach brandy, yielding fifty to a hundred barrels from an orchard. The pulp was used for feeding pigs.

He saw that the peaches were invariably propagated from the stones, never by budding, and so the orchards consisted of endless different types, hardly two trees being alike. However, out of the many trees some had fruits of really good quality. When he got back to England, Braddick asked a United States correspondent to select from the orchards any young trees whose fruit he considered of exquisite flavour and to send them to him. Out of a bundle of about two dozen selected trees, only one grew and that became Braddick's American. However, in spite of its good initial reception, this peach does not seem to have been widely cultivated, although it was recommended by Forsyth in 1824.

PLATE 33 labelled *Braddicks American Peach*

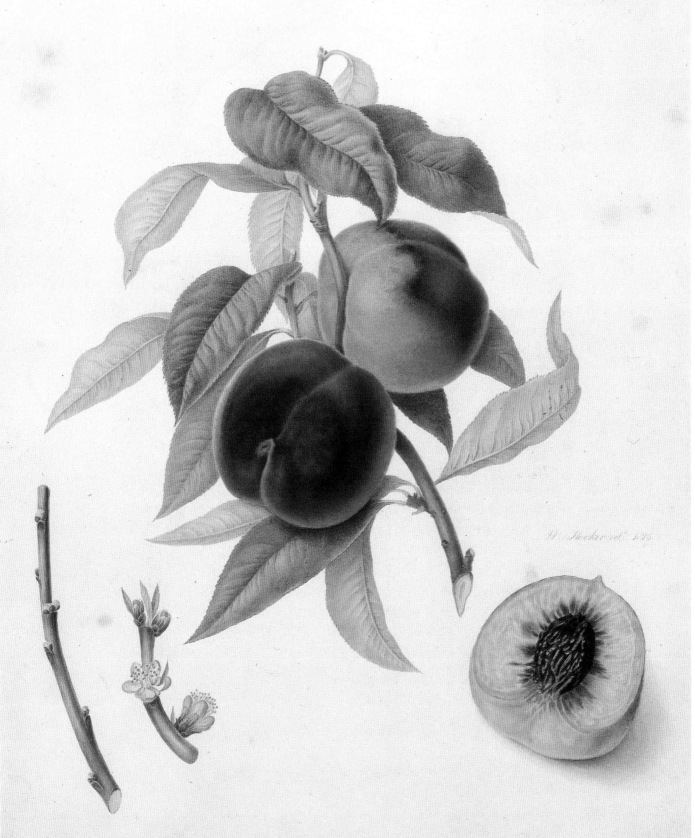

Braddicks American Peach

BOURDINE PEACH

Prunus persica Linnaeus　　　　　　　　　　　　　　　　　Rosaceae

The Bourdine, like so many peaches grown in the past, is an old French variety, named after Bourdine, gardener to Louis XIV. It was referred to by de la Quintinye in 1693 and Switzer in 1724. Both writers recommended it, although Switzer said it had the reputation of not bearing well as a young tree but, when older, cropped heavily, even under adverse conditions when exposed to cold winds. Forsyth, in 1806, also said that Bourdine cropped very well especially on older trees and was suitable for growing as a standard tree in the open. This was at a time when most peaches grown in England were given the protection of being trained on the walls surrounding gardens.

Hooker similarly wrote that Bourdine was very hardy and vigorous and was, perhaps, the best late peach for the English climate, particularly for the north of the country where, in seasons when other varieties were tasteless, its fruits were still good and often of excellent flavour. In the United States, Downing, in 1857, said that it was one of the old French varieties which had received the approval of the best cultivators everywhere and that it was hardy and productive in any climate.

Apart from its good cropping, Bourdine was praised for its very large, roundish fruits with greenish-white, very melting flesh and a delicate, exquisite flavour, which were ripe from mid-September to early October.

PLATE 34 labelled *The Bourdine Peach*

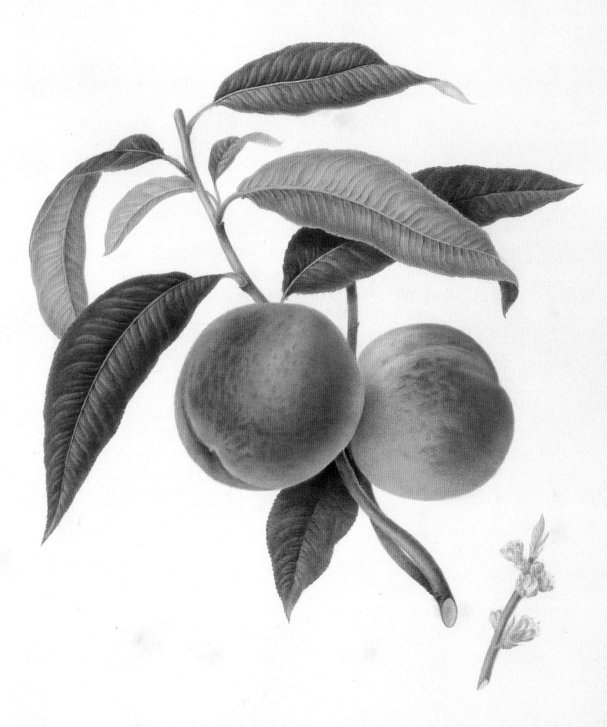

GALANDE PEACH

Prunus persica Linnaeus Rosaceae

As Hooker noted, in 1768 the French writer Duhamel said that Galande and Bellegarde were names for the same peach, and, though Hooker called it Galande, Bellegarde was the name generally used. In 1693 the French authority de la Quintinye and in 1724 Switzer in England both recommended Bellegarde and the same name was used by all subsequent writers in Europe and America and is still used today.

The origin of Bellegarde is not known but the fact that it was first recorded in France in the seventeenth century, and recommended by Bunyard in the twentieth century as 'altogether first rate – one of the finest grown', indicates the high reputation it has had for at least 300 years. For many years it was the peach most widely grown in the Montreuil district for supplying the markets of Paris. In 1857, Downing in the United States considered Bellegarde one of the most handsome and delicious fruits grown there.

Ripe from early to mid September, the beautiful appearance of the large roundish fruits with their pale yellow, melting, juicy and well-flavoured flesh accounted for the continuing popularity of this peach.

PLATE 35 labelled *The Galande Peach*

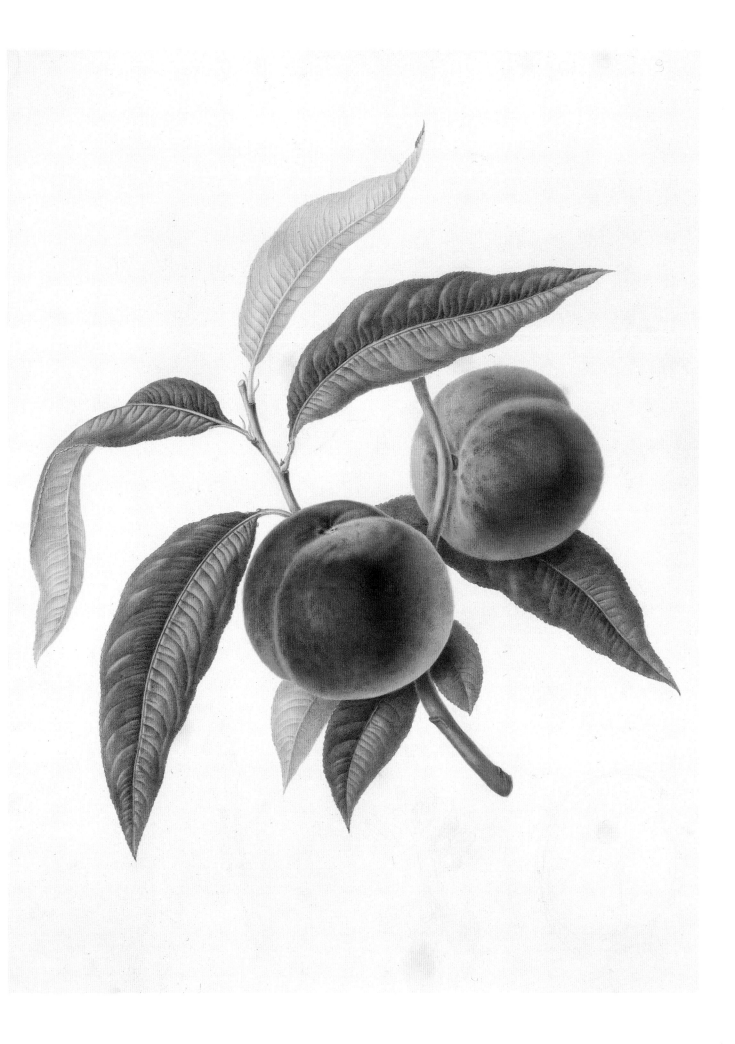

NOBLESSE PEACH

Prunus persica Linnaeus Rosaceae

There has always been some confusion over the origin of the Noblesse peach as, although it has a French-sounding name, it was not recorded by any of the early French writers. In England, the first reference to Noblesse was by Switzer who wrote in 1724, 'It is the best peach (take it altogether) of any we have had from France and a man that is content with, or has room for a few, can't do better than to plant the Montaubon and Noblesse peach preferable to any other.' However, in spite of this and Hogg's suggestion in 1860 that Noblesse originally came from Holland, others, including the French themselves, have assumed it originated in England.

The good opinion of Noblesse expressed by Switzer has been held by all writers up to the present century. In the United States it was added to the list of recommended fruits by the American Pomological Society in 1862 and remained on the list until 1897. Downing, in 1857, said that it was an English peach of the highest reputation, held in great esteem wherever known in America as one of the largest, most delicious and most valuable varieties.

Noblesse, ripe at the end of August or the beginning of September, has been appreciated for the large size of its attractive fruits with their very pale yellow flesh, melting, juicy and highly flavoured. In the past, it was regarded as one of the best for forcing under glass. Like Bellegarde, Noblesse is another peach that remained popular for at least 300 years – a contrast with so many short-lived fruits introduced in the twentieth century.

PLATE 36 labelled *La Noblesse*

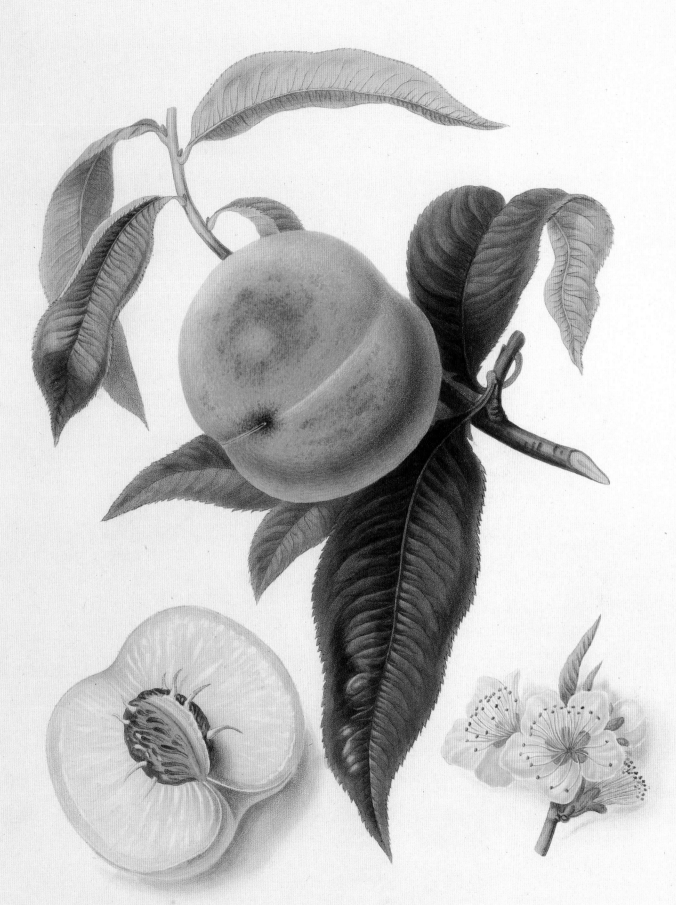

La Noblesse.

RED MAGDALENE PEACH

Prunus persica Linnaeus Rosaceae

Red Magdalene was a very old French variety known in the seventeenth century and often confused with other varieties, and was itself known under numerous synonyms, several of them of French origin. Of these, Madeleine de Courson was one of the most common. John Evelyn's translation of de la Quintinye's *Compleat Gard'ner* in 1693 named it as Red Maudlin. Switzer, in 1724, included the variety among a number of good peaches ready in September. Forsyth in 1806 described Red Magdalen as a very good peach, large, full of rich sugary juice and of excellent flavour.

The skin colour of the fruits was pale yellow, with overlying bright red where exposed to the sun but white in the shade. The flesh was white, firm and of vinous flavour. Although this variety was known in the United States, neither there nor in England did it become of any importance during the nineteenth century.

PLATE 37 labelled *The Red Magdalene Peach*

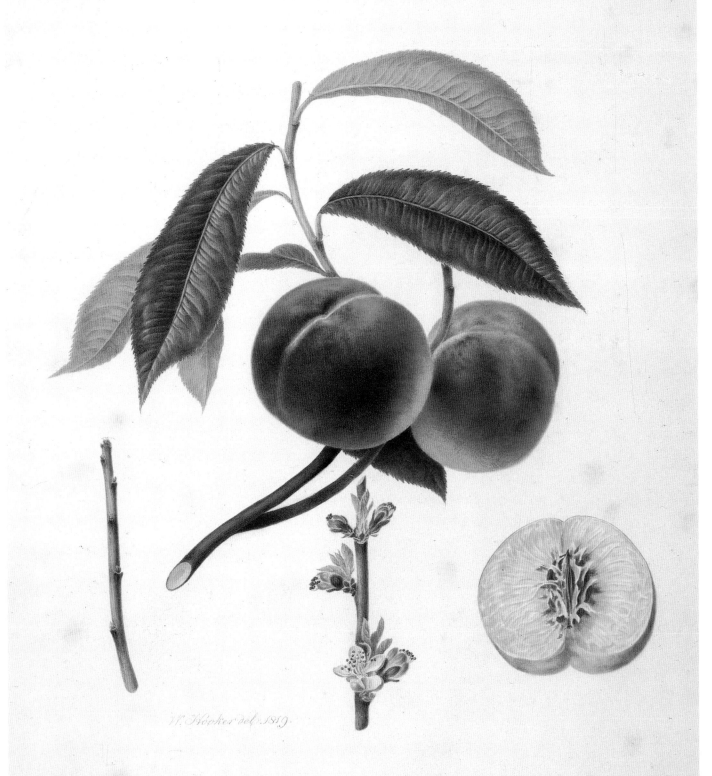

W. Hooker del. 1819.

The Red Magdalene Peach.

BREDA APRICOT

Prunus armeniaca Linnaeus Rosaceae

The apricot is found growing wild over a wide area of central Asia, but in spite of its name, which suggests an Armenian origin, it is thought to have originated in China where there are records of its ancient cultivation. Like the peach, the apricot was probably carried by travellers along the ancient silk route from China in the second or first century BC to Persia, thence to Armenia, Greece and Rome.

It seems to be an intermediate between the plum and the peach and, when it was first brought to Rome in the first century AD, Pliny referred to it as the Armenian plum, as it was regarded as a type of plum. Apricots were grown around Damascus and in Upper Egypt where they were dried for sale throughout Europe.

Apricots were introduced into England in the sixteenth century, and by the end of the century Gerard, in 1597, described two types, the greater and the lesser, which he said were then grown throughout England. By the seventeenth century at least seven varieties were available in nurseries and Worlidge, in 1697, said that the fruit was known almost everywhere.

Breda is thought to have come from Africa and to have been imported to England from Breda in Holland. It was probably brought over at least by the mid eighteenth century as it was listed in 1777 by Richard Weston, a nurseryman. Later it was taken to the United States. It still exists though not of commercial importance. Though small it has been regarded as of good flavour, having deep orange flesh and a free stone and ripening early.

PLATE 38 labelled *The Breda Apricot*

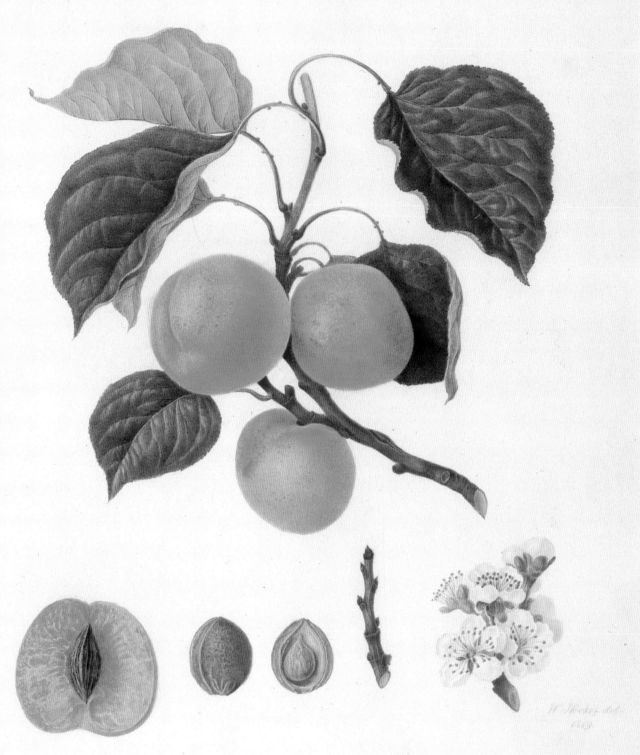

The Breda Apricot.

BRUSSELS APRICOT

Prunus armeniaca Linnaeus Rosaceae

Brussels was a very old variety of apricot which is thought to be synonymous with the Roman or Common variety and, as such, may have been grown in Roman times. It was grown until the present century on a small scale in England and was also grown in the United States but in neither country has it been very highly regarded.

It had the value of being fairly early and also of being successful when trained as either a standard or bush tree in England, whereas most varieties needed the protection of being grown on a wall. The flesh was pale yellow and of inferior flavour.

PLATE 39 labelled *The Brussells Apricot*

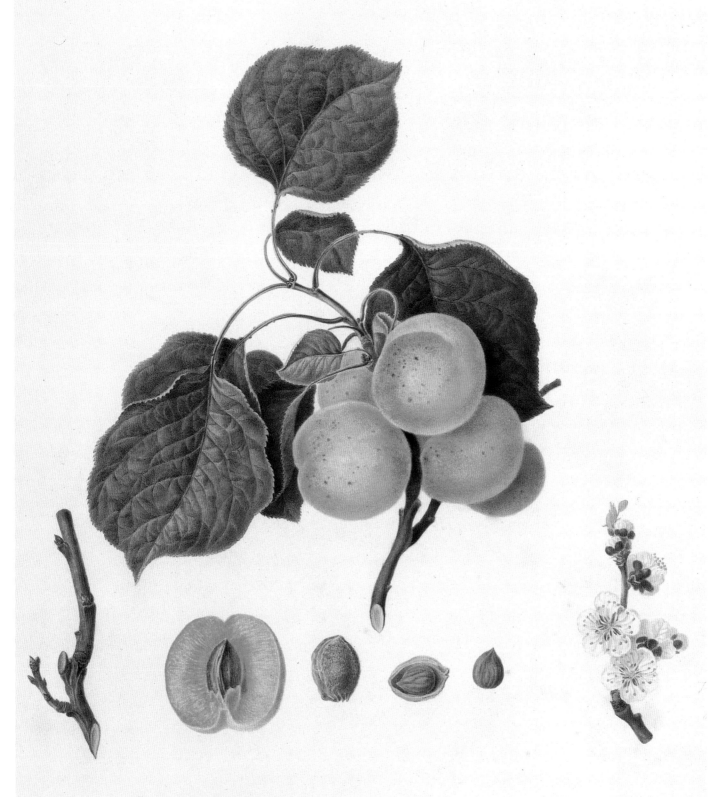

W. Hooker delt. 1821.

The Brussells Apricot.

ORANGE APRICOT

Prunus armeniaca Linnaeus Rosaceae

This is an old variety whose origin is not known, but the fact that two of its synonyms were Persian and Royal Persian indicates that it may well have come from Persia, one of the countries to which apricots were brought from China, where they first evolved, before they were passed on to Greece and Rome.

The Orange apricot was included in their lists of recommended varieties by the writers Hanmer in 1659, Meager in 1688 and others in the eighteenth century. Richard Weston the nurseyman listed it in his catalogue of 1777 as one of the leading nine varieties then in use, while Forsyth in 1824 wrote of it as the best apricot grown.

The Orange apricot was imported into the United States where Downton in 1857 said it was only of tolerable quality for dessert but was highly esteemed for preserving, making delicious tarts even before the fruit was coloured. During the last century it became of no importance.

PLATE 40 labelled *The Orange Apricot*

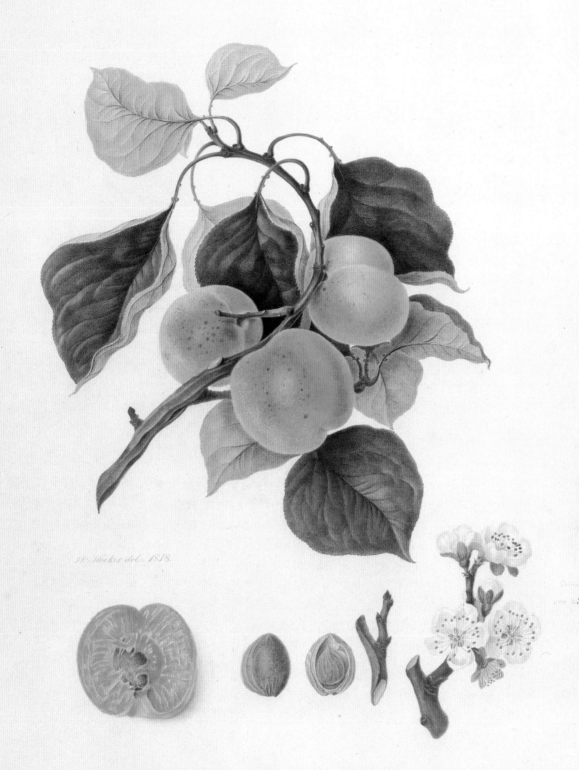

W. Hooker del. 1818.

The Orange Apricot.

MOOR PARK APRICOT

Prunus armeniaca Linnaeus Rosaceae

In the nineteenth century, Moor Park was regarded both in England and the United States, and in other countries where it was grown, as the best quality apricot in existence. In 1938 the American authority, Hedrick, said it was probably the most widely and frequently planted of all apricots and was the favourite one in many parts of California. In 1961, Childers said it remained an important variety in Washington State. It is still appreciated and grown for its good qualities in England.

Exactly when Moor Park was first grown in England is uncertain, but it was certainly by the eighteenth century. In 1777 Richard Weston, in his nursery catalogue, included Temple, which was a synonym for Moor Park; and in 1788 another nurseryman, William Driver, in his *Pomona Britannica*, only included Moor Park.

There has been considerable confusion over its origin but the evidence is that it was introduced in 1760 by the famous admiral Lord Anson, and first fruited at Moor Park, near Watford in Hertfordshire, England. It was probably a seedling of the Peach apricot, a French variety, which often came fairly true from seed and had several characters similar to those of Moor Park.

Moor Park has large fruits, ready in August, with brilliant orange flesh, melting and of excellent flavour.

PLATE 41 labelled *The Moor Park Apricot*

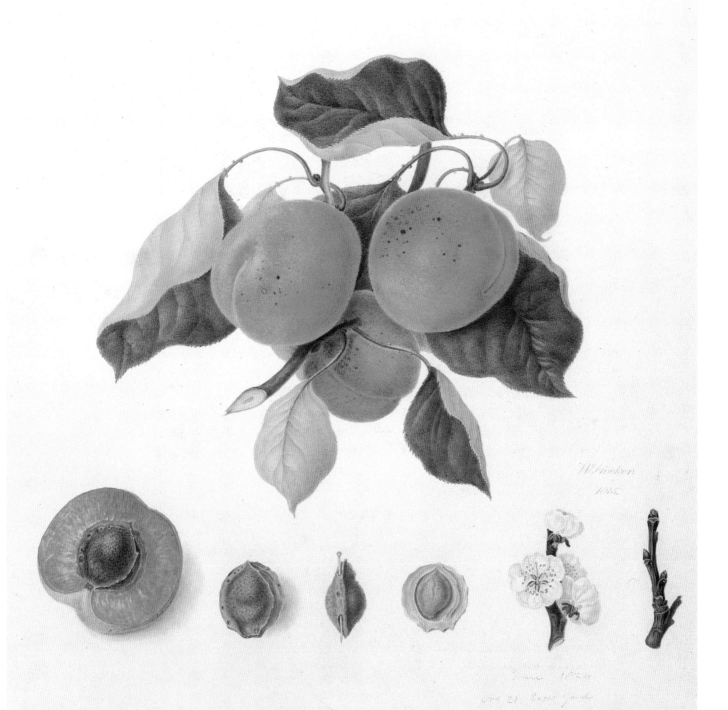

The Moor Park Apricot

RED ROMAN NECTARINE

Prunus persica var. *nectarina* Rosaceae
(Aiton) Maximowicz

The nectarine is a smooth-skinned hairless form of the peach, which normally has a downy skin. Smooth skin is a recessive character as is yellow flesh. The trees do not differ in any respect from those of the peach. Nectarines occur spontaneously as single bud mutations on peach shoots, all fruits borne on growths from these buds showing the typical hairless characters of the nectarine. There are rare instances of a nectarine bud reverting back to a peach.

The history of the cultivation of nectarines in Britain is similar to that of peaches. Red Roman was among the first nectarines to be recommended both by Parkinson, in 1629, and by the second edition of Gerard's *Herball* in 1633. The latter said this variety was, 'the best of fruits'. The name suggests a possible link with the Roman period but there is no direct evidence of this, though Pliny did say that 'The palm among peaches belongs to the duracinus [the nectarine]'. Red Roman must have have been brought to England from the continent of Europe where it was very popular, but there is nothing to show at what date. However, as many improved varieties of fruits were brought to England in the early part of the sixteenth century, it is likely that Red Roman was among them.

It was imported into the United States where, as in Europe, it was recognized as one of the richest and best of the clingstone nectarines, with large fruits having greenish-yellowish flesh, juicy and highly vinous, ripe in September. Although still existing in the present century, Red Roman is now rarely seen.

PLATE 42 labelled *The Red Roman Nectarine*

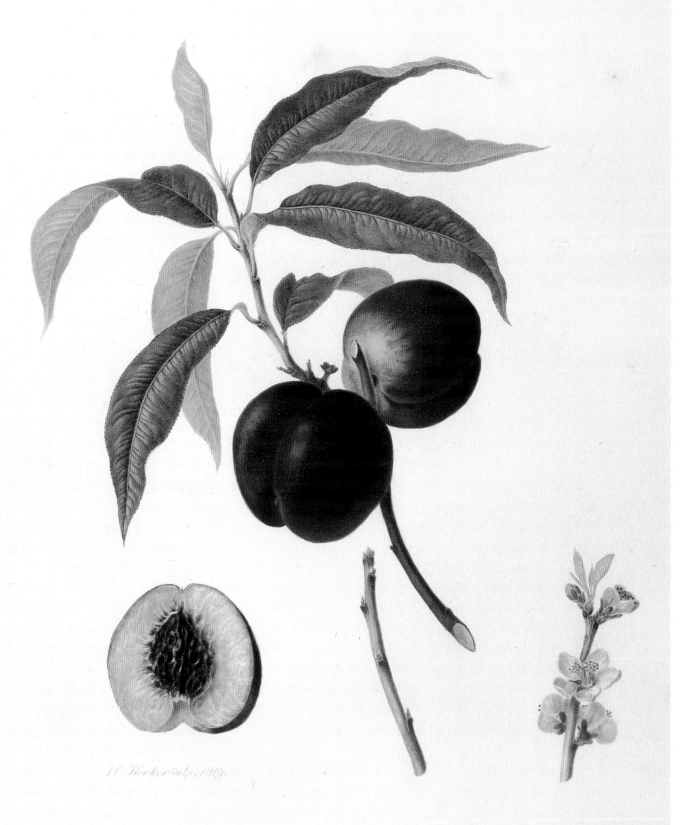

W Hooker delt. 1819.

The Red Roman Nectarine.

ELRUGE NECTARINE

Prunus persica var. *nectarina* Rosaceae
(Aiton) Maximowicz

Elruge has been regarded as one of the best varieties of nectarine for
over 300 years. It is still in existence. It was raised by Captain Leonard
Gurle, a nurseryman at Hoxton (then 'Hogsden') in London during
the reign of Charles II, before 1670. Captain Gurle had a reputation
as one of the most reliable nurserymen for the best quality fruit trees
and in 1677 was appointed gardener and keeper of the royal garden
in St James's Park. The name Elruge was a reversal of the letters of
his own name.

This nectarine quickly gained favour as being of the highest
quality, melting, juicy and richly flavoured. Writers of all periods, both
in England and America, spoke very highly of it. It was praised by
Leonard Meager in England in 1688, and by Hedrick at Geneva, New
York State, in 1938 who wrote, 'Elruge is a time-honoured landmark
in the evolution of nectarines, and, at the same time, one of the best
of its species.' Few fruits have maintained their good reputation over
such a long period.

PLATE 43 labelled *El Rouge*

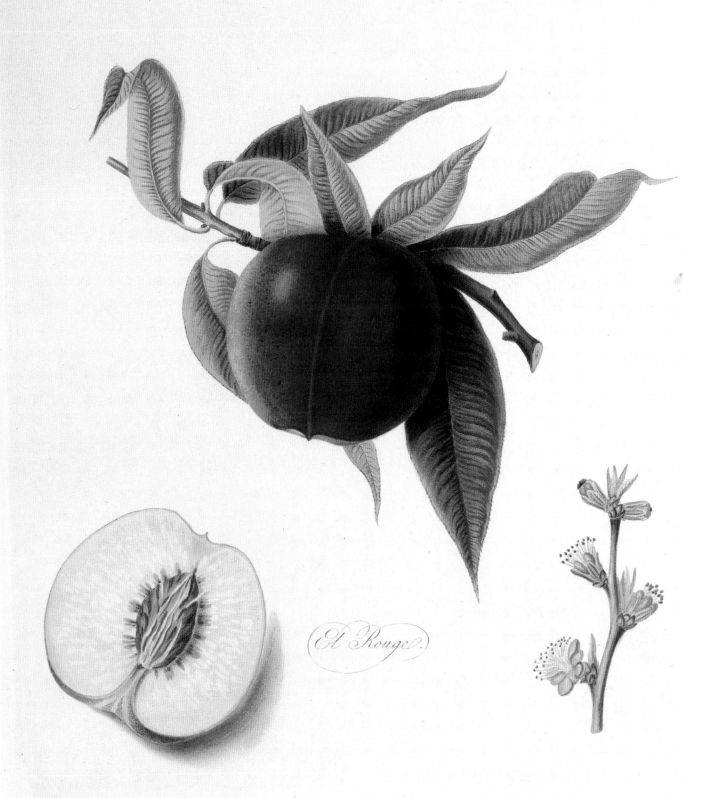

El Rouge.

PITMASTON ORANGE NECTARINE

Prunus persica var. *nectarina* Rosaceae
(Aiton) Maximowicz

Pitmaston Orange was raised by John Williams of Pitmaston near Worcester, England, from the seed of the Elruge nectarine. The tree first fruited in 1815, and samples were shown at a meeting of the Horticultural Society in London in 1820. At that time and for over a century following, it was considered the best quality yellow-fleshed nectarine available both in England and in the United States where it had been taken early in the last century. In 1938 Hedrick wrote that no other nectarine excelled Pitmaston Orange in beauty and quality.

The fruits are large, the skin a rich orange, brownish in the sun, the flesh deep yellow, melting, juicy, sweet and of excellent flavour. It is ripe from the middle to the end of August. In the United States it had the reputation of being a regular and good-cropping nectarine but rather susceptible to frost damage.

PLATE 44 labelled *The Pitmaston Orange Nectarine*

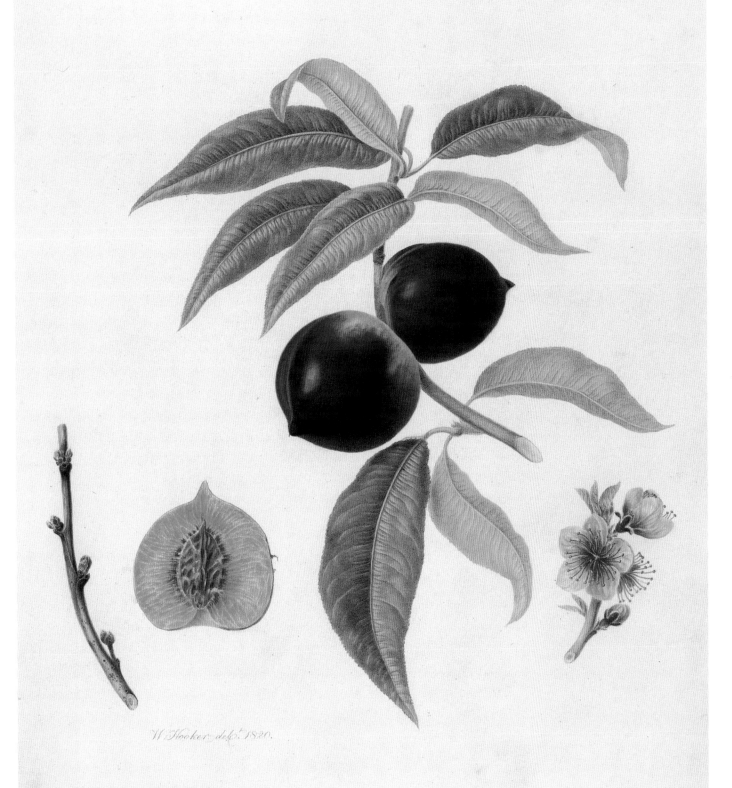

W. Hooker delt. 1820.

The Pitmaston Orange Nectarine.

FAIRCHILD'S EARLY NECTARINE

Prunus persica var. *nectarina* Rosaceae
(Aiton) Maximowicz

This nectarine was raised by Thomas Fairchild (*c.* 1667–1729), the
most noted in the eighteenth century of a number of nurserymen in
the Hoxton region of London. He established his nursery about 1691
and introduced several plants of importance. He had strong botanical
interests and made experiments on the movement of sap. A Fairchild
lecture or sermon is still given, in accordance with his will, in the church
of St Leonard, Shoreditch, in London.

However, his nectarine was not very successful and, though grown
in both England and the United States until the middle of the last cen-
tury, was never highly regarded. The fruits were small, the flesh rather
dry with a sweet but indifferent flavour. Its only value seems to have
been its earliness, as it was ripe in England at the beginning of August.

PLATE 45 labelled *Fairchild's Early Nectarine*

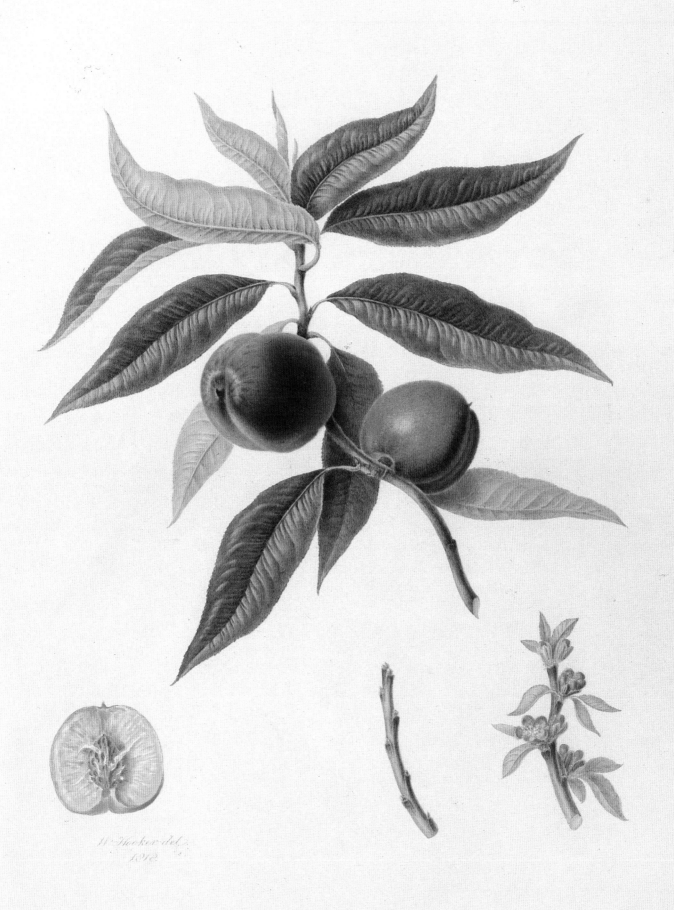

W. Hooker del.
1812.

Fairchild's Early Nectarine.

VIOLETTE HÂTIVE NECTARINE

Prunus persica var. *nectarina* Rosaceae
(Aiton) Maximowicz

Violette Hâtive is one of the oldest nectarines still in existence. It was known in France before 1659 under this name, the term 'hâtive' being applied to all fruits ready early in the season. All the early writers, in both France and England, considered it as the best of the early nectarines. John Evelyn's translation of the book by de la Quintinye, published in 1693, says of it, 'the juice and taste are enchantingly delicious'. Hooker himself wrote that Violette Hâtive was more generally cultivated than any other. The name Violette was given to this nectarine since, although the basic skin colour was pale yellowish-green, it became dark purple where exposed to the sun.

Ripe at the end of August to early September, the flesh of the fruits, which is nearly white except near the stone, was described by Hooker and subsequent writers as juicy, sweet and of delicious flavour. In the United States, according to Downing in 1857, Violette Hâtive was everywhere ranked highest among nectarines for its delicious flavour, fine appearance and the fact it was hardy and very productive. Although it still exists after over 300 years of popularity, it has been largely replaced by newer varieties.

PLATE 46 labelled *The Violette hâtive Nectarine*

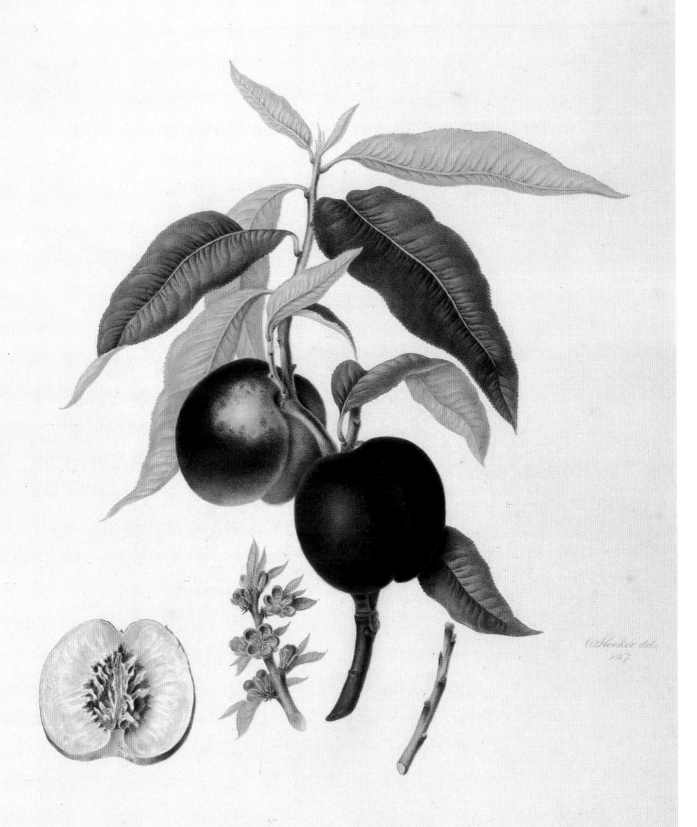

The Violette hâtive Nectarine.

WHITE NECTARINE

Prunus persica var. *nectarina* Rosaceae
(Aiton) Maximowicz

The colour of this nectarine, white to greenish-yellow with an occasional slight red tinge towards the sun, was in strict contrast to that of more richly coloured varieties such as Violette Hâtive and others of the same period, so that Hooker suggested it could be a great ornament. Alternative names for this variety were New White and Flanders. New White was the name given to distinguish it from Old White, from a seed of which it had been raised by the Revd Neate near London, some time before 1800.

The White nectarine was described and recommended by Forsyth in 1826 and later, in 1857, by Downing in the United States. Downing said that this nectarine was the finest light-skinned variety, was beautiful, hardy and bore abundant crops. His description of its fruit as having a rich, vinous flavour was similar to that of Hooker but the latter added that, although ripe in August, under unfavourable conditions it tended to fall when immature. Like so many of the older fruits this nectarine gradually went out of favour.

PLATE 47 labelled *The White Nectarine*

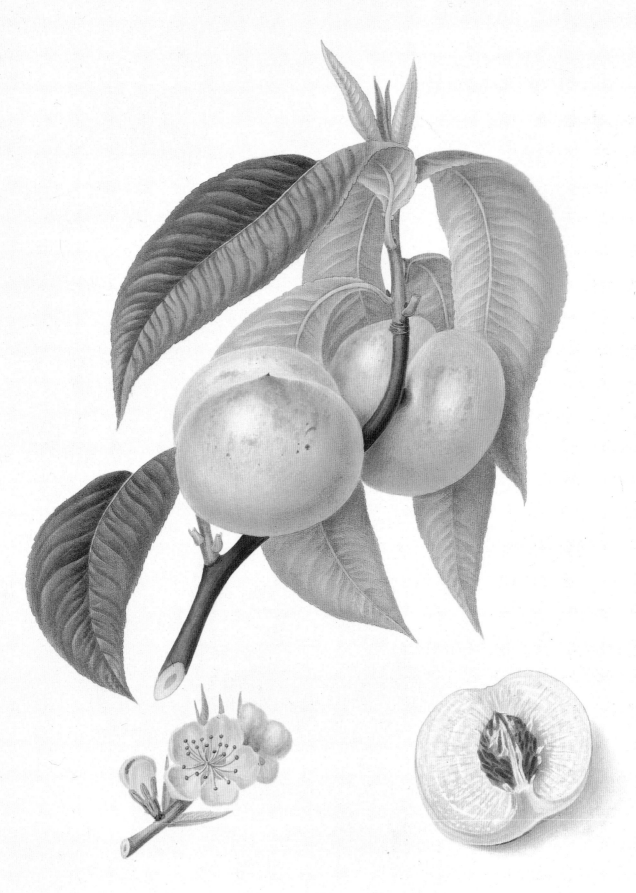

The White Nectarine.

IMPÉRATRICE PLUM

Prunus domestica Linnaeus Rosaceae

Several species of *Prunus* were involved in the development of plums. Most of those cultivated in Britain and in many parts of Europe are grouped as derivatives of *P. domestica*, considered to have arisen as a cross between *P. cerasifera*, the cherry plum and *P. spinosa*, the sloe or blackthorn. This could have occurred in the Caucasus region where both species grow wild. For many thousands of years plums and other *Prunus* derivatives formed an important part of the food of the people living in the area of the Caucasus, Transcaucasia and the country bordering the Caspian sea. Plums were cultivated in ancient Greece and Rome. Pliny described twelve varieties grown in Italy during the first century AD.

Plum stones have been found on Roman sites excavated in London, but it is not known if plums were grown in England at that time. By the eighth and ninth centuries they were widely grown in Europe. There are records of their cultivation in England in the thirteenth century and numerous varieties became available during the ensuing centuries. In 1597, Gerard said that he had sixty of the best and rarest varieties in his garden and each year received new ones not previously known.

Impératrice, also known as Blue Impératrice, is a very old variety of uncertain origin which was known under many names in Europe. Switzer in 1724 said it was 'of an excellent Taste and being the latest Plum we have is of great Use, it hanging on the Tree till the beginning of October; the fruit will also keep in the House on Shelves.' This opinion was confirmed by Hooker and others. It is no longer commonly grown but still exists in fruit collections.

PLATE 48 labelled *The Imperatrice Plum*

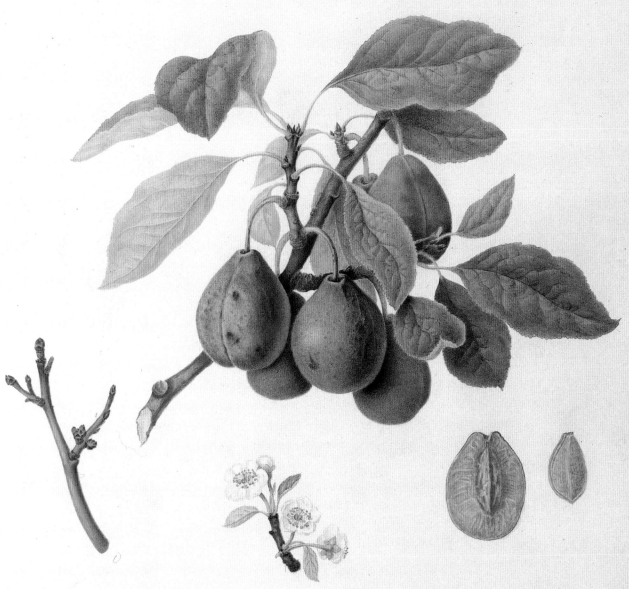

William Hooker fecit
London. 1816.

The Imperatrice Plum.

GREEN GAGE

Prunus domestica Linnaeus Rosaceae

This is the oldest plum or gage still cultivated today and it still retains
the good reputation for delicious flavour that it had 500 years ago. It
is believed to have come from Armenia and been taken to Greece, and
thence to Italy, where it was known as Verdocchia, and to have reached
France during the reign of François I (1494–1547) where it was named
Reine Claude in honour of his consort. It does not seem to have been
grown in France to any extent at this time, as earlier writers did not
refer to it.

As Verdoch, taken from the Italian name, it was recorded in Eng-
land by Parkinson in 1629, and the recovery of plum stones from the
wreck of the *Mary Rose*, the flagship of Henry VIII sunk in 1543 and
raised in 1982, disclosed some stones thought to be of the Green Gage.
It seems therefore that this variety had been imported direct from Italy.

In France it continued to be known as Reine Claude and was again
brought to England some time before 1712, when this plum and some
others were sent to Sir Thomas Gage of Hengrave Hall, near Bury St
Edmunds, by the monks at Chartreuse near Paris. Apparently the label
on the Reine Claude was lost, and the gardener, when it cropped, simply
called it 'Green Gage', and this became the accepted name, under which
it was sent to the United States. There, however, this variety was also,
and more usually, sold under its original name of Reine Claude.

The Green Gage comes fairly true when grown from the stones
and thus many variations of the original form have arisen. Ready at
the end of August to early September, the rounded green fruits, with
a slight red flush or dots, have yellow-green flesh, tender and of excellent
flavour.

PLATE 49 labelled *The Green Gage Plum*

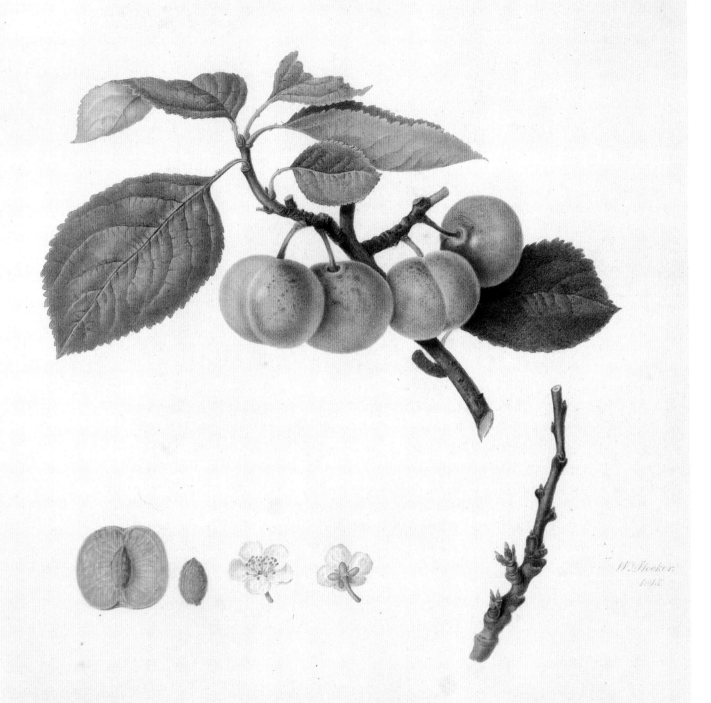

The Green Gage Plum

CATHERINE PLUM

Prunus domestica Linnaeus Rosaceae

This is a very old French variety, known in France as Sainte Cathérine and grown there for hundreds of years. During that time the dried plums have been sold as the famous Pruneaux de Tours. De la Quintinye said in 1693 that although others thought Sainte Cathérine was only fit for drying, at Versailles, by growing it on the walls of the garden, he had found it excellent for dessert. This view was supported by all later writers. Switzer in 1724, using the name St Katherine, wrote, 'it is, I think, the very best of all the White Plums, and of excellent Use in the Confectionary; it is at first whitish, but as it ripens, grows yellowish; it has a very rich sugar'd Juice, a good Bearer, and is indeed an excellent Plum.'

The good opinions of de la Quintinye in France and Switzer in England were fully supported by William Hooker in 1815, and by Downing in the United States in 1857, who wrote that among the fine old varieties, the St Catherine was one of the most celebrated, esteemed for preserving and excellent for dessert. It was also very well thought of by Hogg in the middle of the century, but gradually lost popularity in England and is no longer planted.

PLATE 50 labelled *The Catharine Plum*

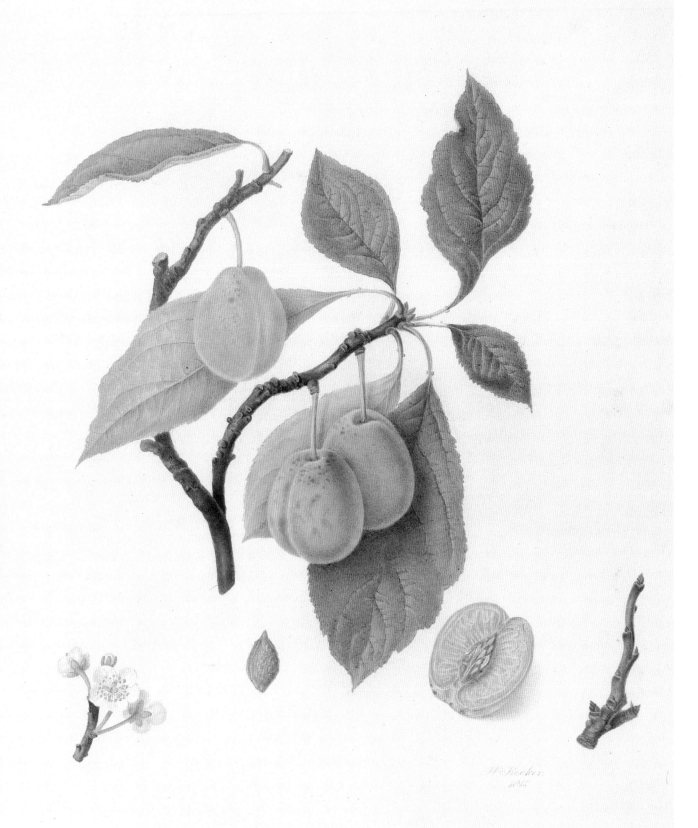

The Catharine Plum

NECTARINE PLUM

Prunus domestica Linnaeus Rosaceae

This is an old plum whose origin is uncertain. It has often been confused with Goliath, another old plum also of uncertain history. Hooker said in 1817 that this plum had recently been seen in the shop of Mr Ross of Caledonian Nursery, Newington, London, who called it Caledonian. The name Nectarine was given to it by the Fruit Committee of the Horticultural Society as its close resemblance to the nectarine in size and colour caused many people, at first sight, to confuse the two fruits. The plums were also being sold at Covent Garden market as the Nectarine.

The fruits are very large, nearly round, with firm, greenish-yellow flesh, very juicy and of fair flavour. This plum was recommended to market gardeners because, though not of the best quality, it was valuable on account of its good appearance and heavy cropping. It was imported into the United States where, as in England, its appearance and size were appreciated but it was considered to be of only second quality. It still exists in English Fruit Trials under the name of Goliath.

PLATE 51 labelled *The Nectarine Plum*

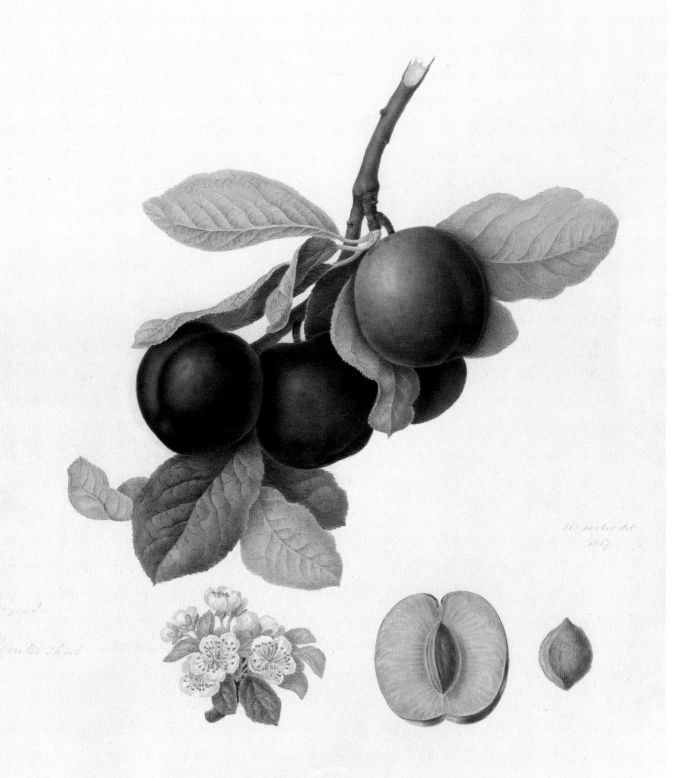


 Most text is illegible handwriting. 

The Nectarine Plum

COE'S GOLDEN DROP PLUM

Prunus domestica Linnaeus Rosaceae

This valuable variety was bred by Jervaise Coe, a market gardener of Bury St Edmunds, Suffolk, England, who raised a number of new plums after 1750. Coe's Golden Drop was bred towards the end of the century. Coe thought the parents were Green Gage crossed with White Magnum Bonum as these two varieties were growing side by side in his nursery.

The merits of the new variety were quickly recognized by members of the Horticultural Society in 1818 when they were told by T. A. Knight that, from his own experience, Coe's Golden Drop could be recommended as superior to any late plum then available. This early assessment was fully justified both in England and other countries of Europe as well as in the United States. However, although its merits were well known, its poor cropping and need for cross-pollination meant that it never became popular with commercial growers, but it is still grown by the connoisseur gardener.

Ready at the end of September, it will keep in good condition for some time after being picked and, with careful storage in dry conditions, has been kept for several months. Coe's Golden Drop, as suggested by the name, has light yellow skin and golden yellow flesh, the latter very tender, juicy and sweet with an excellent flavour, better than that of most other plums now grown.

PLATE 52 labelled *Coe's Golden Drop*

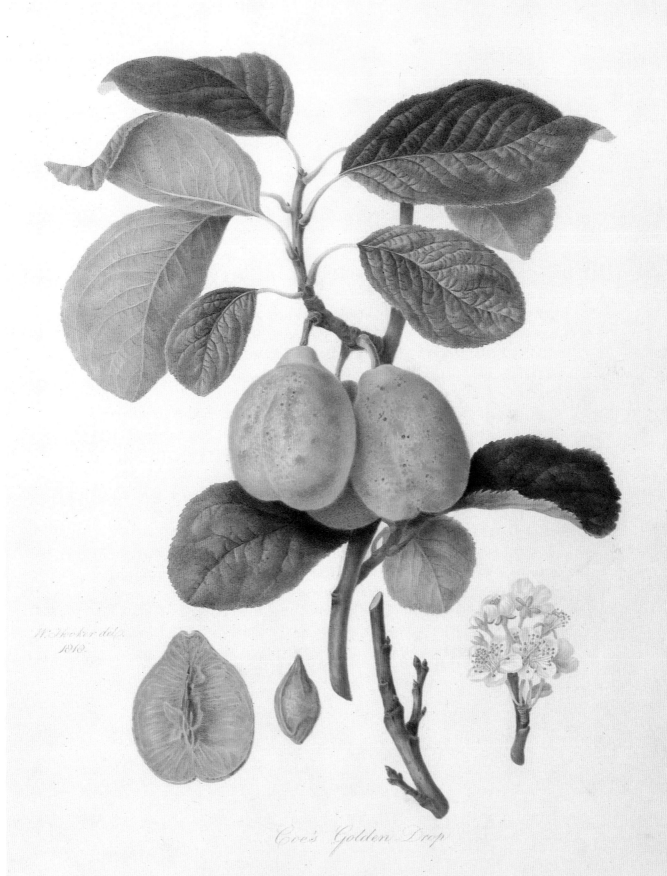

Coe's Golden Drop

MOROCCO PLUM

Prunus domestica Linnaeus Rosaceae

Morocco is a very old plum of which relatively little is known as to its origin. Parkinson in his *Paradisi in Sole (Paradisus Terrestris)* (1629) simply said, 'The Morocco plumme is black like a Damson, well tasted and somewhat dry in eating.' It was known by a number of synonyms including Black Damask, Black Morocco and Early Damask. Switzer in 1724 included Black Damascen in his list of plums but said nothing about it.

It was valued for its earliness as it was ready at the end of July. The plums were of medium size, with very dark purple, almost black, skin, covered with a thin, pale blue bloom. The flesh was greenish-yellow, juicy with a sweet, brisk flavour. Hogg, in 1860, considered Morocco to be an excellent early plum, the tree vigorous, and that it was a heavy cropping variety. Its value as an early plum was the reason for its virtual disappearance: in 1834 Thomas Rivers, the famous English nurseryman, introduced his Rivers Early Prolific to take its place. This was a good plum and quickly became popular as an early culinary variety and it has maintained this position for 150 years.

Downing in 1857 said that Morocco was a good early plum in the United States but there also it was found to be inferior to the better-quality Rivers Early.

PLATE 53 labelled *The Morocco Plum*

[128]

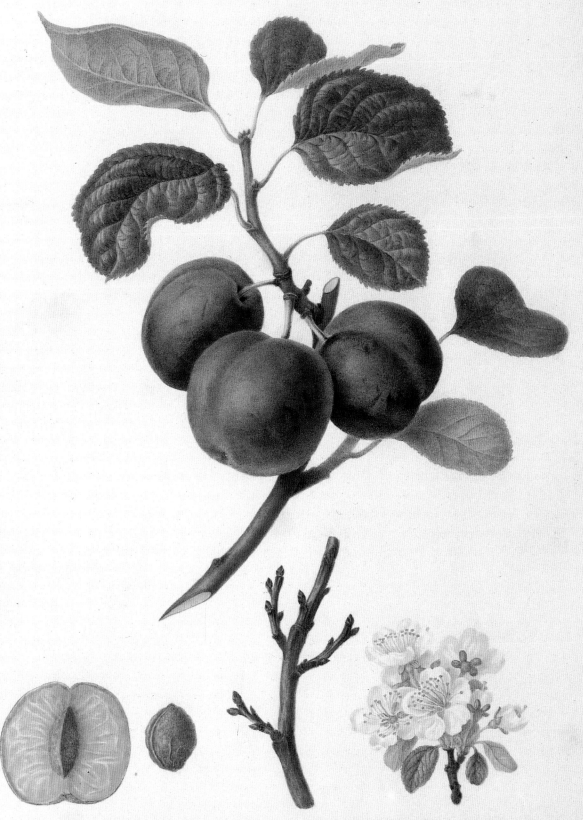

1819 The Morocco Plum.

LA ROYALE PLUM

Prunus domestica Linnaeus Rosaceae

Like many plums in the past, La Royale was another that had its origin in France. In 1724 Switzer said that he thought it was the best plum they had, having an exquisite taste and beautiful appearance. Hooker, in 1815, also thought it an excellent variety which had long been grown in the Royal Garden at Hampton Court, succeeding Green Gage in season and one of the best to ripen in September. Hooker said that its characters differed from the description by Duhamel of Royale, and from his Royale de Tours. So often at this time there was much confusion over the naming of the numerous fruit varieties brought from nurseries on the Continent to the nurseries in England, which were very ready to sell the varieties but often mixed up the names or sent them out under their own names. The nursery lists in the nineteenth century included many hundreds of varieties, most of which are unknown today. For example, Lawson's catalogue in 1865 had seventy-seven strawberries and as many as 102 varieties of pineapple.

In the United States, Downing in 1857 also considered Royale to be one of the richest plums, with its dull yellow, fairly firm flesh, but rather melting and very juicy with a sweet, vinous flavour. However, since it only bore moderate crops, Downing thought it more suited to the garden than to commercial orchards. It was perhaps the indifferent cropping which resulted in Royale losing its importance in England so that by the end of the last century it was no longer recommended.

PLATE 54 labelled *La Royale Plum*

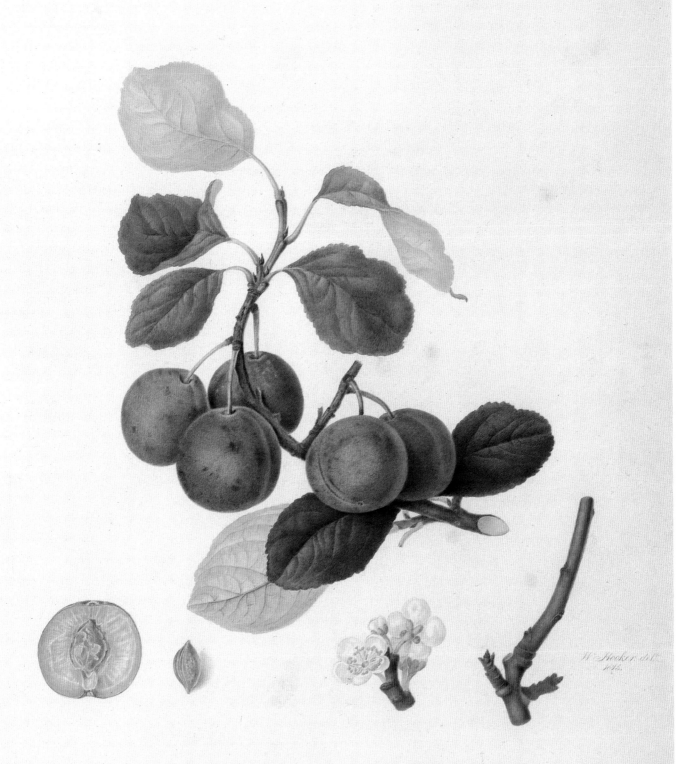

La Royale Plum

WILMOT'S NEW ORLEANS PLUM

Prunus domestica Linnaeus Rosaceae

This plum, now generally known in England as Early Orleans, is an old French variety. In France it is called Monsieur Hâtif, but it has been and still is grown in many countries of Europe under a wide range of names, most of which indicate its earliness. It has been known in England for over 300 years, and throughout this time has often been confused with Orleans, which is just as old; but they can be distinguished by the fact that Early Orleans is ripe from early to mid August, while Orleans is about ten days later.

Early Orleans is a medium-sized, reddish-purple plum with pale yellow flesh having only moderate flavour when eaten fresh but excellent when cooked. It has been fairly widely grown for market in England and in the United States but has largely been surpassed by River's Early Prolific for early picking.

PLATE 55 labelled *Wilmot's New Early Orleans Plum*

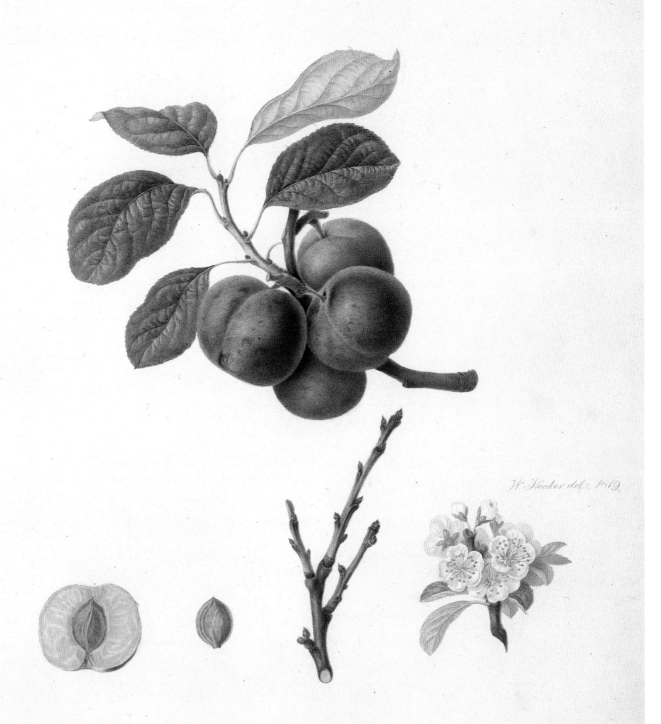

Wilmot's New Early Orleans plum.

PRÉCOCE DE TOURS PLUM

Prunus domestica Linnaeus Rosaceae

Précoce de Tours has existed in the past under a number of synonyms, of which the most commonly used was Blue Perdrigon. For centuries it has been the basis for the manufacture of Brignole prunes in the Basse Alpes. It is readily raised from the stones and there have been a number of variations, of differing colours but also called Perdrigon. It was first imported to England in 1582 from Italy, when it was known as Blue Perdrigon. In 1629 Parkinson wrote of it: 'The Perdrigon plumme is a dainty good plumme, early, blackish and well rellished.' In 1697, de la Quintinye said, 'I think any Gentleman would be much in the wrong not to place among his plums one Violet Perdrigon, that he may have about the middle of August some of those beautiful Plums that are reasonably large and long . . . so marvellously delicious for their fine Pulp, sugared Juice and high Taste.'

Although William Hooker painted this plum under the name of Précoce de Tours, the name used in parts of France, Blue Perdrigon was the name still used by Forsyth in 1824 and Loudon in 1834, and in the United States in 1857. Later writers knew it as Précoce de Tours and this is the name under which it is still grown in the fruit trials in England.

Précoce de Tours has generally been used as an early culinary plum, in July, or dried for use as prunes, but when left to ripen on the tree, as observed by de la Quintinye in 1697 and Hogg in 1860, it becomes an excellent dessert plum. If left on the tree until it shrivels it can be eaten as a sweetmeat.

PLATE 56 labelled *Precoce de Tours Plum*

[134]

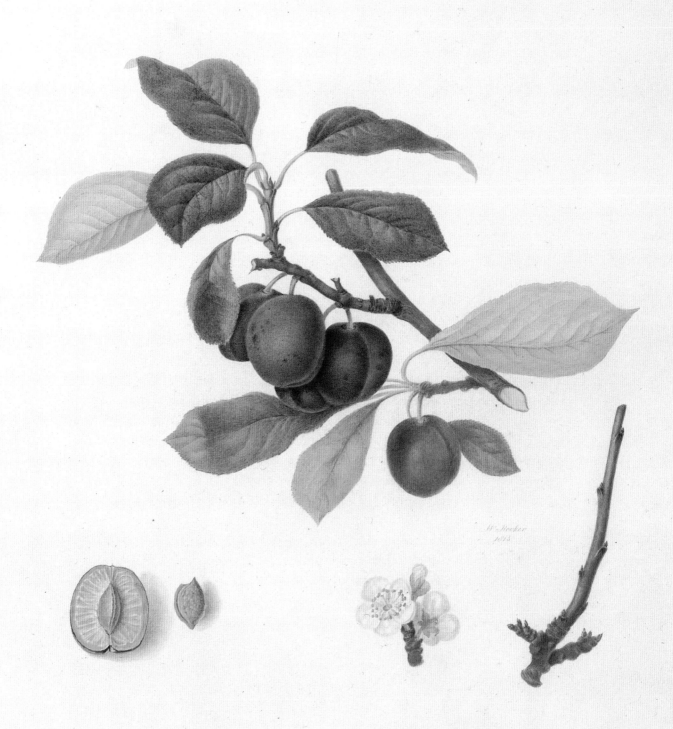

Precoce de Tours Plum

SHROPSHIRE DAMSON

Prunus insititia Linnaeus Rosaceae

Prunus insititia occurs in the wild form, the bullace, in Britain and other countries of Europe. It is the Mirabelle of France, and it is thought that the damsons were derived from this species. Pliny, the Roman writer, stated in the first century AD that the damson was named after Damascus in Syria (where this fruit was grown before the Christian era) and that it had been grown in Italy for a long time.

In Britain damsons were mentioned in the earliest literature and in 1526 Peter Treveris, in his *Grete Herball*, said that 'the damaske plummes or damassons' were among the best of the black plums, and wrote of drying their fruits. The drying and preserving of damsons and plums had been important from the earliest days of their cultivation.

The Shropshire Damson was an improved seedling selected from the wild in the seventeenth century, the fruits being much larger than those of the wild forms and more distinctly oval. As well as being a popular variety in Britain, the Shropshire also became known as the best damson in the United States both for its productivity and also for its use in cooking, preserving, bottling and canning. It is still grown in Britain and is the only damson recommeded for planting.

PLATE 57 labelled *The Shropshire Damson*

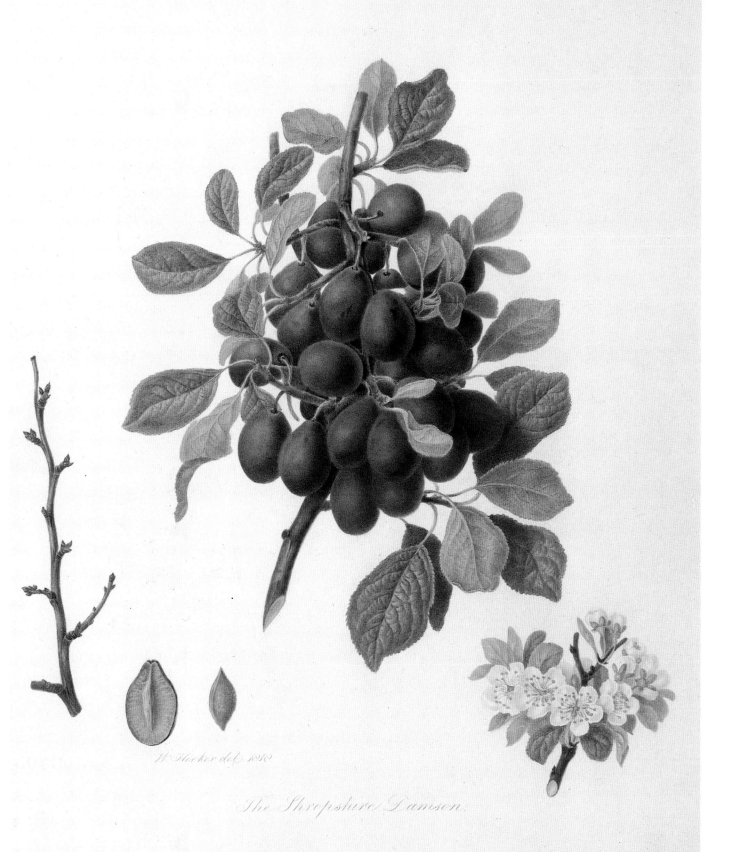

W. Hooker del. 1818

The Shropshire Damson.

PEAR-SHAPED QUINCE

Cydonia oblonga Miller Rosaceae

The country of origin of the common quince is uncertain but it occurs wild in many regions, including Turkestan and Transcaucasia where many variations of this fruit are seen in the mountainous areas. It is also found in Anatolia and Iran. The quince seems to have been first cultivated in Mesopotamia, and grew commonly in Crete from where it was taken to Greece. It was highly regarded by both the Greeks and the Romans. In Rome it was dedicated to Venus and used to decorate the temples of Cyprus and Paphos. Pliny described four varieties of quince grown by the Romans, who were expert in storing the fruit for use throughout the year, often covered with honey water, in sealed amphorae.

The first evidence of the cultivation of the quince in England was in AD 1275, when it was planted in the gardens of the Tower of London for Edward I. More trees were planted in the Royal Gardens at Westminster in 1292. The quince was much used in medieval kitchens for making marmalade, jellies and candied fruits, and its popularity continued throughout the next 500 years.

In 1629, Parkinson described six varieties of quince, the three most important being the common English apple-shaped, the Portingall apple and the Portingall pear quince. The pear-shaped variety was, according to Hogg in 1866, the most commonly grown variety, though its flesh was rather dry and woolly. The same opinion was expressed by Downing in the United States about this time. He said that the apple-shaped variety was the most popular. Both types of quince, as well as some more recent introductions, are still grown in many parts of Europe as well as in America. The quince is commonly used as a rootstock for pear trees.

PLATE 58 labelled *The Pear-shaped Quince*

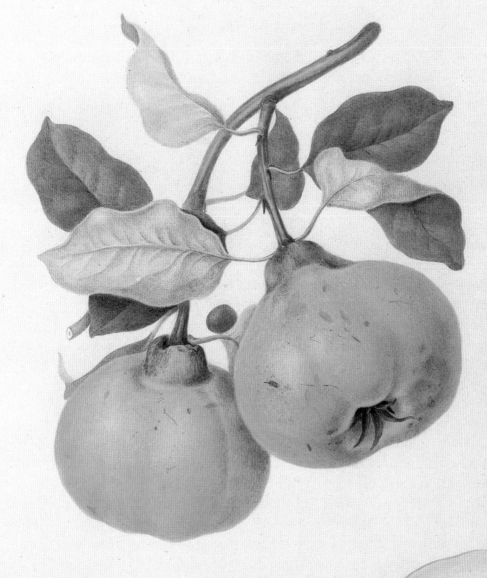

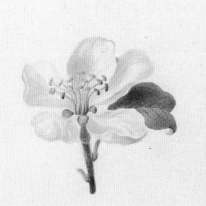

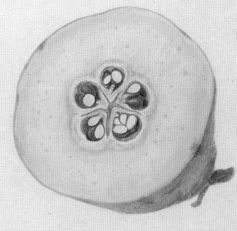

W. Hooker.
1816.

The Pear-shaped Quince.

BIGARREAU CHERRY

Prunus avium Linnaeus Rosaceae

Prunus avium, the species from which the sweet cherries have been derived, grows wild throughout most parts of Europe including Britain. For several thousand years its fruits were collected as food by Mesolithic people in Denmark and the prehistoric lakeside dwellers in Switzerland. Cherries were cultivated in the orchards of Assyria in the eighth century BC and in ancient Greece and Rome. Pliny wrote of improved varieties having been brought from Pontus, a state on the Black Sea, part of Armenia. Sweet cherries had long been part of the basic diet of the people of Pontus. Pliny said that these cherries had been sent to Britain in the first century AD.

Cherries were very popular in England during the Middle Ages and were regularly grown in monastery gardens. By the sixteenth and seventeenth centuries increasing numbers of new varieties became available, many of them brought from Europe. It is difficult to be certain of the origin of the Bigarreau depicted by Hooker as the name was used for so many different types of heart cherries having firm flesh, but this was probably the Yellow Spanish illustrated by Gerard in 1597 and may well have been the Duracina, the hard-berry cherry of Pliny. It was also known as Amber and Graffion. Bigarreau has always been regarded as one of the best-quality cherries, its large fruit having firm, sweet, well-flavoured flesh.

It was imported into the United States in 1802 under the name of Yellow Spanish by the nurseryman William Prince of Flushing. It became widely dispersed and highly thought of by growers. It is still grown in many countries.

PLATE 59 labelled *The Bigarreau Cherry*

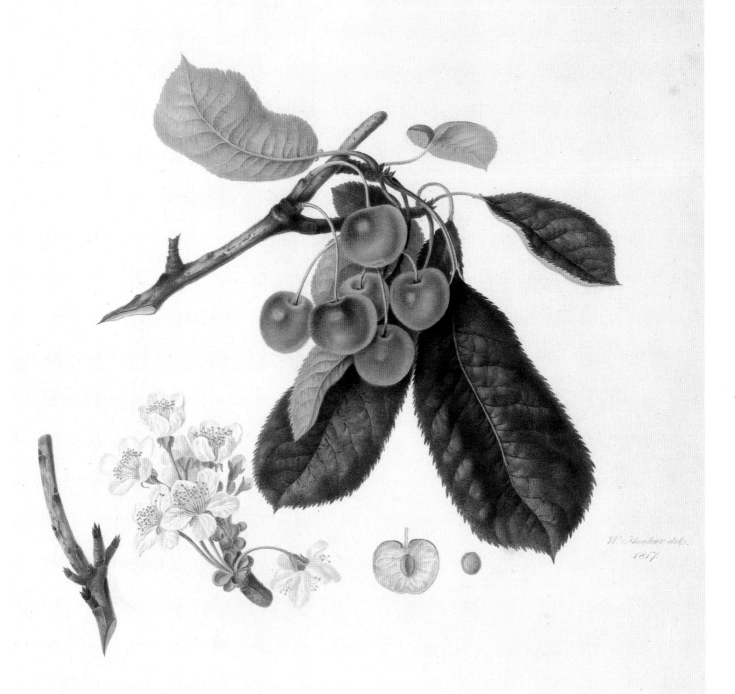

W. Hooker del.
1817

The Bigarreau Cherry

THE MORELLO CHERRY

Prunus cerasus Linnaeus Rosaceae

The acid cherry, *P. cerasus*, from which the Morello has been derived, is found growing wild throughout central and southern Europe and temperate Asia and as far north as Scandinavia. The Morello cherries have been grown for many centuries. Gerard in 1597 wrote that they were called Morelle by the French, who dried them for winter use, and he advised the same treatment. Switzer in 1724 called them the Morella or Milan cherries. In England, as well as being used in cooking and for preserves, Morello cherries had a long history of use for making cherry brandy. In the United States, the Morello has been commonly used as the late sour cherry to follow Montmorency.

The fruits of the Morello hang well on the tree and become progressively darker, blackish-red in colour. The flesh is dark crimson with coloured juice which, though very acid earlier in the autumn, becomes bittersweet as the fruits darken, and of a refreshing flavour. Since they have been grown for such a long time and in many countries of the world, many minor variations have arisen.

PLATE 60 labelled *The Morello Cherry*

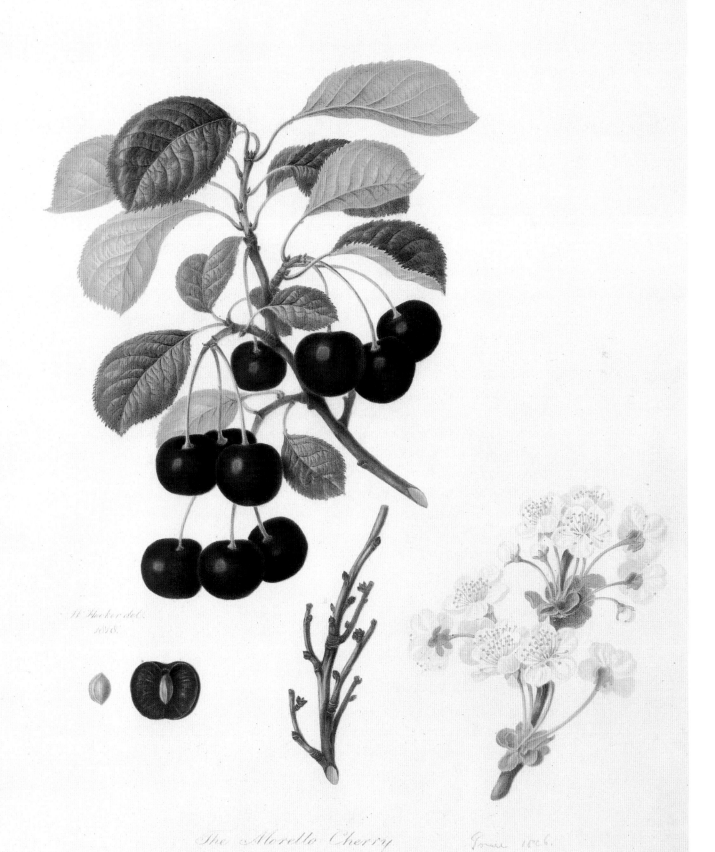

The Morello Cherry

MAY DUKE CHERRY

Prunus cerasus Linnaeus × *Prunus avium* Linnaeus

Rosaceae

The Duke cherries arose as hybrids between the sweet *P. avium* and the acid *P. cerasus*. The Dukes were first mentioned in England by Parkinson in 1629, who, writing of another variety of the same group, the Archduke, said it 'is one of the fairest and best cherries wee have, being of a very red colour ... scarce one in twentie of our Nurserie men doe sell the right, but give one for another: for it is an inherent qualitie almost hereditarie with most of them, to sell any man an ordinary fruit for whatsoever rare fruit he shall ask for: so little are they to be trusted.' This was a common complaint about nurseries in the seventeenth and eighteenth centuries when hundreds of new fruit varieties were introduced.

The Dukes probably had their origin in England since in France they were known as 'Anglais', though others have thought that May Duke is a corruption of Médoc, the province of France where they believe the Dukes originated. William Hooker said that May Duke was the most popular variety, among market gardeners around London, for producing early cherries for Covent Garden and was much cultivated in Brentford and Isleworth. It was also excellent for forcing, and in 1721 Bradley said these cherries were forced under frames and on the market as early as March and April.

May Duke has long been popular in all countries of Europe and in the United States where it was one of the first cherries imported and, in the last century, was among the most planted varieties, very adaptable to soil and climate and especially useful for local markets. The flesh is tender and acid if picked early in the season, but if left to hang on the trees to ripen it becomes sweet and juicy.

PLATE 61 labelled *The May Duke Cherry*

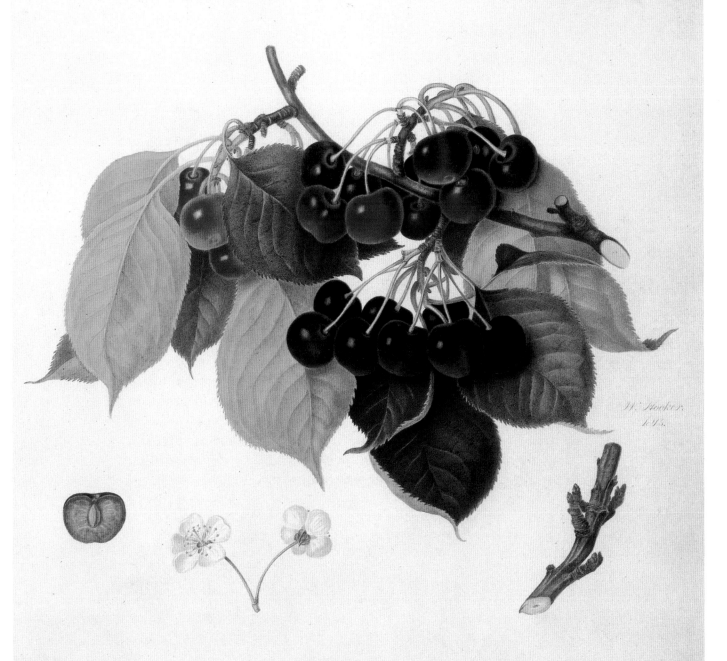

The May Duke Cherry

ELTON CHERRY

Prunus avium Linnaeus Rosaceae

At the beginning of the nineteenth century Thomas Andrew Knight, President of the Horticultural Society, included the breeding of sweet cherries among the many fruits to which he devoted his great abilities at Downton Castle in Herefordshire. Most of the new cherries introduced by him before 1820 proved to be of excellent quality and were soon accepted for growing both in gardens and commercial orchards in England and, after being exported to the United States, several became of first importance there. Knight's cherries are still grown and have maintained their reputation for quality, though they are now being replaced by modern varieties.

All Knight's successful cherries had Bigarreau, the very old but good-quality cherry, as the female parent, pollinated either by the *P. cerasus* × *P. avium* hybrid May Duke, or another old sweet cherry, White Heart. Elton was raised in 1806 from Bigarreau pollinated by White Heart. Knight said he selected it from about fifty seedlings. Its large size, beautiful appearance and excellent flavour were appreciated from its first introduction. Norman Grubb, a cherry expert in England, wrote in 1949 that Elton was commonly regarded as the standard for dessert quality, but was little planted owing to its unreliable cropping.

PLATE 62 labelled *The Elton Cherry*

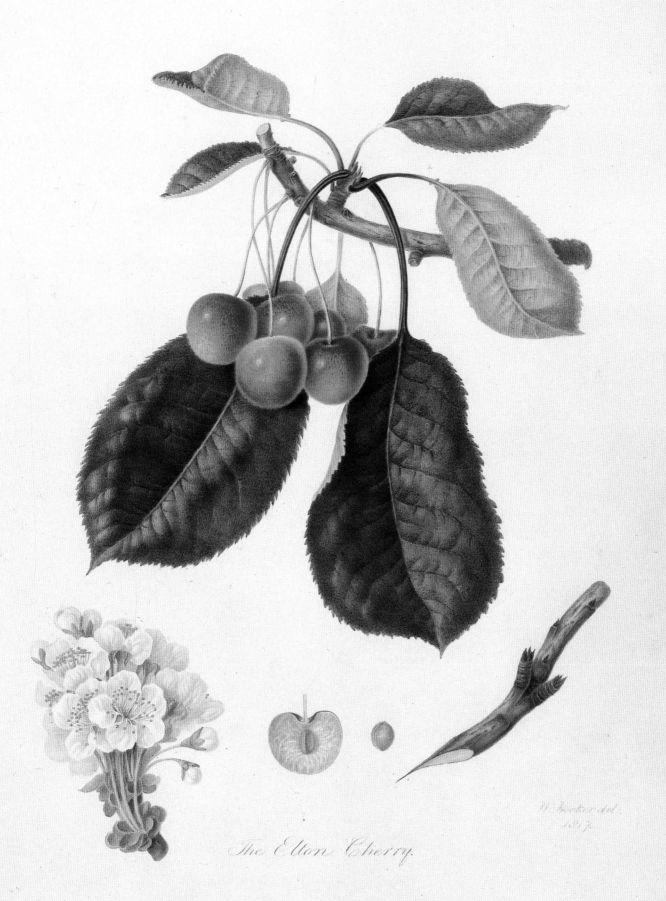

The Elton Cherry.

W Hooker del.
1817.

KNIGHT'S EARLY BLACK CHERRY

Prunus avium Linnaeus Rosaceae

This variety was raised in 1810 by Thomas Andrew Knight from Bigarreau pollinated by May Duke. Fruits were shown to the committee of the Horticultural Society in London in 1818, when the original tree was only eight years old. Like Knight's other introductions, this cherry, which is still grown on a limited scale, is of first-rate quality. It is of large size and has dark purple flesh with a rich, sweet flavour. In England it is ready early in the season, from the middle of June to early July.

According to Hedrick at Geneva, New York, it was sent to the United States in 1821, surprisingly soon after being first shown to the Horticultural Society, and, in 1921, was to be found in home gardens in the eastern States as often as any other variety, with the exception of Black Tartarian; but, in spite of its excellent quality, its low yields generally made it unsuitable for commercial orchards.

PLATE 63 labelled *Knight's Early Black Cherry*

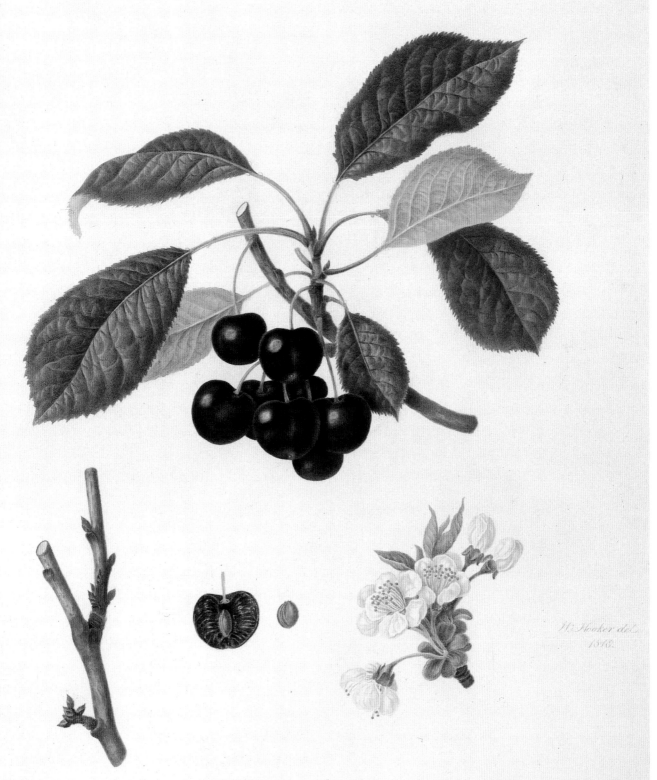

H. Hooker del.
1818.

Knight's Early Black Cherry.

WATERLOO CHERRY

Prunus avium Linnaeus Rosaceae

Waterloo was another cherry bred by T.A. Knight from Bigarreau pollinated by May Duke, a remarkably successful cross which resulted in more good-quality varieties than any other recorded hybrids. It was first shown to the Horticultural Society in London in 1815. Knight said he called the variety Waterloo as the battle, at which Napoleon had been defeated, had been fought a few days before the first cherries ripened.

Ripe at the end of June to early July, this cherry is of medium size, and has firm dark red flesh with a rich and delicious flavour. Until the middle of the present century it was known to all cherry growers in England for its high quality, but it has never been grown on a large scale and was less well known in America than Knight's other varieties. Reasons for its lack of commercial use are the way in which the cherries are scattered along the branches, making picking difficult and expensive, and also the tendency of the fruits to drop right up to the time of picking.

PLATE 64 labelled *The Waterloo Cherry*

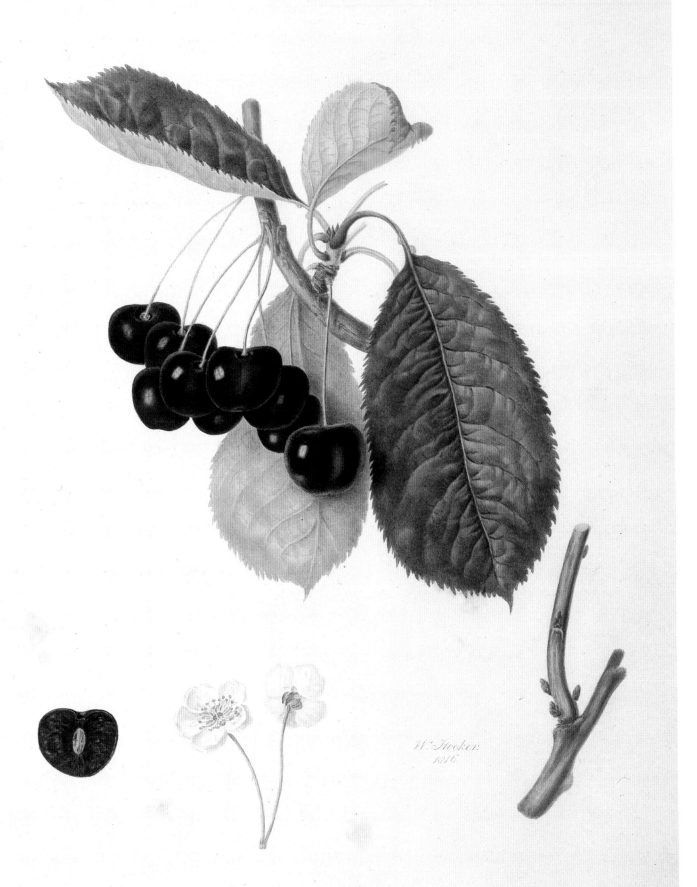

W.ᵗ Hooker.
1816.

The Waterloo Cherry.

BLACK EAGLE CHERRY

Prunus avium Linnaeus Rosaceae

This was another sweet cherry bred by T. A. Knight although he attributed it to his daughter, Elizabeth, who took an interest in his work and helped him with the cherries. Raised in 1806 and introduced about eight years later, it was bred, like Knights's Early Black and Waterloo, from Bigarreau crossed with May Duke.

Black Eagle, which still exists, ripens at the beginning of July, a few days later than Black Tartarian, has deep purple flesh and a rich, highly flavoured juice. Like Knight's other cherries, it was sent to the United States where Hedrick regarded it as one of the best varieties, recommending that it should be planted in every home garden and for local markets which required a high quality fruit.

PLATE 65 labelled *The Black Eagle Cherry*

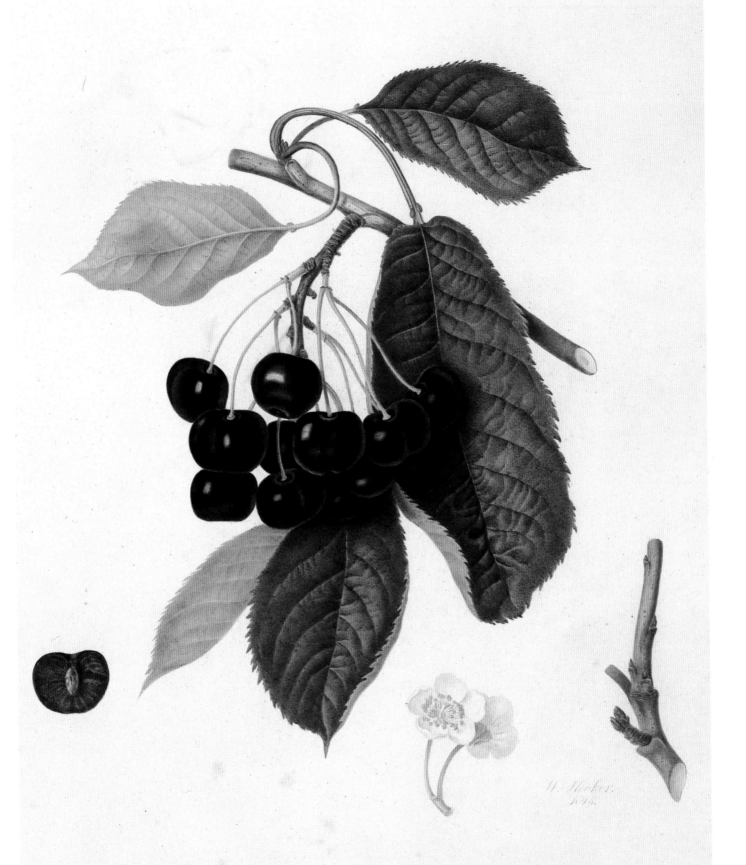

The Black Eagle Cherry

BLACK TARTARIAN CHERRY

Prunus avium Linnaeus Rosaceae

This variety has, at times in the past, been called Circassian which indi-cates its place of origin. The region known as Circassia, at the eastern end of the Black Sea, was important for its cherries in the time of the ancient Greeks. Black Tartarian was said to have been brought by Prince Potemkin, the chevalier of Catherine the Great, from Pontus after the conquest of the Crimea in 1783. The merit of having intro-duced it to England was attributed to a nurseryman, Hugh Ronalds of Brent, London, who in 1794 issued a circular signifying his intention of distributing it at £5 a plant. It was subsequently brought from Russia by John Fraser, distinguished for his botanical discoveries in North America and, later, for his travels to Russia. He purchased it from a German who cultivated it in St Petersburg, and brought it to England in 1796.

Black Tartarian was imported into the United States about 1827 by William Prince of Flushing, Long Island. It is still cultivated both there and in England. However, several different forms of it occur and it is difficult to say which is the original. It has always been liked for the good size, quality and attractive appearance of its fruit.

PLATE 66 labelled *The Black Tartarian Cherry*

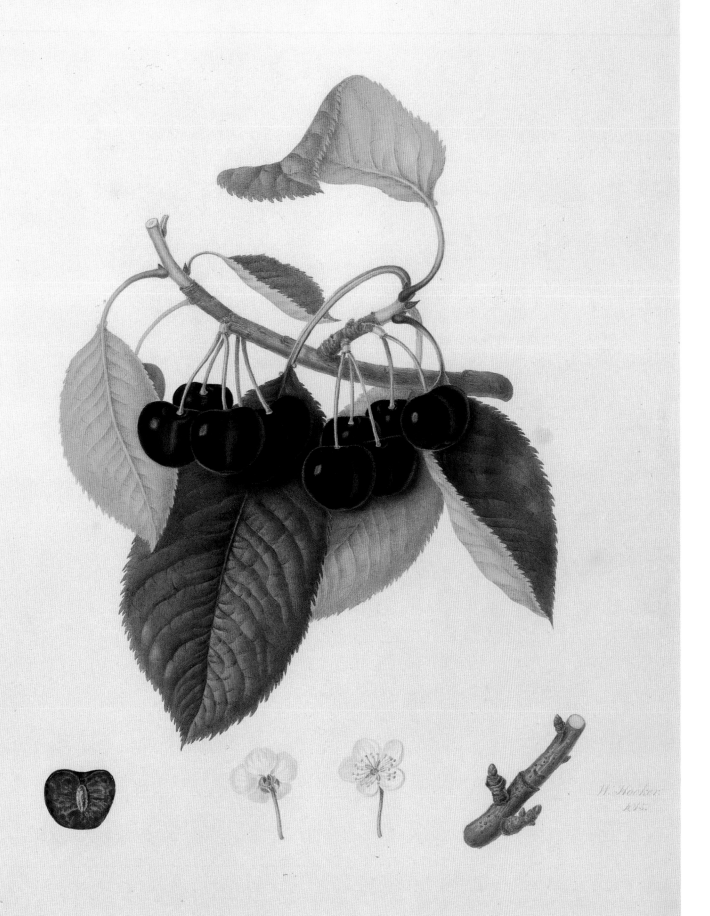

W. Hooker
1815.

The Black Tartarian Cherry.

FLORENCE CHERRY

Prunus avium Linnaeus Rosaceae

At the time of its introduction to England during the eighteenth century, this cherry was well known to visitors to Florence, commonly under the name Du Hamel though incorrectly so since the latter, while very similar in some characters, shows distinct differences in others.

The first two trees of Florence were brought to England by Houblon who planted one in the garden of one of his houses, the Priory, in Essex. Richard Vachell who later lived in the house took grafts from this tree and gave some of the trees he raised to his friend Calvert, who planted them at Parsonage House, Hudson, Hertfordshire. It was Calvert who sent fruits and grafts to the Horticultural Society.

Florence is a good-quality late mid-season cherry which hangs well on the tree. It has very firm flesh, is juicy and pleasantly flavoured and has been a favourite in many orchards during the present century.

PLATE 67 labelled *The Florence Cherry*

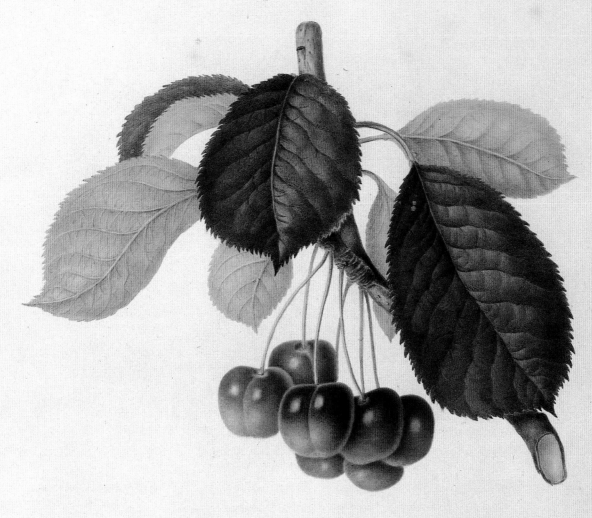

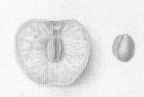

The Florence Cherry.

THE TRADESCANT CHERRY

Prunus avium Linnaeus Rosaceae

This sweet cherry was introduced to England about 1611 by John Tradescant the Elder (*c.* 1570–1638) when he was in charge of the gardens at Hatfield House in Hertfordshire and bought many fruit trees and other plants in the Netherlands for his master Robert Cecil, first Earl of Salisbury. In 1618 he accompanied an expedition to Archangel in northern Russia, and in 1620 another to Algeria and Morocco. In 1630 he was appointed Keeper, by Charles I, of His Majesty's Gardens at Oatlands in Surrey. This cherry must have become popular fairly quickly as in 1629 Parkinson said that it was often used as a substitute in nurseries for Archduke, since it was more easily propagated. However, buyers would not complain as it was itself of good quality, large and deep-coloured, and it cropped well.

Tradescant's cherry continued to be of importance for the next three centuries, being generally known as Tradescant's Heart. After it had been exported to the United States it was seen growing in a garden in Maryland about 1830 by the nurseryman William Prince, and he distributed it as Elkhorn. Early in the present century it was reintroduced in England under the name of Noble and is still grown under that name.

It is a large, firm-fleshed cherry with a very rich flavour and has always been appreciated for its good quality and the way it hangs well on the tree.

PLATE 68 labelled *The Tradescant Cherry*

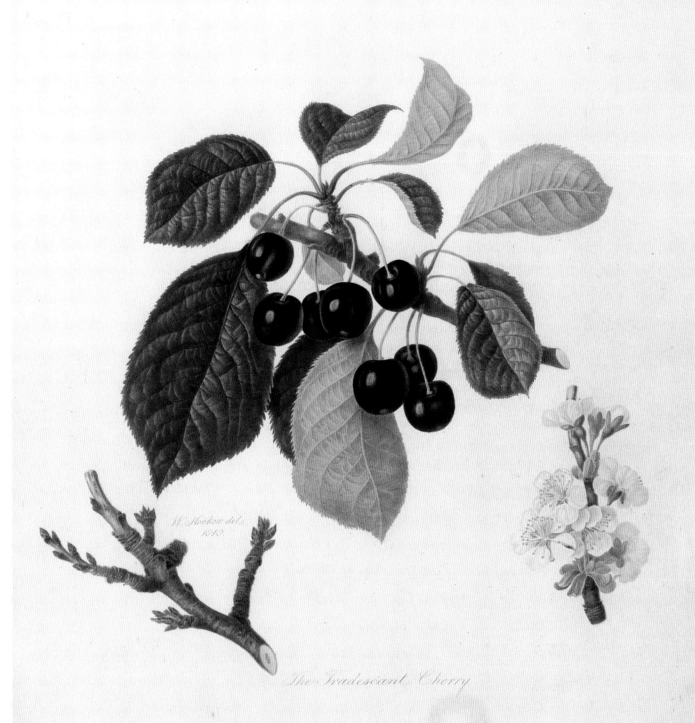

W. Hooker del.
1818

The Tradescant Cherry

DUTCH MEDLAR

Mespilus germanica Linnaeus Rosaceae

The medlar is found growing wild in hedges and thickets from central and southern Europe to the Caucasus and in the countries of Asia Minor, but is considered to have originated in Transcaucasia. It seems to have been taken to the United States by the French Jesuits. In Florida it is commonly used as a hedge plant.

Mespilus is closely related to *Crataegus*, the hawthorn, but is distinguished by its very large flowers. Medlars were cultivated by the Assyrians, introduced to Greece and thence to Rome. The two varieties, the Dutch and the Nottingham, which are both still grown, are probably direct descendants of the Roman varieties, Setania and Anthedon. A single medlar seed was found on a Roman site at Silchester in England and it is likely that they were grown for many years before the first written record of this fruit which was in a list, in 1270, of fruits the gardener monk had to produce for Westminster Abbey.

Medlars are normally left on the trees in autumn until they become brown and half rotten inside, and, by tradition, were eaten thus at the end of a meal with a glass of port. Their flavour is disliked by many people and although they had limited popularity in the Middle Ages in England, few are now grown.

PLATE 69 labelled *The Dutch Medlar*

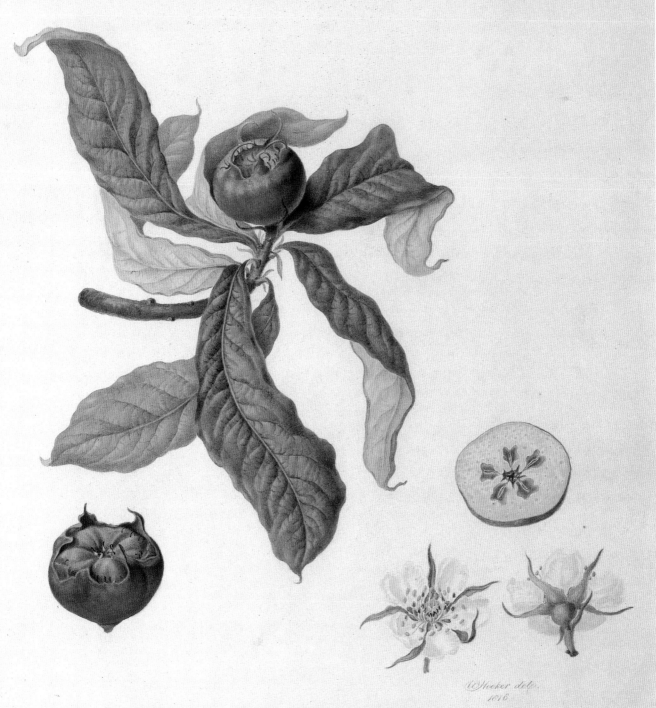

The Dutch Medlar.

W.Hooker delt.
1816

NOTTINGHAM MEDLAR

Mespilus germanica Linnaeus Rosaceae

Medlars are still fairly common in the markets of France and Germany. In France they were the basis of the famous preserve made in Orléans, known as *cotignac*, which was always offered to the Sovereign when he entered the city and was the first present made to Joan of Arc when she led her troops into Orléans.

The lack of general demand for medlars, the tree being as much grown for the beauty of its large white flowers as for its fruit, meant that little attempt has been made to improve the latter by breeding. The large-fruited Dutch has been recorded under this name since the seventeenth century and, though the first reference to the Nottingham in England was in nursery lists over 100 years later, it is probable that this was simply a new name for the old Neapolitan medlar which had been grown for many centuries and had been described by Gerard in 1597.

The Nottingham has smaller fruits than the Dutch but has always been considered to have the better flavour.

PLATE 70 labelled *The Nottingham Medlar*

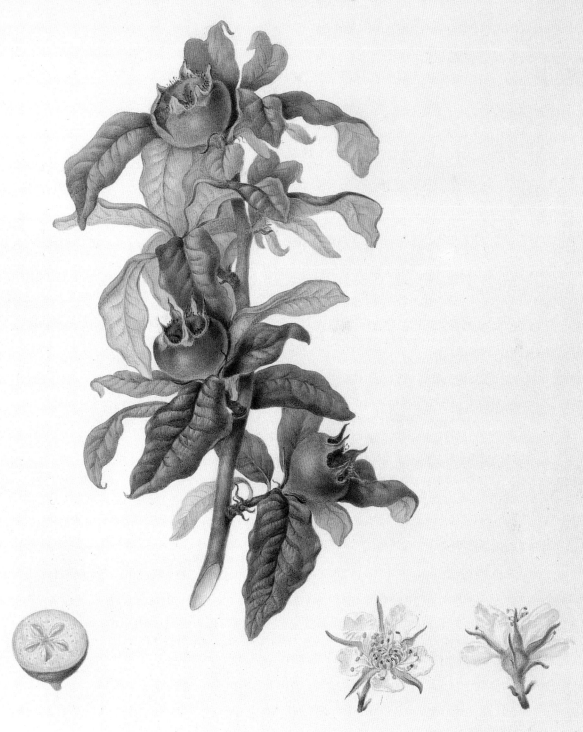

W. Hooker del.
1816.

The Nottingham Medlar.

PEAR-SHAPED SERVICE

Sorbus domestica var. *pyrifera* Hayne Rosaceae

The wild service tree grows in the woods of eastern and southern Europe and as far as the Caucasus and parts of North Africa. There are two main varieties of the cultivated form, the pear-shaped and the apple-shaped. The pear-shaped service trees are distinctive for their comparatively large pear-shaped fruits, which are green speckled with brown and become reddish when exposed to the sun.

Pliny mentioned four varieties of service, including both the pear-shaped and apple-shaped. Gerard, in 1597, said that the fruits could be eaten but only some time after they had been picked and had been allowed to become mealy, as is done with medlars whose taste they somewhat resemble. Forsyth in 1806, writing of the cultivated pear- and apple-shaped service, said that the trees were well worth growing, both for their fruit and as an ornament in the garden or orchard. They were beautiful when in flower in June, while the fruits in autumn were of fine appearance and grew to a large size if the trees were thinned and not overloaded with wood. He suggested gathering the fruits when ripe and putting them in the fruit room until nearly decayed when they would provide a useful addition to other fruits at table. He said the wood of the trees was very useful for making picture frames and toys. Loudon wrote that the fruits were eaten in some parts of Scotland and Wales and were used to produce a pleasant fermented liquor which could be distilled to give a strong spirit.

PLATE 71 labelled *The Pear-shaped Service*

[164]

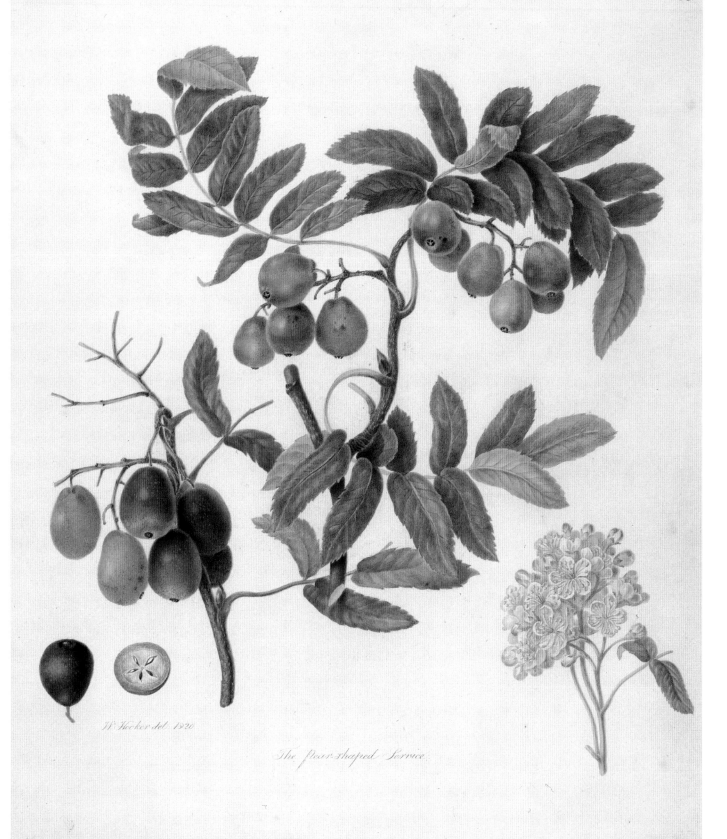

W. Hooker del. 1820.

The pear-shaped Service.

CHILI STRAWBERRY

Fragaria chiloensis Linnaeus Rosaceae

Fragaria chiloensis is the common species of strawberry growing wild from Alaska to California and in South America from Peru to Patagonia. It was the South American form, which differs slightly from those of North America, which played a major part in the development of modern, large-fruited varieties. The Chilean strawberry has larger berries than any of the other species and it was its size and appearance which attracted a French naval officer, Captain A.F. Frézier (1682– 1773), in 1712 when he found it growing on Concepción Isle in Chile. He collected some of the plants and managed to get five back to France, two of which he gave to the Royal Gardens in Paris. These plants required pollinating by another variety or species in order to set fruit and this was probably the reason why they did not at first attract much attention. From France, plants were taken to Amsterdam in Holland and from there sent to the Apothecaries' Garden at Chelsea in London in 1727.

With suitable pollination, *F.chiloensis* produced berries large in comparison with any others grown in the early nineteenth century and, although they had little aroma or colour, their large size made them a commercial success around London and the Brest area of France. It was the hybridization of the Chili strawberry with the American *F.virginiana* that resulted in the development of the large-fruited varieties of better quality.

PLATE 72 labelled *The Chili Strawberry*

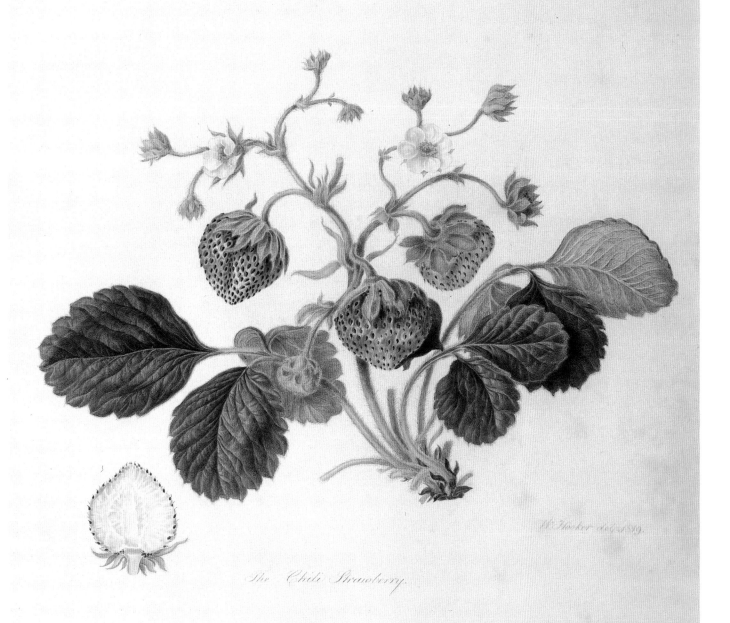

W. Hooker delt. 1819.

The Chili Strawberry.

ROSEBERRY STRAWBERRY

Fragaria virginiana Duchesne Rosaceae

The introduction to Europe at the beginning of the seventeenth century of the Virginian Strawberry, *F. virginiana*, a species native to the eastern part of North America where it commonly grows in woodlands and hedgerows, was an important stage in the production of strawberries, especially in Britain, as prior to this the small-berried wood strawberry, *F. vesca*, had been mainly used. In comparison with this, *F. virginiana* had larger berries, juicy and sweet and of very good flavour.

Many seedlings were raised from seed imported from North America and Canada but it was about 100 years before any named varieties of note appeared. Generally these were not regarded as having such good flavour as the original Virginian Scarlet but they were in demand for forcing and early marketing. The Roseberry was one of these *F. virginiana* derivatives. It arose about 1808 as a chance seedling under a rose bush in the garden of Robert Davidson of Aberdeen, hence its name. He gave plants to Messrs Cadenhead who distributed runners in the Aberdeen area, where it became popular, and in 1815 packets of the plants were sent to the London markets. While its general appearance was similar to the Common Scarlet, it was of rather better size, had firmer flesh and produced flowers in succession over a longer period, sometimes extending into August.

Roseberry was also tried in the United States but did not meet with much favour and in Britain it went out of production once larger-fruited varieties were introduced.

PLATE 73 labelled *The Roseberry Strawberry*

[168]

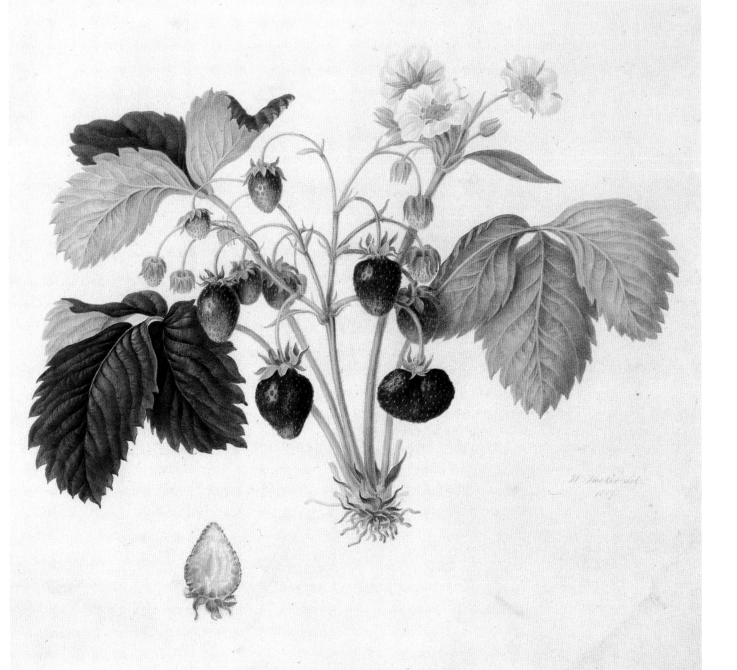

The Roseberry Strawberry.

WILMOT'S LATE SCARLET STRAWBERRY

Fragaria virginiana Duchesne, derivative Rosaceae

This strawberry was raised by John Wilmot, a noted nurseryman of Isleworth, London, about 1810. It was one of a number of new varieties introduced by Wilmot who was responsible for breeding many valuable strawberries, including Black Prince and Wilmot's Superb, the latter being the largest-berried strawberry produced during the early years of the nineteenth century. His Late Scarlet was a derivative of the North American species, *Fragaria virginiana*, liked for its good flavour though of limited size.

At the time of the introduction of Wilmot's Late Scarlet, the cultivation of strawberries was especially important with market gardeners around London as they had a ready sale for every kind of strawberry, even the most inferior. Unfortunately, the better-flavoured varieties such as the Scarlets were mostly either less productive or had a shorter season than the poorly-flavoured Chilean strawberry, so the latter dominated the markets.

The Committee of the Horticultural Society selected Wilmot's Late Scarlet for recommendation as having strong claims, including hardiness of growth and fertility, combined with a beautiful appearance and fine flavour. Before its introduction, John Wilmot had successfully grown this variety for market and many other growers had shown that it was well adapted to replace the commonly cultivated Old Scarlet. It started cropping at the end of June and its succession of flowers extended the picking until August. The berries, though not large, had soft flesh of excellent flavour and were well suited for use in making ice cream, an important requirement at this time.

PLATE 74 labelled *Wilmot's Late Scarlet*

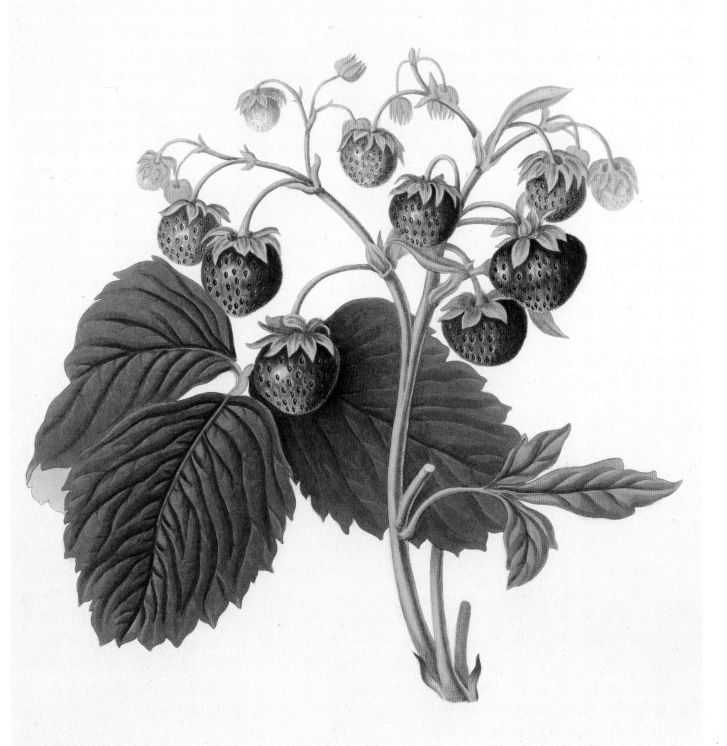

Wilmot's Late Scarlet.

PINE STRAWBERRY

Fragaria hybrid Rosaceae

The first important derivatives of *Fragaria chiloensis* during the middle
of the eighteenth century were the pine varieties. There was some con-
fusion over the precise origin of these varieties, but by this time the
strawberry industry in the north-west area of France had been consider-
ably expanded using the infertile *F. chiloensis* grown with varieties of
the Hautbois *F. elatior* and the Virginian strawberry *F. virginiana*. In
this way satisfactory crops were obtained and a number of new varieties
developed, some of which came fairly true from seed. One of these,
Fruitilles, which was sent in 1764 from Cherbourg to the Royal Garden
at the Trianon, was, according to the French botanist Duchesne, a true
pine.

The Pine strawberries were noteworthy for their relatively good
size and very firm, pale red flesh, having a rich, so-called pine flavour.
A number of other pine varieties were introduced during the latter part
of the eighteenth century and in the London markets they were con-
sidered of much better quality than the poorer, but large, Chili straw-
berries which dominated the markets at the beginning of the nineteenth
century.

PLATE 75 labelled *The Pine Strawberry*

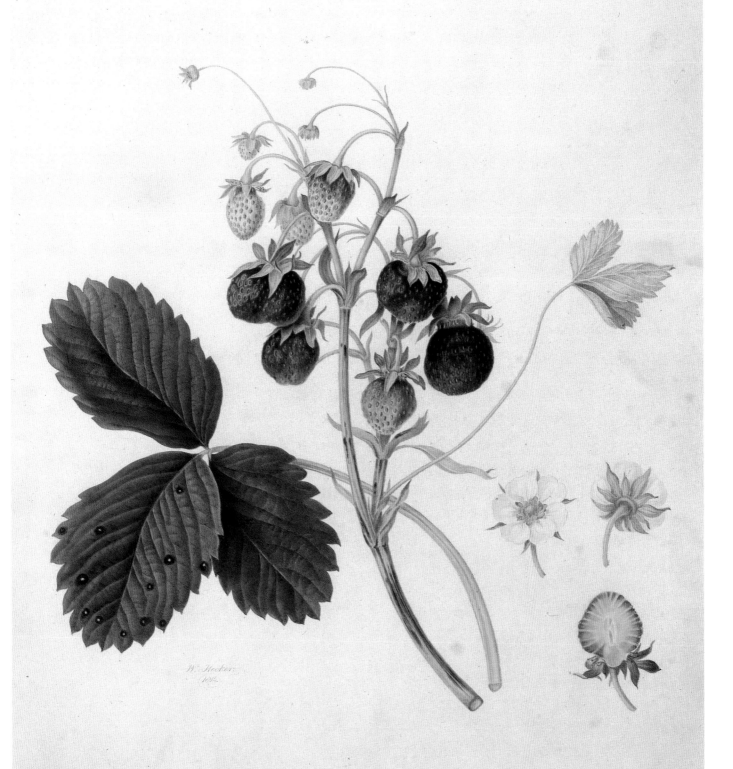

W Hooker
1814

The Pine Strawberry.

DOWNTON STRAWBERRY

Fragaria hybrid Rosaceae

This strawberry is one of the many fruits raised by Thomas Andrew Knight who, in 1811, became President of the Horticultural Society of London. He contributed more to the breeding of new varieties of fruits than any other person in his time. He approached the breeding of plants scientifically, choosing both parents with care, whereas, in the past, insufficient attention had been paid to the source of pollen.

During the early years of the nineteenth century there was intense interest in raising new varieties of a number of fruits, especially strawberries. The hybridization between *F. chiloensis* derivatives and those of *F. virginiana* was the turning point in strawberry production. Knight's success with strawberries was less than with cherries but his Elton Pine and Downton remained in use for many years. Downton was bred in 1817 from Knight's Large Scarlet, derived from Virginian Scarlet pollinated by Old Black. It was a late variety of moderate size, heavy cropping, a dark scarlet colour, highly aromatic and of good flavour, useful for dessert and preserving.

It was exported to the United States in 1825 and was popular there for a few years.

PLATE 76 labelled *The Downton Strawberry*

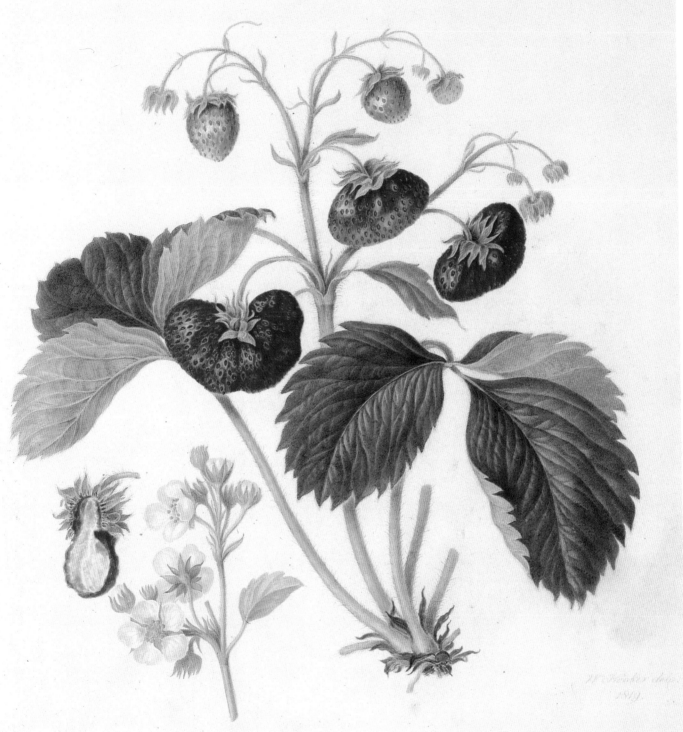

The Downton Strawberry.

W. Hooker del.
1819.

YELLOW ANTWERP RASPBERRY

Rubus idaeus Linnaeus Rosaceae

Rubus idaeus is widely distributed in many countries of the western world, in the woods of Europe, and in the temperate parts of Asia. In America the species *R. strigosus* has been of major importance. *R. idaeus* is native to Britain. Its seeds have been discovered in deposits of the late glacial period in Scotland and on several Bronze Age sites in the south of England. Although not cultivated by the Greeks or Romans, the berries were often collected from the wild and their seeds have been found on Roman sites in Britain.

The wild berries were used in medieval times for making into drinks, but it was not until the sixteenth century that the cultivation of raspberries in gardens was reported. Parkinson, in 1629, said there were only two kinds, a red and a white, both selected from the wild. By the end of the seventeenth century a larger form of red raspberry was being grown and the fruits became very popular both for dessert and for making wines and other drinks.

Yellow Antwerp, the first of the comparatively large raspberries to be grown in England, was given to the son of Lord Middleton about 1783 by the Governor of Antwerp, and grown by his father in Yorkshire. It had originally come from Hungary. By 1788 it was listed by a London nurseryman. Yellow Antwerp had large berries with a mild sweet flavour and strong-growing, vigorous canes, very different from the old raspberries. It often produced a second crop in autumn.

PLATE 77 labelled *The Yellow Antwerp Raspberry*

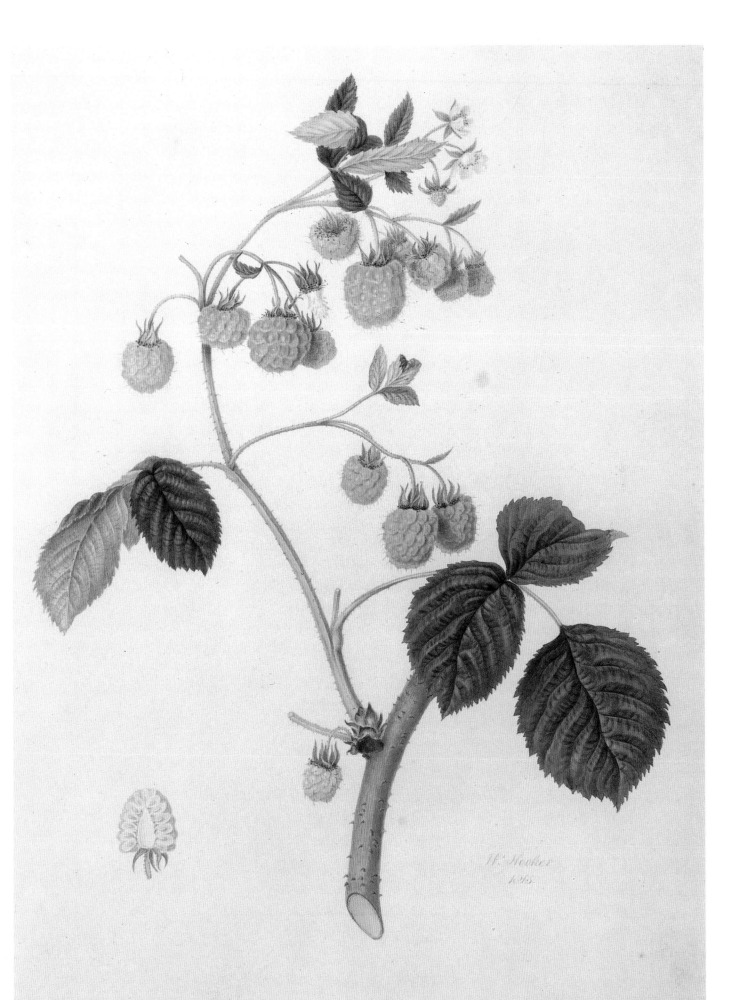

The Yellow Antwerp Raspberry

RED ANTWERP RASPBERRY

Rubus idaeus Linnaeus Rosaceae

The introduction of the large-fruited Yellow Antwerp raspberry into commerce in England came at a time, in the early nineteenth century, when there was considerable interest in the breeding of new and improved forms of both strawberries and other berried fruits. Its characters of large fruits and good growth of canes had a marked influence on the new varieties introduced at this time. The first of these was Red Antwerp, raised by Cornwall of Barnet, London, who named it thus because the berries grew as large as those of Yellow Antwerp. Cornwall also introduced another variety which he called Barnet after his own district, and which had even larger fruits. This and Yellow and Red Antwerp had a long period of popularity and were still in cultivation during the first half of the present century.

Red Antwerp's berries are early and have a rich sweet flavour, and it produces vigorous, smooth canes. It was exported to America where it also became popular and was widely planted in many parts of the country, though most of the red raspberries in the United States have been developed from *R. strigosus* which is hardier than *R. idaeus*.

PLATE 78 labelled *The Red Antwerp Raspberry*

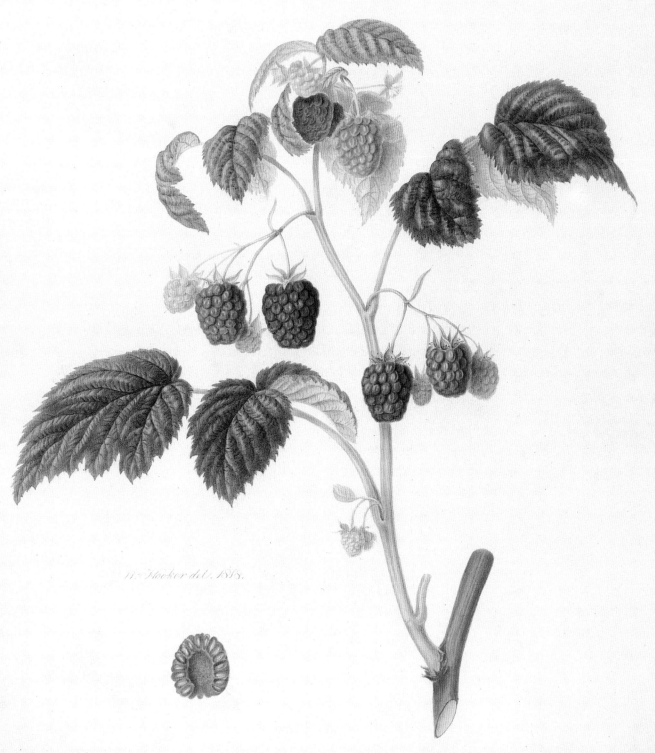

W. Hooker delt. 1818.

The Red Antwerp Raspberry.

BLACK HAMBURGH GRAPE

Vitis vinifera Linnaeus

Vitaceae

The grape traditionally grown in Europe, *V.vinifera*, has been known for many thousands of years in the Middle East and in North Africa. It is found growing wild over a very wide area but it is likely that it originated in Asia Minor and the Caucasus region.

Grapes were recorded as being grown in Canaan in Israel about 2400 BC and vineyards existed in Egypt in 2200 BC. The Greeks and Romans cultivated grapes for wine and for sale fresh. At the time of the Roman occupation of Britain there is evidence that grapes were grown on a limited scale in England, and in AD 731 the Venerable Bede wrote that they were grown in both England and Ireland. From that time on, vineyards for wine became of increasing importance in Britain, especially after the Norman Conquest in 1066.

Black Hamburgh is a very old variety. It was imported to London by John Warner, a merchant, early in the eighteenth century, from Hamburg, and planted in his garden at Rotherhithe. It was and still is grown on a very wide scale throughout Europe and in the United States, and has been known under many synonyms, most of which were German, indicating a German origin. It was recommended for planting by Thomas Hitt in 1757. The famous vine growing at Hampton Court, London, is a Black Hamburgh planted in 1769 and it is still cropping heavily. The bunches are large, their skin thin and the grapes sugary and highly flavoured.

PLATE 79 *The Black Hamburgh Grape*

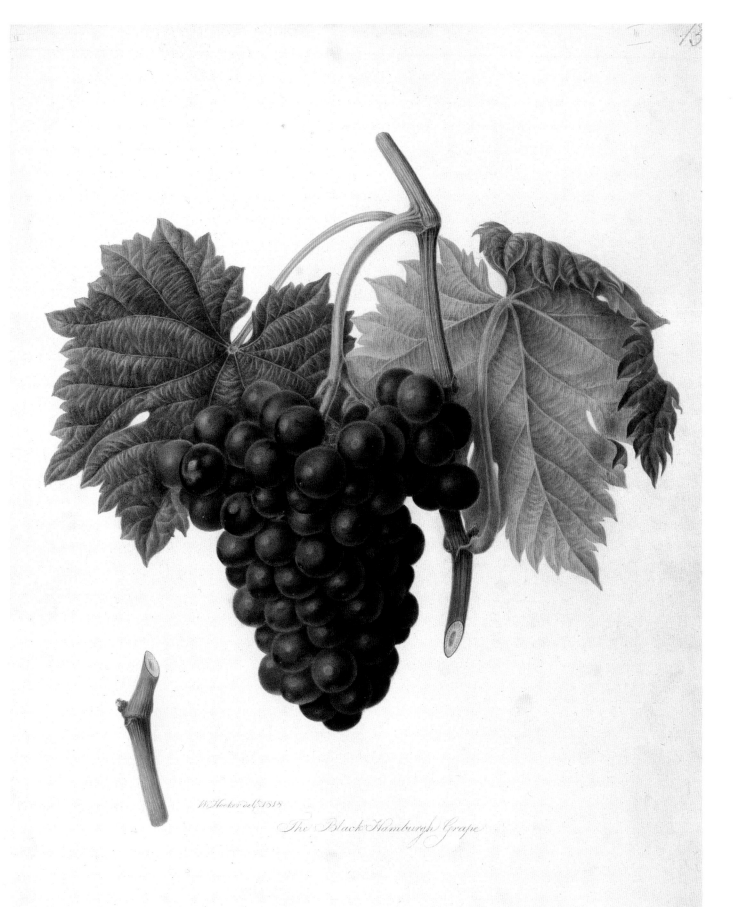

W. Hooker del. 1818.

The Black Hamburgh Grape

ESPERIONE GRAPE

Vitis vinifera Linnaeus Vitaceae

There is no evidence of the origin of this grape but it was brought to the attention of the Horticultural Society in London in 1818 by John Aiton, gardener to Her Majesty Queen Charlotte at Windsor. He said he had obtained it from Richard Williams, a nurseryman of Turnham Green, about 1804, and planted three vines at Windsor where, within four years, they were carrying heavy crops. He found it prolific to an extraordinary degree, which was also the opinion of Downing in the United States where it was first imported about the middle of the last century. Downing said that it was very hardy and grew well outside and he thought it justified more general cultivation. Esperione was also recommended in the English nursery list of Lawson in 1865 but in spite of this seems to have lost favour later in the century.

This grape was sometimes confused with Black Hamburgh but was distinguished from the latter by the fact that its leaves died off with a rich purple colour. It was of first quality with large, quite round grapes, firm, juicy, sweet and briskly flavoured.

PLATE 80 labelled *The Esperione Grape*

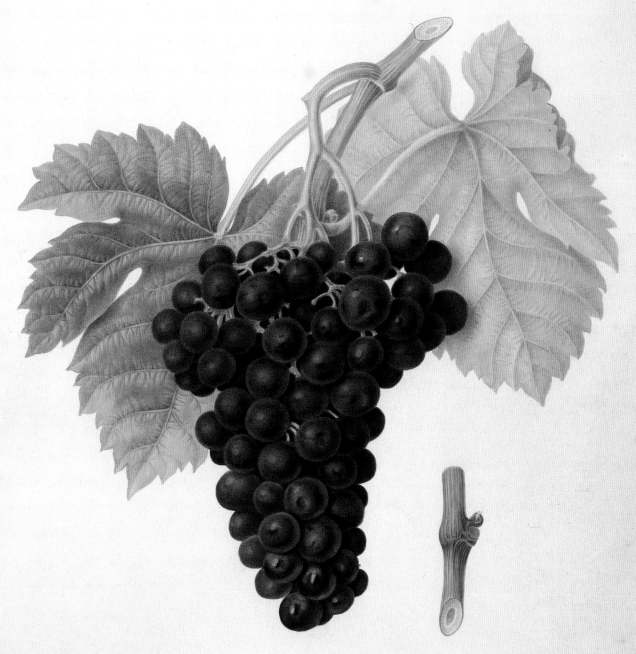

W. Hooker del.
1817

The Esperione Grape.

RAISIN DES CARMES GRAPE

Vitis vinifera Linnaeus Vitaceae

Hooker said that this variety had long been cultivated in gardens and so may have received other names, but it was not under any other names in nurserymen's catalogues. Forsyth, in 1826, described it under Raisin des Carmes but in his list of additional varieties worth growing included West's St Peters. All writers and nurserymen throughout the rest of the century described West's St Peters and said Raisin des Carmes was a synonym for it. The explanation seems to lie in the fact that although, as Loudon said in 1834, West's St Peters had been introduced in 1780 by West, the latter had really re-introduced the already established Raisin des Carmes under his own name, as was often done by growers and nurserymen in the past.

All writers agreed that this was a good-quality late variety, with large, well-flavoured berries having almost black skin. A special characteristic of the variety was that, like Esperione, the leaves turned purple in the autumn before falling. To ripen satisfactorily, even in glasshouses, it required additional heat.

In the United States, Downing described West's St Peters under yet another synonym, Black Lombardy, which was also occasionally used in England. Although it was still in existence earlier in the twentieth century, it has never regained a position of any importance.

PLATE 81 labelled *Le Raisin des Carmes Grape*

[184]

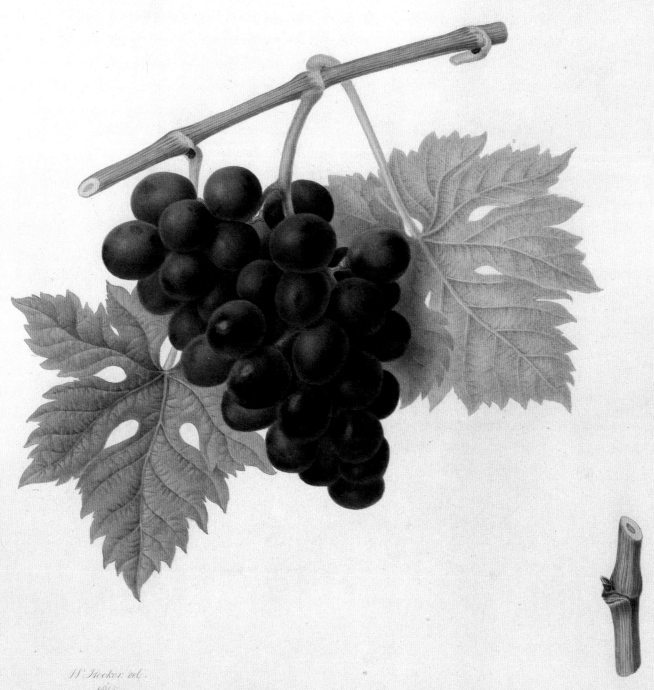

Le Raisin des Carmes Grape

VERDELHO GRAPE

Vitis vinifera Linnaeus Vitaceae

This grape was imported to England about 1807 by John Williams of Pitmaston, near Worcester, from the island of Madeira where it was a celebrated grape used in the production of Madeira wine. This variety was one of several grown in the vineyards but was among the few especially famous for the quality of their wine.

Williams told the Horticultural Society, in 1816, that he found the grapes very acid until they reached full maturity when they turned to a fine amber colour and developed a rich, saccharine flavour. The bunches and berries were small and it was not a variety worth growing in England except as a curiosity.

At a later meeting of the Society, the President, T. A. Knight, said he had grown this grape in a greenhouse and found it tolerated shade well. He suggested it might well be grown in southern parts of Africa and could be of benefit to the British Empire since it was an abundant producer and had the reputation of excellence from Madeira.

As in most of the grape-growing regions of Europe, attacks by the insect *Phylloxera vitifolia* virtually stopped production of Madeira wine in the 1870s. Later replanting of the vines on *Phylloxera*-resistant American rootstocks partly restored production but most of the grapes planted were inferior to the classic varieties: Sercial, which gives a full, dry wine, Verdelho, dry but richer and fuller, Bual with a slight sweetness and Malmsey, a soft, sweet wine. These varieties are still grown today.

PLATE 82 labelled *The Verdelho grape*

[186]

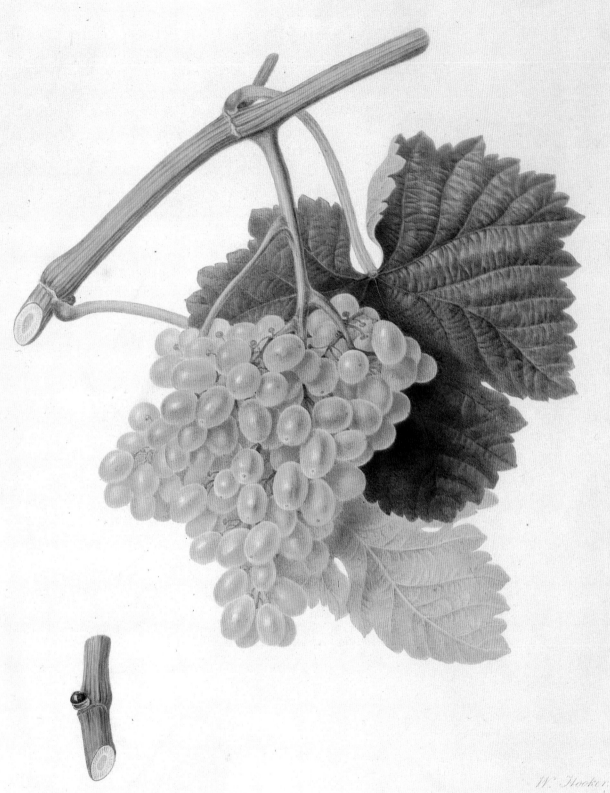

W. Hooker. 1816.

The Verdelho Grape.

BLACK FRONTINIAC GRAPE

Vitis vinifera Linnaeus Vitaceae

Black Frontiniac is a variety which for many hundreds of years had a reputation as an excellent grape. It was also known as Black Frontignan as it had its origin in the town of that name in the south of France where it, and similar varieties, have long been used for making muscadine or muscat wine. The Frontignan region produces the most famous of these wines.

Many different types of grape were included under the name of Frontignan, and it seems to have been used as a general classification for a wide range of individually-named muscat grapes. For example, Lawson in 1865 listed thirteen varieties in this group.

As well as being grown in many parts of Europe and in England, Black Frontignan was also exported to the United States where the grapes were appreciated for their rich, musky flavour, thin skins and firm, red flesh.

In England this grape was recommended by most writers in the seventeenth and eighteenth centuries, including John Rose in 1666 and Bradley in 1739. In 1724 Switzer said the Frontiniacs were so well known and widely grown that it was hardly necessary to describe them. In England they are no longer grown but these muscat grapes are still of importance in wine-producing countries.

PLATE 83 labelled *The Black Frontiniac Grape*

[188]

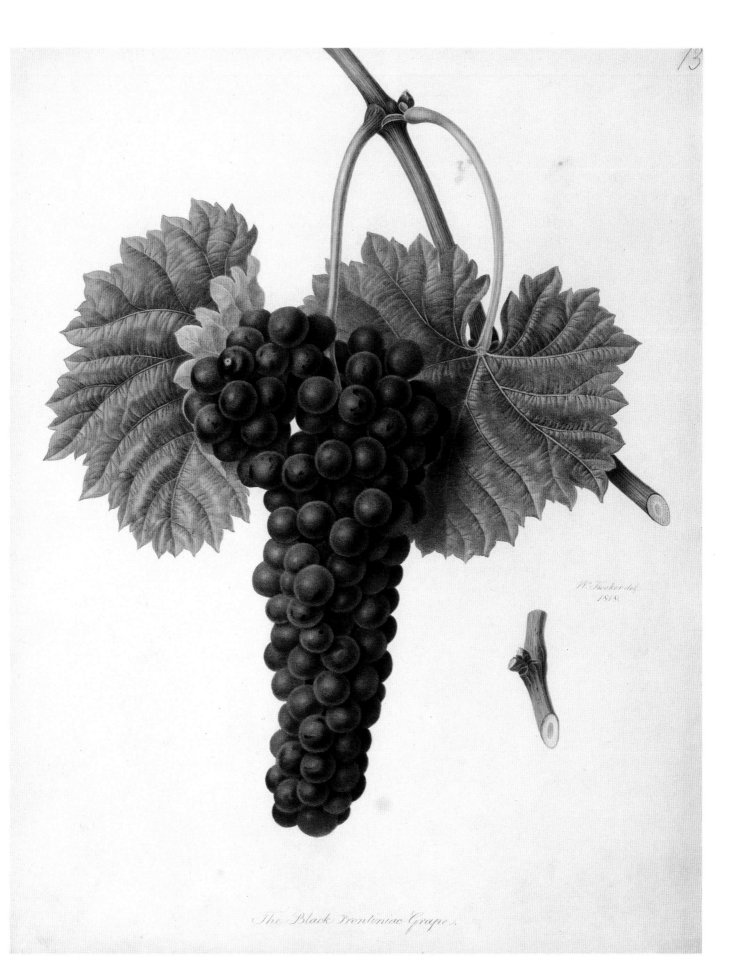

13

W. Hooker del.
1818.

The Black Frontiniac Grape.

BLACK CORINTH GRAPE

Vitis vinifera Linnaeus Vitaceae

It is from the Black Corinth grape that dried currants are produced, and the word 'currant' is simply a corruption of 'Corinth'. These grapes are grown around Corinth and in the Greek islands of Zante and Cephalonia. In the past the grapes were gathered and simply dried on the ground in the sun, which accounted for the small stones and grit often found among the currants.

Black Corinth was reported as having been brought to England in 1582 following the opening of trade with the island of Zante. It was grown in England only as a curiosity, because of the smallness of its fruit. The bunches are small and compact and the grapes often not much larger than peas. Their flesh is juicy and sweet, richly-flavoured and without seeds.

PLATE 84 labelled *The Black Corinth Grape*

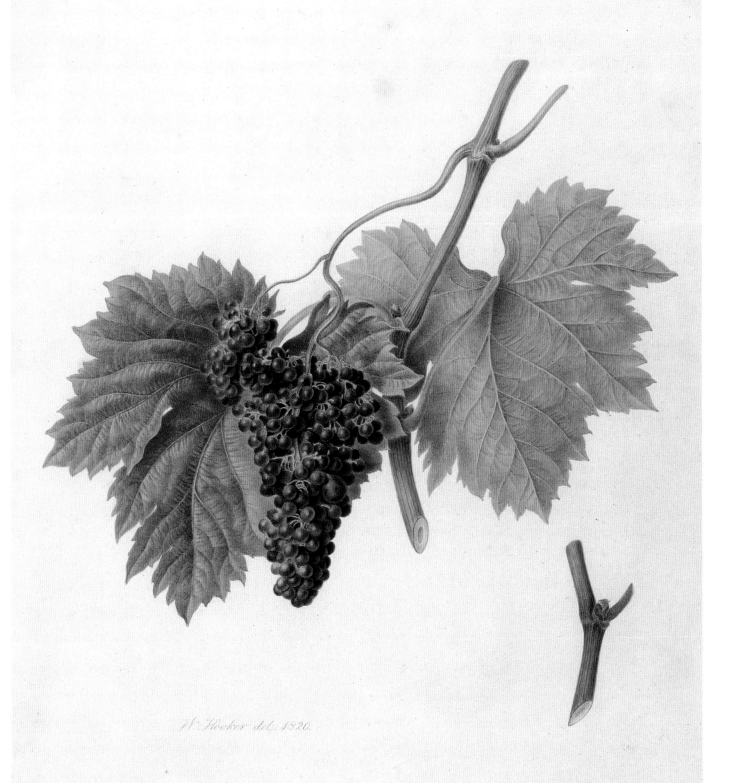

W. Hooker del. 1820.

The Black Corinth Grape.

BLACK PRINCE GRAPE

Vitis vinifera Linnaeus Vitaceae

Black Prince was probably of Italian origin. The first recorded figure of it was in 1763 by Knoop. It was popular in England for about 100 years and its good quality made it valued for exhibition. William Hooker said that many people considered it as equal, if not superior, to Black Hamburgh. The grapes had rather thick skins and were covered with bluish bloom. Their flesh was greenish-white, tender, very juicy and of a rich, sugary flavour. The fact that it had over 100 synonyms throughout Europe was evidence of its popularity during the last century.

In the United States, Downing in 1857 said Black Prince was very highly esteemed, being hardier than Black Hamburgh and cropping well in the open air, having large excellently flavoured berries. About the same time in England, the nurseryman Lawson in 1865 also considered this variety valuable for its hardiness and good cropping, but though it continued to be grown for some years, it gradually lost its popularity and has been little seen in the present century.

PLATE 85 labelled *The Black Prince Grape*

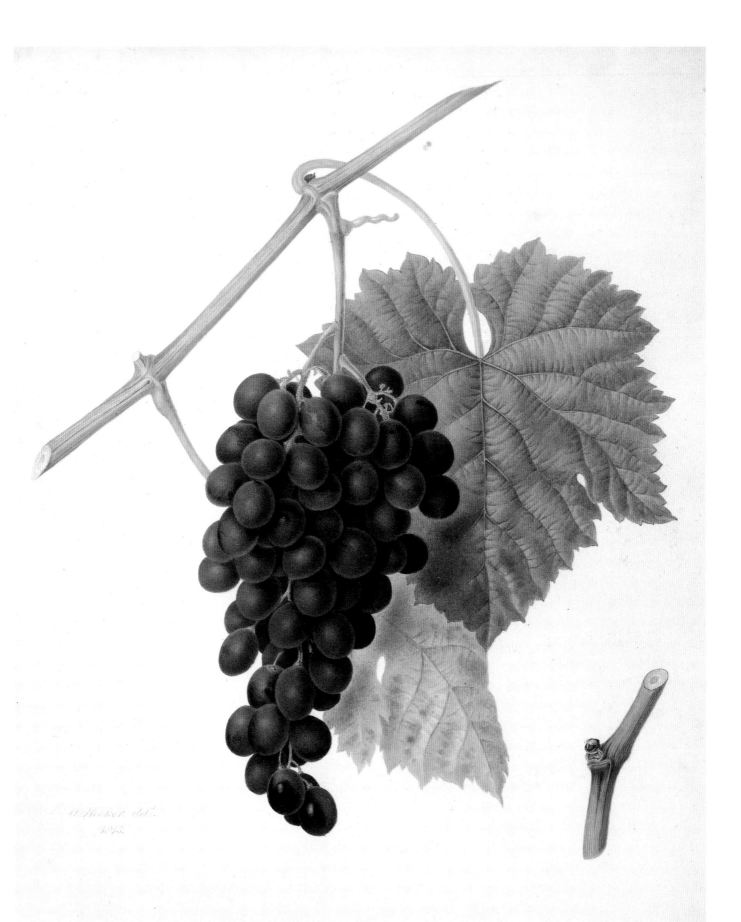

The Black Prince Grape

RED WARRINGTON GOOSEBERRY

Ribes grossularia Linnaeus
(*R. uva-crispa* Linnaeus)

Grossulariaceae

The gooseberry occurs wild in thickets, open woods and hedges in rocky areas of parts of central and southern Europe, western Asia, the Caucasus and northern Africa. Gooseberries growing wild in Britain are mostly thought to be escapes from cultivation since this fruit was grown so widely in cottage gardens in the past. The name 'gooseberry' is considered to have arisen from the use of the berries for making a sauce to go with young or 'green' geese.

There are no records of any cultivation of gooseberries or other members of the genus *Ribes* by the Greeks or Romans, one reason being their unsuitability for cultivation in warmer climates. The earliest record of their use in England was in 1275, when bushes were brought for planting in the gardens at the Tower of London for Edward I. By the time of Gerard, in 1597, gooseberries were grown in abundance in London gardens and from then on their culture and the number of varieties grown increased considerably.

Gooseberries are readily raised from seed, and in the eighteenth century the weavers and other industrial workers in Lancashire and adjoining counties started clubs whose members competed to grow the heaviest berries. To this end they raised hundreds of gooseberry seedlings and from these were selected many of the varieties still in cultivation, including Warrington which appeared in nursery catalogues in 1783. Throughout the last century it was considered one of the best large-fruited varieties both for preserving and for dessert, and it still exists today.

PLATE 86 labelled *The Red Warrington Gooseberry*

[194]

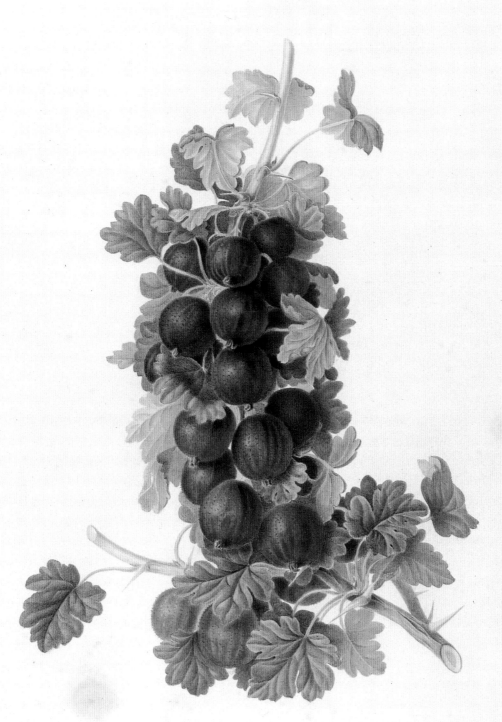

W. Hooker del.
1818.

the Red Warrington Gooseberry

WILMOT'S EARLY RED GOOSEBERRY

Ribes grossularia Linnaeus Grossulariaceae
(*R. uva-crispa* Linnaeus)

This gooseberry was selected by the Fruit Committee of the Horti-
cultural Society in London as the best one among many which were
shown at a meeting in 1814. It was raised about 1805 by John Wilmot
of Isleworth, one of the leading market gardeners in the London area
who became famous for his success in breeding strawberries. Of this
gooseberry he said that he now grew it more than any other for the
London markets as it was ripe early, of excellent flavour and cropped
heavily.

Although the Society had a great many of the varieties raised by
members of the gooseberry clubs of the north of England, most of these
had been bred for the size and weight of the berries rather than for
their quality. At one time, in their variety collection at Chiswick
gardens, the Society had 360 varieties. Early Red was admired for its
earliness since in May, when it was first ready for picking green, it
was larger than any other variety.

PLATE 87 labelled *Wilmot's Early Red Gooseberry*

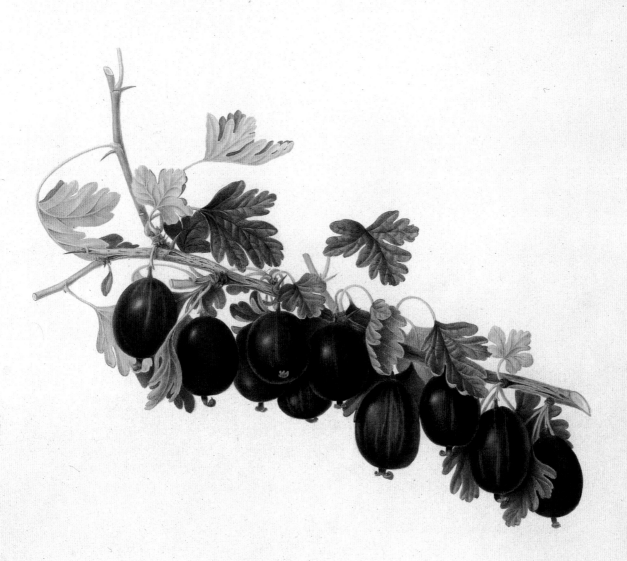

Wilmot's Early Red Gooseberry

WHITE DUTCH CURRANT

Ribes rubrum Linnaeus Grossulariaceae

Ribes rubrum occurs wild in central and northern Europe and Asia, eastwards into Siberia and Manchuria and extending to the Arctic circle. It is found in Scotland and the north of England, but seedlings found in the south may be escapes from gardens. The red colour is dominant, the colour being suppressed in the white forms. In southern Europe and central Asia, *R.petraeum* is the common species.

There was no reference to these currants by the Greeks or Romans, which is not surprising as they normally grow in cooler regions. Although currants were grown in Europe at least by the beginning of the sixteenth century, the earliest reference to them in England was by Turner by the middle of the century. In 1629 John Parkinson wrote that the red currants were usually eaten fresh when ripe and that the white, though less common, had a pleasant winey taste.

Both red and white currants were commonly grown in the following century for use fresh for dessert and for making wines and jellies, and continued to be one of the most widely planted soft fruits until well into the nineteenth century when, to some extent, they gave place to the new, large-fruited strawberries and improved raspberries. The date of the importation of the White Dutch from Holland is not known but it was some time during the eighteenth century. Its berries were larger than the old white and sweeter than the red, and so preferred for dessert and making wine. It was exported to the United States where it became popular for its earliness, productivity and good quality. Both White and Red Dutch were used in the breeding of modern varieties.

PLATE 88 labelled *The White Dutch Currant*

[198]

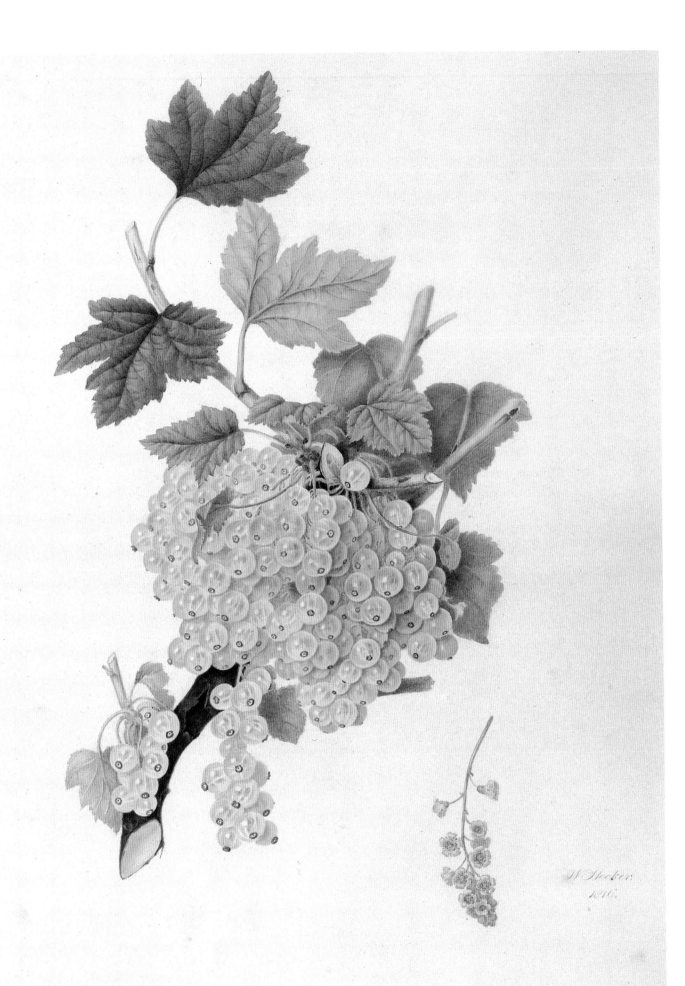

W Hooker.
1816.

The White Dutch Currant.

LARGE BLUE FIG

Ficus carica Linnaeus Moraceae

The fig is a native of western Asia, the eastern Mediterranean region, the Caucasus and the lowest forest zone of Transcaucasia. From the earliest records of civilization figs were of major importance as food throughout Mesopotamia, Palestine and Egypt. Used either fresh or dried, together with dates, they formed the basic diet of travellers and the early agriculturists.

The earliest records of the use of figs are from Egypt, about 2700 BC, and there are frequent references to their use throughout the history of the region as well as in the Bible. Figs were important in ancient Greece and Rome, where they were popular with all classes. In Rome, Columella recommended ten varieties which he named as the best. Seeds of figs have been found on a number of Roman sites in England but there is no evidence of their cultivation there at that time. Although figs were imported for Edward I in 1290 from Spain, the first records of their cultivation in England are in the sixteenth century.

Large Blue is a very old variety which went under many synonyms in England during the sixteenth, seventeenth and eighteenth centuries and is now generally known as Brown Turkey. It seems to have been of Italian origin. Both in Britain and the United States, as well as in Europe, it has always been considered one of the best figs, with deep red, very sweet flesh, and it is still one of the few varieties recommended today for growing in England.

PLATE 89 labelled *The Large Blue Fig*

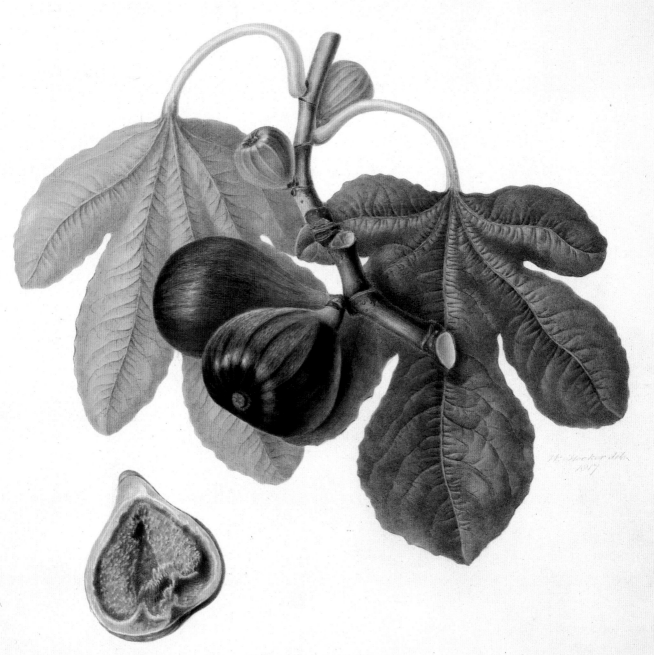

The Large Blue Fig.

WHITE FIG

Ficus carica Linnaeus Moraceae

White is a synonym for White Marseilles which was known for several centuries in Europe and was included in a book of John Evelyn's in 1669. It seems to have been brought to England about that time. It has always been liked for its good quality. In the eighteenth century it was praised for its delicate flavour and early ripening, and in areas where protection in glasshouses is needed for the best results with figs, it has been the first choice.

In the United States in the last century, Downing also considered White Marseilles was one of the most suitable for growing under glass but that it was not so good as Brown Turkey in the open. It has white, transparent, very sweet and rich flesh. The three main varieties of fig grown, albeit on a limited scale, in England now are Brown Turkey, White Marseilles and Brunswick, all of which were included in Richard Weston's nursery list in 1777.

PLATE 90 labelled *The White Fig*

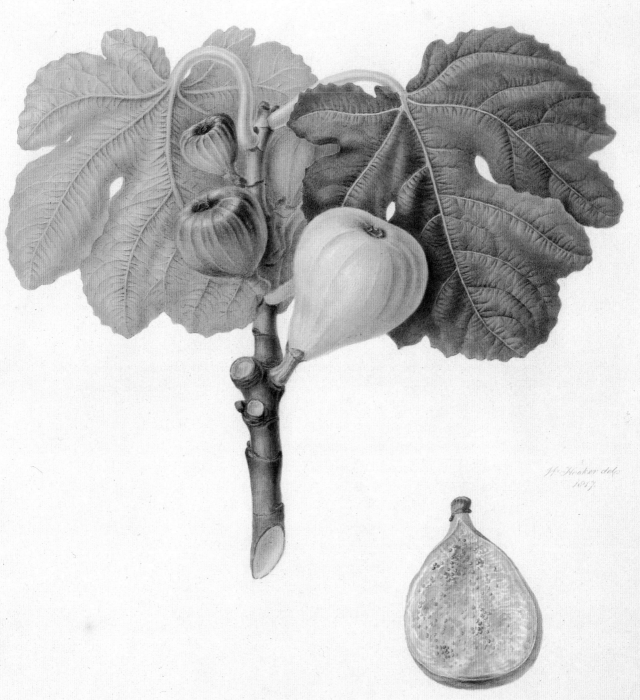

J^s Hooker del^t
1817

The White Fig.

BLACK MULBERRY

Morus nigra Linnaeus Moraceae

The common or black mulberry is thought to have originated in the southern Caucasus or in the mountains of Nepal and is the species cultivated for its fruits, which are eaten raw or made into various drinks and conserves. *Morus alba* L., the white mulberry, a native of China, is the one normally grown for feeding silkworms for the production of silk.

The black mulberry was described by Pliny as being grown around Rome and, from excavations of its seeds on the Roman site of Silchester in England and from Roman sites on ancient wharfs near the River Thames, it appears that mulberries were available in Britain at that time; and since they are such a perishable fruit, they were probably grown here. Mulberry trees are very long-lived and have been known to survive for several hundred years.

In medieval gardens the fruits were used for adding colour and flavour to wines and for making 'murrey', a sort of purée to be added to spiced meats or used as puddings. In 1241 mulberry and raspberry drinks were bought for King Henry III. In 1608 four acres of black mulberries were planted by King James I on a site which is now Buckingham Palace, in the hope of producing silk, but unfortunately the wrong species was chosen and the attempt met with little success.

The black mulberry was taken to the United States but though its fruit was considered better and larger than that of the red mulberry *Morus rubra*, a native of Virginia, it proved much less hardy.

PLATE 91 labelled *The Black Mulberry*

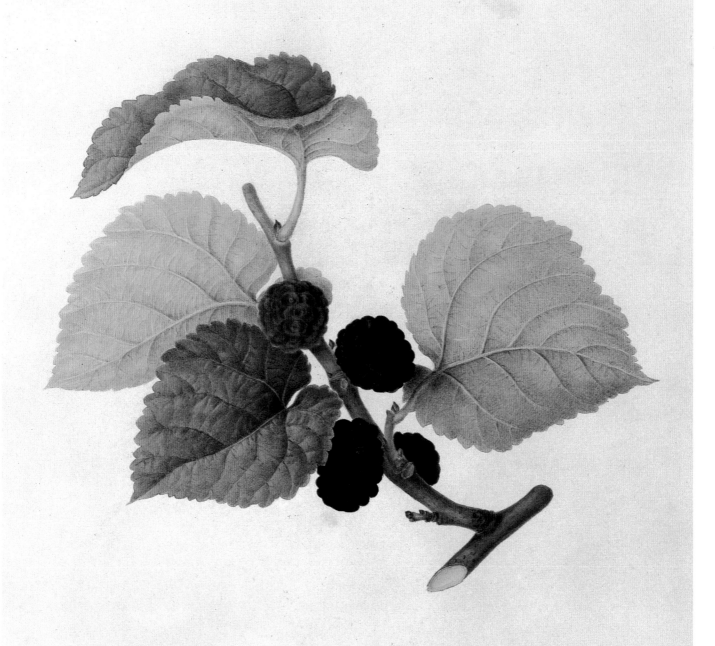

W.Hooker. 1816.

The Black Mulberry.

BLACK ROCK MELON

Cucumis melo Linnaeus Cuccurbitaceae

The country of origin of the melon is uncertain but, since the wild species of *Cucumis* are found there, it is probable that it was in Africa. Melons do not seem to have been known to the Greeks but Pliny, in Rome, referred to them. They were spread into Asia, India, China and Southern Russia and now occur worldwide.

Melons were cultivated in England by 1570 and Gerard, at the end of the century, said he had seen them growing at the Queen's House at St James's and that many were being grown in Bermondsey. In 1629 Parkinson wrote that melons, though they had been rare and were only grown by kings and noblemen, were now more common since they had been brought over from France. He said that many English growers had failed with them in the past but had been more successful since they used hot-beds and covered the plants with bell-glasses. By the nineteenth century melons were commonplace, but the quality of many on the markets was poor.

Black Rock was a very large melon covered with knobs or carbuncles, but the salmon-coloured flesh was sweet and at the beginning of the last century Black Rock was placed first for the richness of its juice, though later better types were evolved.

PLATE 92 labelled *The Black Rock Melon*

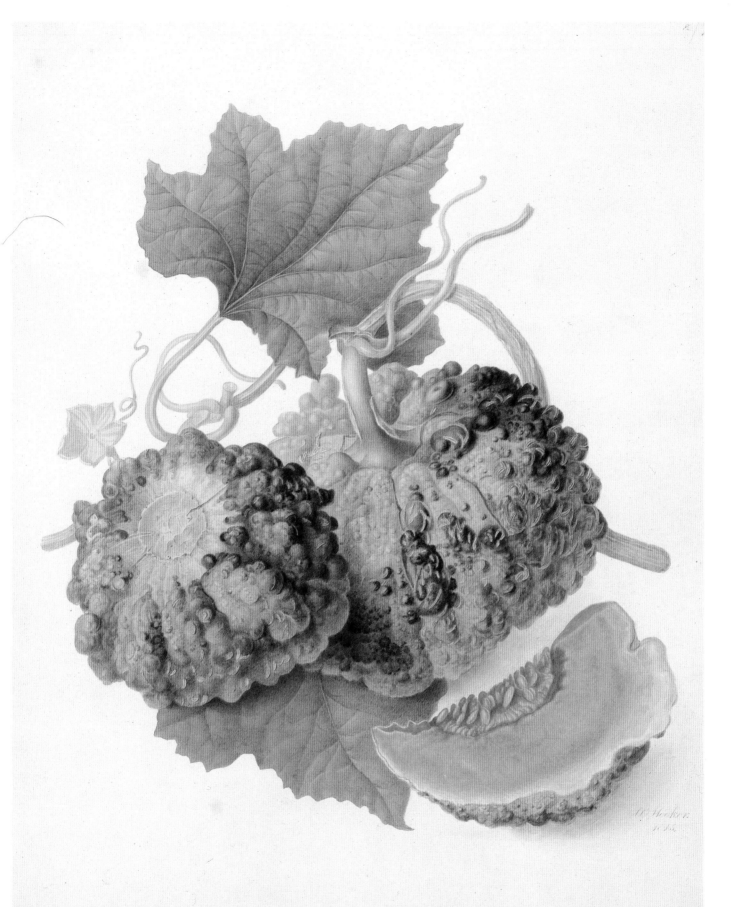

The Black Rock Melon.

QUEEN PINEAPPLE

Ananas comosus (L.) Merrill Bromeliaceae

The cultivated pineapple is thought to have its origin in the Parana-Paraguay river drainage area and to have been selected from the wild by Tupi-Guarani Indians and taken with them during their migrations so that it became domesticated in South America in pre-Columbian times. The first Europeans to record the pineapple were members of Columbus's team who found them on the island of Guadeloupe when they landed there on 4 November 1493. On Columbus's fourth and last voyage in 1502–4 his son Ferdinand, who accompanied him, recorded that the Indians made a wine 'out of a fruit which was found on the island of Guadeloupe, like a great pine cone'. He wrote that the plants were grown in extensive fields from the shoots which grew from the top of the pine cone.

Fruits, and often entire plants, were carried home by early voyagers and quickly spread during the sixteenth century, reaching the Philippines in 1558 and South Africa by 1660. A 'Queen' pineapple from Barbados was given to Charles II in 1661. The plant was introduced to Europe about the middle of the seventeenth century, by Le Cour of Leyden in Holland who, after many trials, was able to produce the first fruits in heated glasshouses. Later, the pineapple plant was kept as a curiosity in the hothouses of the wealthy and, for many years, in the Royal Gardens in London. When one of these plants fruited, people of distinction came from France, Holland and Germany to see it.

The Queen is one of the oldest varieties and is still grown, mainly in Australia and South Africa, for the fresh fruit trade. It is early and fruits freely. By the beginning of the nineteenth century many pineapples were grown in hothouses in England and in 1830 a trial of pineapples carried out by the Horticultural Society in London included no less than fifty-two varieties.

PLATE 93 labelled *The Queen Pine*

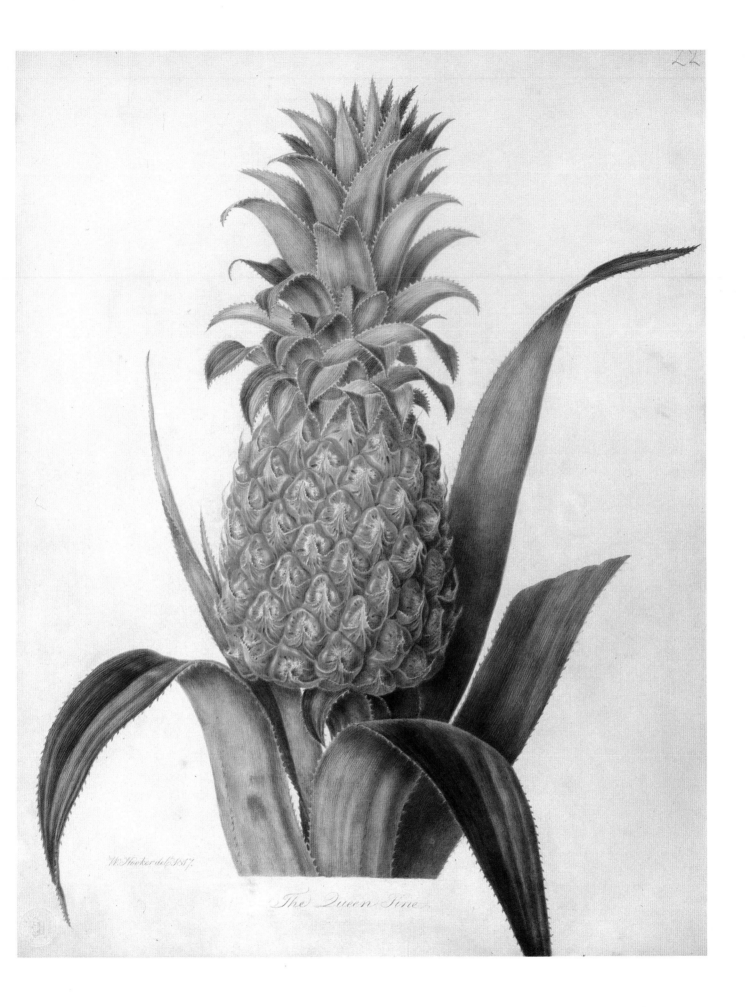

W. Hooker del. 1817.

The Queen Pine.

COB NUT

Corylus avellana Linnaeus Corylaceae

The common hazel or cob nut grows wild in all parts of Europe includ-
ing Britain, and in North Africa, Asia and central Russia excepting the
extreme north. The pollen, wood and nuts have been frequently found
in peat and alluvial deposits and the plant was well established in Britain
before its separation from continental Europe. Remains of nuts have
been found on Stone Age and later settlements and it has been suggested
that they provided a source of food later supplied by cereals. During
the Late Bronze Age, material from the bushes was used in parts of
Somerset for making roads across the marshes and for baskets, fishing
rods and other purposes.

The Greek writer Theophrastus said that the wild nuts were little
inferior to the cultivated ones. Hazel nuts were included in the diet
of Roman soldiers on active service both in Europe and Britain. These
were probably picked locally, as they were for many centuries for sale
in local markets and London. Later their place was largely taken by
varieties of the filbert, *Corylus maxima*, of which the most outstanding
in the nineteenth century was known as Kentish Cob, though really
a filbert.

PLATE 94 labelled *The Cob Nut*

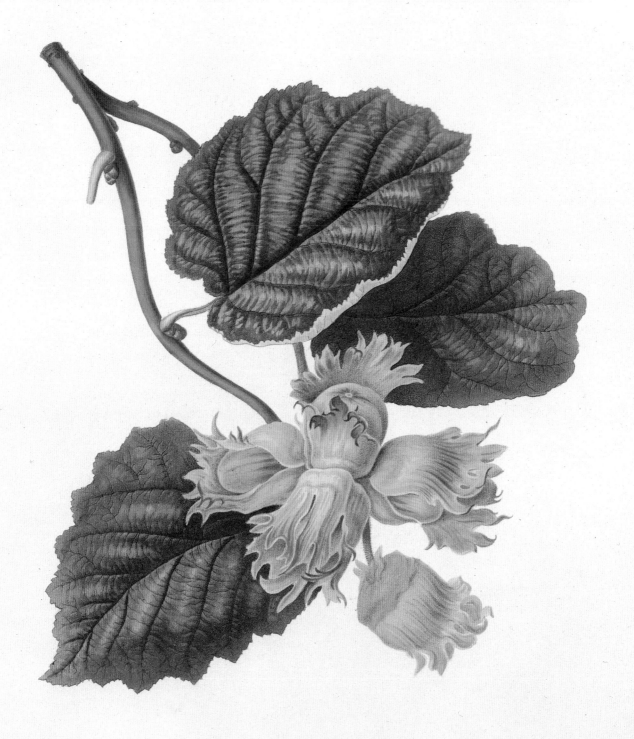

The Cob Nut.

LARGE FRENCH WALNUT

Juglans regia Linnaeus Juglandaceae

The common walnut grows wild over much of Europe, the Middle East, in the forests of Turkestan, the Caucasus and Afghanistan. The nuts were used for food by Stone-Age man and for several thousand years BC in Persia, Syria and the Lebanon where they became an important article of trade. The Greeks and Romans were fond of walnuts and their cultivation spread throughout Europe. Records show that they were grown in gardens in London in the thirteenth century, but they were probably brought to England before that.

The Large French, which had nuts two to three times larger than the common variety, was recorded in England by Switzer in 1724 and it continued in cultivation for many years but, though the nut was large, it kept badly and quickly decayed if not eaten soon after picking. By the middle of the last century it had lost its popularity.

PLATE 95 labelled *The Large French Walnut*

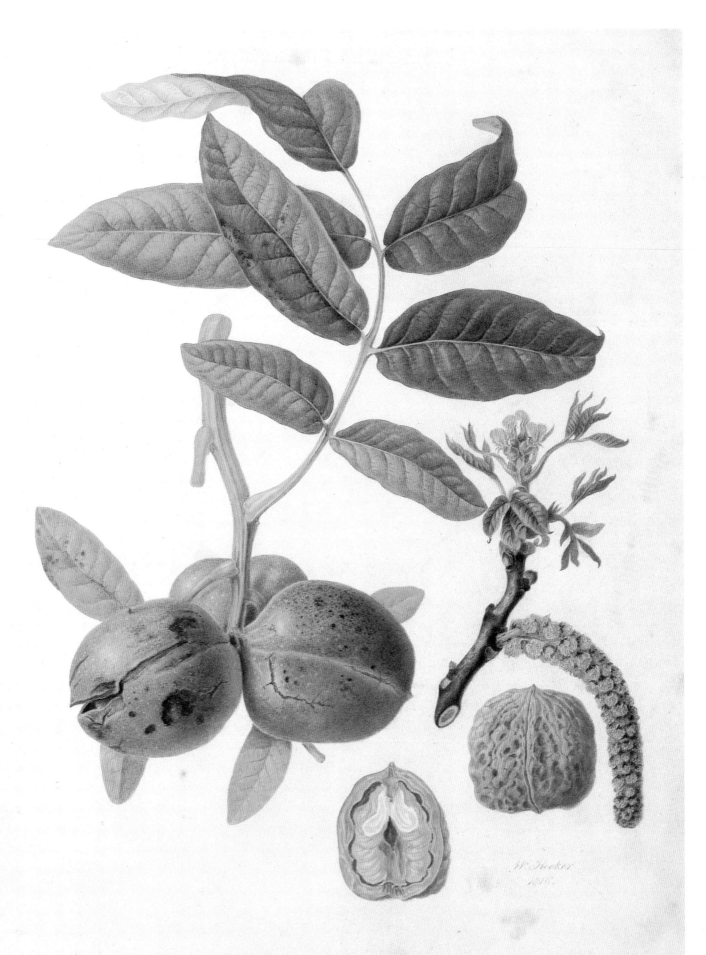

The Large French Walnut

HIGH-FLYER WALNUT

Juglans regia Linnaeus Juglandaceae

Although the production of walnuts in England has always been uncertain owing to their susceptibility to frost, their wood was always of special value for making of the butts of guns and for some types of furniture. In the sixteenth and seventeenth centuries, walnuts were grown so widely in France, Germany and Italy that their timber was used not only for furniture but also for panelling in houses and for the wheels and bodies of coaches.

In 1664, John Evelyn the diarist, in his *Sylva*, encouraged the planting of walnuts for their timber, and many trees were planted in Surrey and adjoining counties. Apart from the nuts being used for eating, the oil was used by painters for mixing white and other delicate colours and for gold size and varnish. It is still used for salads and other culinary purposes.

The High-flyer was one of the new varieties tried in England as the cultivation of the trees for their nuts became more popular. The nuts ripened earlier than most others and would even mature in Scotland. They were of good size and flavour.

PLATE 96 labelled *The High-flyer Walnut*

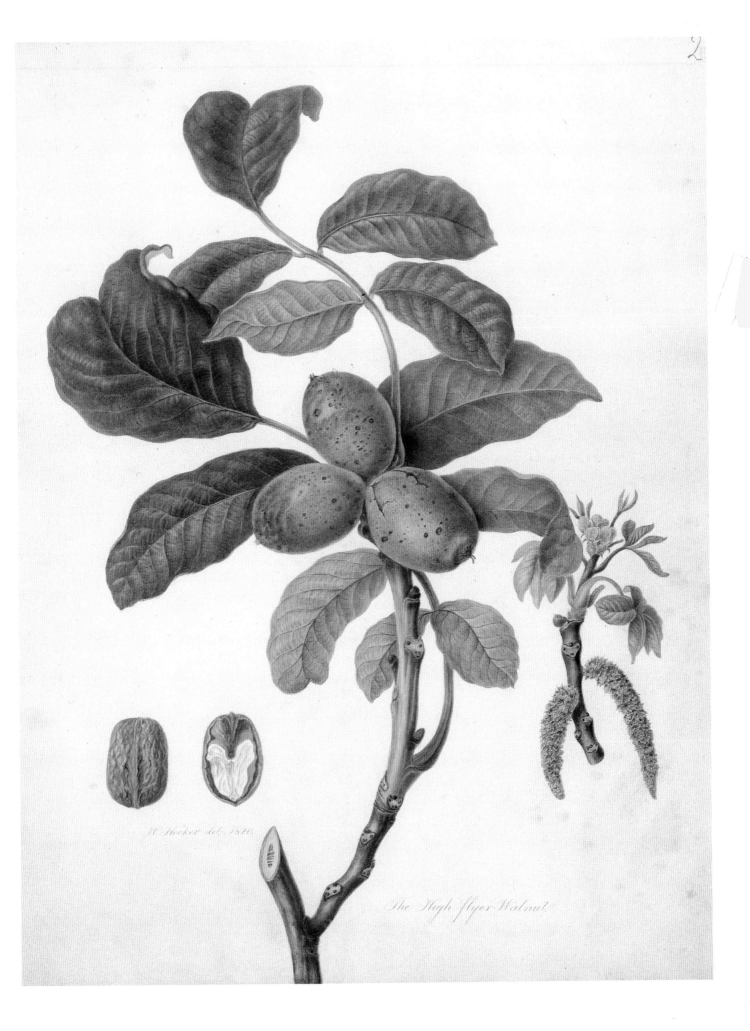

W. Hooker del. 1818.

The High flyer Walnut

BIBLIOGRAPHY

BRADLEY, RICHARD *A General Treatise of Husbandry and Gardening*, London 1726

BROOKSHAW, GEORGE *Pomona Britannica*, London 1812

BULTITUDE, JOHN *Apples*, London 1983

BUNYARD, EDWARD A. *A Handbook of Hardy Fruits. Apples and Pears*, London 1920

BUNYARD, EDWARD A. *A Handbook of Hardy Fruits. Stone and Bush Fruits, Nuts etc.*, London 1925

CORDUS, VALERIUS *Annotationes in Pedacii Dioscoridis Anazarbei de medica Materia Libros*, Strasbourg 1561

DOWNING, A.J. *The Fruits and Fruit Trees of America*, first published New York 1845, revised C. Downing 1857

DUCHESNE, A.N. *Histoire Naturelle des Fraisiers*, Paris 1766

DUHAMEL DU MONCEAU, H. L. *Traité des arbres fruitiers*, Paris 1768

FORSYTH, WILLIAM *Culture and Management of Fruit Trees*, London 1802, 1806, 1824

GERARD, JOHN *The Herball*, London 1597

GERARD, JOHN *The Herball* (revised by Thomas Johnson) London 1633

GRUBB, NORMAN H. *Cherries*, London 1949

HANMER, SIR THOMAS *Garden Book*, unpublished 1659, published London 1933

HEDRICK, U.P. *The Peaches of New York*, New York 1917

HEDRICK, U.P. *The Pears of New York*, New York 1921

HEDRICK, U.P. *The Small Fruits of New York*, New York 1925

HOGG, ROBERT *The Fruit Manual*, London 1860, 1866, 1874, 1875, 1884

HOGG, ROBERT *Herefordshire Pomona*, London 1876–85

HOOKER, WILLIAM *Pomona Londinensis*, London 1818

HORTICULTURAL SOCIETY *Transactions I–VII*, London 1816–24

KNIGHT, THOMAS ANDREW *A Treatise on the Culture of the Apple and Pear and on the Manufacture of Cyder and Perry*, London 1797, 1809

LAUFER, B. *Sino-Iranica (Field Museum of Natural History Publication, Anthropological* 15, no.3), Chicago 1919

LOUDON, JOHN CLAUDIUS *The Encyclopaedia of Gardening*, London 1822, 1834

MEAGER, LEONARD *The English Garden*, London 1670, 1688

MERLET, JEAN *L'Abrégé des bon fruits*, Paris 1667–90

PARKINSON, JOHN *Paradisi in Sole (Paradisus Terrestris)*, London 1629

PLINY (the Elder) *Natural History VIII–XIX* (trans. H. Rackham), London 1967

QUINTINYE, JOHN DE LA *The Compleat Gard'ner* (trans. John Evelyn), London 1693

REA, JOHN *Florae, Ceres et Pomona*, London 1676

ROACH, F.A. *Cultivated Fruits of Britain. Their Origin and History*, Oxford 1985

SANDERS, ROSANNE *The English Apple*, Oxford 1988

SMITH, MURIEL W. G., *National Apple Register of the United Kingdom*, London 1971

Switzer, Stephen *The Practical Fruit Gardener*, London 1724

TAYLOR, H.V. *The Apples of England*, London 1948

TAYLOR, H.V. *The Plums of England*, London 1949

THEOPHRASTUS *De Causis Plantarum I* (trans. B. Einarson and G.K.K. Link), London 1976

THEOPHRASTUS *Enquiry into Plants* I & II (trans. A.F. Hort) London 1968

TREVERIS, PETER *The Grete Herball*, London 1526

WORLIDGE, JOHN *Systema Agriculturae, the Mystery of Husbandry discovered*, London 1669, 1675, 1681, 1697

WORLIDGE, JOHN *Vinetum Britannicum or, a Treatise on Cider*, London 1676, 1678, 1691

INDEX

Ahlefeldt, Count Chr. 26
Aiton, John 182
Alexander, Emperor of Russia 60
American Pomological Society 94
Ananas comosus 208–9
Andrews, Henry C. 12
Ann, Queen of England 72
Anneslia falcifolia 15
 A. grandiflora 15
Annotationes (Cordus) 9
Anson, Lord 104
Apothecaries' Garden, London 166
apple 21, 24–63
 cider 62
 crab 24, 62
 propagation 16
 scab 28, 62
apricot 98–105
Arnold Arboretum, Journal of the 20
Augustenberg, Duke of 26

Bagley (gardener) 34
Banks, Sir Joseph 12, 13, 17
Bartlett, Enoch 78
Barton, William Smith 17
Bateman, James 19
Bauer, Ferdinand 12, 20
Bauer, Franz 11–12
Bede, Venerable 180
blackthorn 118
*The Botanical Magazine or Flower
 Garden displayed* 12, 13
*The Botanist's Repository for new and
 rare Plants* 12, 13
Bourdine (gardener) 90
Braddick, John 88
Bradley, Richard 52, 144, 188
Brewer, Thomas 78
Brodiaea 11, 15
 B. grandiflora 14–15
Brodie, James 15

Brompton Park Nurseries 28, 32, 40
Brookshaw, George 11
Brown, Robert 14
bullace 136
Bunyard, Edward Ashdown 10–11, 21,
 92
Burtonia 15
 B. grossulariaefolia 13

Cadenhead (nurserymen) 168
Caledonian Nursery 124
Candolle, Augustin Pyramus de 13
Carter, John 78
Catherine the Great, Empress of
 Russia 154
Cato the Elder 66
Cattley, William 20
Cattleya 20
Cecil, Robert, first Earl of Salisbury 158
Charles I, King of England 158
Charles II, King of England 208
Charlotte, Queen 40, 182
cherry 140–59
cherry plum 118
Childers, N.F. 104
cider
 apple 62
 making 16
Clark, William 17
Clarkia 17
clones 16
cob nut 210–11
Coe, Jervaise 126
Collectanea botanica (Lindley) 20
Columbus, Christopher 208
Columella 200
Colvill, James 13
Compleat Gard'ner (de la
 Quintinye) 96, 114
Cordus, Valerius 9, 40, 70
Cornwall (nurseryman) 178

Corylus avellana 210–11
 C. maxima 210
Cotton, Barbara 19
Cox, Richard 30
crab apple 24, 62
Crataegus 160
Cucumis melo 206–7
currant
 (dried grape) 190
 red 198
 white 198–9
Curtis, William 12
Cydonia oblonga 138

damson 136
Davidson, Robert 168
Downing, Andrew Jackson 36, 52, 70,
 74, 76, 80, 90, 92, 94, 102, 114, 116,
 122, 128, 130, 138, 182, 184, 192, 202
Driver, William 104
Drummond, William 28
Duchesne, A.N. 172
Duhamel du Monceau, H.L. 10, 74, 92,
 130
'Dutch Jacob' 80

Edward I, King of England 138, 194, 200
Ehret, G.D. 12
Ellis, William 24
English Botany (Sowerby and Smith) 12
Evelyn, John 96, 114, 202, 214

Fairchild, Thomas 52, 112
Ficus carica 200–3
fig 200–3
filbert 210
Flora Americae septentrionalis
 (Pursh) 11, 17–18
Flora Danica (Pauli) 10
Forbes, James 16
Forsyth, William 28, 42, 44, 46, 76, 84,
 88, 90, 96, 102, 116, 134, 164, 184
Fragaria chiloensis 166–7, 172, 174
 F. elatior 172
 F. vesca 168
 F. virginiana 166, 168–71, 172, 174
 F. hybrids 172–5
Francis, J.W. 17
François I, King of France 120
Fraser, John 154

Frézier, Captain A.F. 166
Fruit Manual (Hogg) 46

gage *see* plum
Gage, Sir Thomas 120
Gansel, Lieutenant-General 76
The Genera of Plants (Salisbury) 15
*The Generic Characters in the English
 Botany collated with those of Linné*
 (Salisbury) 14
George III, King of England 82
Gerard, John 86, 98, 106, 118, 140, 142,
 162, 164, 194, 206
Goodenough, Samuel 14
Goodrick, Sir Henry 30
gooseberry 194–7
gooseberry-growing clubs, English 194,
 196
grape 180–93
Gray, J.E. 14
Gray, S.F. 14
greengage 10, 120
The Grete Herball (Treveris) 136
Grimwood and Wykes (nurserymen) 54,
 82
Grubb, Norman H. 146
guava 19–20
Gurle, Captain Leonard 108

Hampton Court 18, 84, 180
Hanmer, Sir Thomas 102
Hawkins, Sir Christopher 44
hawthorn 160
hazel 210
Hedrick, U.P. 30, 104, 108, 110, 148, 152
Henry III, King of England 204
Henry VIII, King of England 120
Herball (Gerard) 106
Herefordshire Agricultural Society 62
Hibbertia 15
 H. crenata 13
Hitt, Thomas 180
Hogg, Robert 24, 28, 30, 34, 40, 42, 46,
 50, 58, 84, 94, 122, 128, 134, 138
Hooker, Sir William Jackson 11, 14
Hookera 11, 15
 H. coronaria 14, 15
 H. pulchella 14
Hookeria 11, 14, 15
Hooker's Green (colour) 11